Historical Comedy on Screen

Historical Comedy on Screen

Subverting History with Humour

Edited by Hannu Salmi

intellect Bristol, UK / Chicago, USA

First published in the UK in 2011 by
Intellect, The Mill, Parnall Road, Fishponds, Bristol, BS16 3JG, UK

First published in the USA in 2011 by
Intellect, The University of Chicago Press, 1427 E. 60th Street,
Chicago, IL 60637, USA

A catalogue record for this book is available from the
British Library.

Cover Image: The Private Life of Henry VIII (1933), ITV Studios Global
Entertainment.

Cover designer: Holly Rose
Copy-editor: Rebecca Vaughan-Williams
Typesetting: Mac Style, Beverley, E. Yorkshire

ISBN 978-1-84150-367-7 / EISBN 978-1-84150-522-0

Contents

Chapter 1: Introduction: The Mad History of the World 7
Hannu Salmi, University of Turku

PART I: Comedians and Comic Representations 31

Chapter 2: Buster Keaton's Comedies of Southern History: *Our Hospitality* and
 The General 33
Susan E. Linville, University of Colorado Denver

Chapter 3: Comedians and Romance: History and Humour in *Kalabalik* 53
David Ludvigsson, University of Uppsala

Chapter 4: From Ideal Husbands to Berserk Gargoyles: A Survey of Period
 Comedies Representing the British Past in the 1950s and 1960s 79
Harri Kilpi, University of Helsinki

Chapter 5: Forms of History in Woody Allen 101
Maurice Yacowar, University of Calgary

PART II: No Laughing Matter 111

Chapter 6: No Laughing Matter? Comedy and the Spanish Civil War in Cinema 113
David Archibald, University of Glasgow

Chapter 7: A Killer Joke? World War II in Post-War British Television and Film Comedy 129
Rami Mähkä, University of Turku

Chapter 8: 'Holocaust-Nostalgia', Humour and Irony: The Case of *Pizza in Auschwitz* 153
Hagai Dagan, Sapir College

Chapter 9: Comedy and Counter-History 175
Marcia Landy, University of Pittsburgh

Index 199

Chapter 1

Introduction: The Mad History of the World

Hannu Salmi, University of Turku

'History is about the most cruel of all goddesses', wrote Friedrich Engels in 1893, 'she leads her triumphal car over heaps of corpses, not only in war, but also in "peaceful" economic development' (cit. Carr 1961: 105). In Engels's view, history is a cruel tragedy, and the conception of history as something profoundly tragic has made our image of the past grim and joyless. Although one might assume there would be plenty of amusement to be found in the past, historians rarely laugh at the objects of their study. The same can be said for historical films: there is no doubt that the majority of filmed portrayals of the past paint a sombre tone. Examples from the past decades include such films as Oliver Hirschbiegel's *Der Untergang* (Downfall, 2004), Roland Emmerich's *The Patriot* (2000), Ridley Scott's *The Gladiator* (2000) and Luc Besson's *The Messenger: The Story of Joan of Arc* (1999). While the past is always noble and majestic, it is, first and foremost, tragic.

This linking of history and tragedy can be traced far back into the history of Western civilization. While the tragedians Euripides, Sophocles and especially Aeschylus wrote exclusively about an ancient era of heroic deeds, the comic playwright Aristophanes found his subject matter in everyday life and politics. The contemporary environment of the author's audience was considered more appropriate raw material for merriment than the past. Methods of characterization would also vary in tragedy and comedy. In the *Poetics*, Aristotle considered tragedy – like the epic – 'an imitation in verse of characters of a higher type', while comedy would mainly portray 'characters of a lower type' (1449a, 30–35; 1449b, 5–10). Because we normally have no reason to laugh at human beings suffering from ethical dilemmas, the overall tone of tragedies is therefore serious. Aristotle does not appear to have had a particularly favourable opinion of satirists and comic authors. In the *Rhetoric*, for example, he calls them 'evil-speakers and tell-tales' (1384b, 10–15).

Ancient Greek notions of gravitas and ridiculousness, the tragic and the comic, are so deeply ingrained that they still affect our ways of imagining and portraying the past. Filmmakers – like historians – have no desire to appear as 'evil-speakers' when it concerns history and those who are no longer with us. Nevertheless, films do manage to laugh at the past surprisingly often. This collection of essays is devoted to exploring this comic treatment of history on screen.

Only little has been written on historical comedy so far. This book aims at offering new insights and openings on this rarely discussed theme, not only on historical comedy as a generic entity but, more broadly, on the role of the comic in the audiovisual representation of the past. The first part of the book deals with comedians and comic representations: Susan E. Linville analyses Buster Keaton's silent comedies on Southern history, especially

Our Hospitality (1923) and *The General* (1927), while David Ludvigsson raises up a more recent example, the Swedish historical comedy *Kalabaliken i Bender* (1983) which starred several nationally known film comedians. Both Linville's and Ludvigsson's articles show comic history in the making. Obviously, humorous representations of history can be studied through different methodological approaches. Harri Kilpi makes an interesting experiment by not focusing on any particular moment in film history or any single example of comic storytelling. Instead, he makes a survey of period comedies about the British past in the 1950s and 1960s and shows how historical comedy can be studied by considering larger trends in film production. Maurice Yacowar, instead, writes on one comedian, Woody Allen, who has dealt with history throughout his career, with ample references to earlier films, and who draws much on his own filmic history. For Allen, history is not something external; it is part of one's identity.

The second part of this book is comprised of articles dealing with the comic treatment of traumatic historical events. David Archibald points out that there has been a place for laughter even in the middle of the Spanish Civil War tragedies. Rami Mähkä, in turn, concentrates on the description of World War II in post-war British film and television. Most serious and tragic features of European history have received a comic treatment, through various modes of comic narration, from parody to irony. Hagai Dagan continues to explore traumatic events in his in-depth analysis of a documentary *Pizza in Auschwitz* (2008) which interestingly combines irony with nostalgia. The book ends with Marcia Landy's essay 'Comedy and Counter-History', arguing that parody and satire are effective rhetorical techniques for producing a counter-narrative of the historical past. Landy's examples range from such hilarious portraits of history as Mario Monicelli's *L'armata Brancaleone* (Brancaleone's Army, 1966) to Stanley Kubrick's ironic studies about the past.

Before going more deeply into the subject, it is important to track down basic features of historical humour. This introduction starts by dealing with conceptual questions and, after that, tries to outline the practices and devices of historical comedy, including the conscious use of anachronisms, the deconstruction and revision of genre conventions, and the 'othering' of the past, i.e. making it strange and absurd which often seems to be the case.

History, Comedy and Humour

The question of the relationship between history and humour in film is a complex one. As already implied, the articles in this collection not only focus on one subgenre of historical film, namely historical comedy, but also on the ways of being comedic that have been used to inject comic relief or critical edge into history films. Many of the films examined in this volume are historical films that can be classified as comedies, such as Alexander Korda's *The Private Life of Henry VIII* (1933), Sacha Guitry's *Si Versailles m'était conté* (Royal Affairs in Versailles, 1954), Mario Monicelli's *L'armata Brancaleone* (Brancaleone's Army, 1966) and Jean Yanne's *Deux heures moins le quart avant Jésus-Christ* (Quarter to Two Before Jesus

Christ, 1982). On the other hand, the articles also focus on the role of comedy in historical narration, which is a mode usually founded on tragedy. This includes films like Moshe Zimerman's documentary *Pizza in Auschwitz* (2008) and tragi-comedies such as Carlos Saura's *¡Ay, Carmela!* (1990). Time travel films, such as Jean-Marie Poiré's *Les Visiteurs* (The Visitors, 1993), in which the eleventh-century knight Godefrey de Papincourt and his servants are unexpectedly transported to 1990s France, also traverse the zone between history and humour.

It is important to make a distinction between comedy, being comedic and being comic. Since laughter is always communicative, the quality of being comic is linked to the question of the reception of any particular film. In his classic *Laughter* (Le Rire, 1899), the French philosopher Henri Bergson links three individual elements to the quality of being comic. Laughter, he claims, is always associated with humanity: no comedy exists without the presence of human beings. This is why a landscape, for example, 'may be beautiful, charming and sublime, or insignificant and ugly [but] it will never be laughable'. Another important element is a certain 'absence of feeling': indifference is a fruitful ground for laughter, while dispensing with pity and compassion liberates laughter. Bergson (2008: 11) calls his third identifying characteristic a connection between intelligences: 'laughter appears to stand in need of an echo', he writes. In theatre, the spectator laughs: 'the fuller the theatre, the more uncontrolled the laughter of the audience!' Cultural researchers have for decades discussed and argued about the relationship between text and context on one hand, and between the reader/viewer and his or her cultural environment on the other. In the case of comedy,

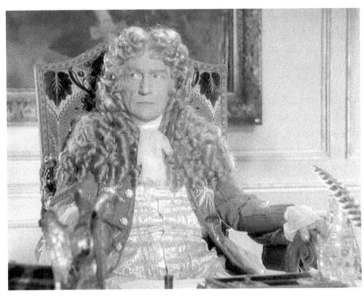

Sacha Guitry, *Si Versailles m'était conté* (Cocinor, 1954).

however, it is very clear that laughter is born out of communication: it would be absurd to assume that laughter was immutably encoded within the text. A tragic work from the past may, in certain situations, become comic, and conversely a comedy may suddenly be given a serious or tragic reception.

Although laughing at the past in general is a fascinating theme for further research, this collection focuses on films that attempt to make the spectators laugh by *telling stories about the past*, or, when irony is being employed, by at least pointing towards the past with a sly smirk. Over the past decades historians have become increasingly interested in all acts of narrating the past – both literary and cinematic. The demarcation line between 'history' and 'fiction' does not appear to be as clear as it once perhaps was. This is also reflected in a theory of history by which talking about the past is no longer understood as a straightforward presentation of facts but rather as a complex question involving poetics. Analysing the laughter could, moreover, be a fascinating opportunity for examining both our historical awareness and our relationship with the past. Film comedies would constitute an important case study in this connection.

Historical comedies have been made throughout the twentieth century. They cover comedian comedies, like Buster Keaton's films analysed by Susan E. Linville in this collection, but they also include period comedies, generic parodies, episodic farces and even sex comedies situated in the past, as reminded by Harri Kilpi in his essay. Some of the historical comedies, such as Frank Tuttle's *Roman Scandals* (1933) and the Monty Python group's *The Life of Brian* (1979), have become cult classics. In analysing historical humour on screen, it is also important to pay attention not only to historical comedies as such but also to the past that is used as raw material for comedy. *Roman Scandals* refer to ancient history, but national themes are often also laughed at. In this collection, David Archibald, David Ludvigsson and Rami Mähkä deal with films that address national audiences and raise up periods of history that have been deemed crucial from the national point of view. Clearly, the temporal distance has an influence on the nature of laughter. *Kalabaliken i Bender* can carnivalize its main figure, the Swedish warrior king of the early eighteenth century.

In small national cultures, however, laughing about the past may be taboo or at least very suspect. Finland, a nation that developed amid the political constellation between Eastern and Western Europe, is a good example. The total number of historical films made in Finland is approximately 80–90, with their overall tone being serious and solemn. Humour has remained on the periphery. Although laughter is used to add levity to many stories, only a few films that can be classified as historical comedies exist, as for example Valentin Vaala's *Sysmäläinen* (The Man from Sysmä, 1938) and Jukka Virtanen's *Noin seitsemän veljestä* (Approximately Seven Brothers, 1968).

As an object of study, historical comedy is as nebulous and difficult to define as historical film, whose identifying characteristics also elude easy definition. One observation that can be made regarding historical comedy is that the characteristic of being historical has more often been linked to other genres, such as the musical. Historical comedy may, in fact, be

said to derive its power more from the tradition of comedy films than from serious historical dramas, especially if the intention of the filmmaker is not to poke fun at the conventions of historical films. This is why Vaala's *Sysmäläinen*, for example, is highly reminiscent of 1930s Hollywood comedies in which the central theme is the battle between the sexes. Comedies of this type do not usually seek particularly to undermine the illusion of the past. On the contrary, it appears as if Robert A. Rosenstone's (2005: 54–61) distinction between mainstream historical films and experimental history films could be useful in connection with historical comedies. While mainstream films usually portray the past as a closed process that has a clear beginning and a clear ending, the stories told in experimental films may remain open, revealing their narrative processes to the spectator. Traditional historical films employ an illusory way of depicting the past, presenting the spectator with a unified and coherent narrative about the past, avoiding anachronisms and references to the cinema apparatus. In historical comedy, the contrast is clear: in films like *Sysmäläinen* the epoch is presented as a closed whole, while films like Mel Brooks' *The History of the World: Part I* (1981) playfully disrupt that narrative by all possible means.

Amusing Anachronisms

One of the most popular ways of provoking laughter in historical comedies is the conscious use of anachronisms: the present is permitted to make an appearance in the past or the epoch that is portrayed is explicitly commingled with other epochs. This is precisely the case when the medieval knights start discussing imperialism in *Monty Python and the Holy Grail* (1975). An analogue for this kind of humour might be the everyday observation of how unintended anachronisms in serious historical films become amusing in the eyes of later generations. For present-day spectators, it is all too easy to guess when Mervyn LeRoy's *Quo Vadis* (1951) or William Wyler's *Ben-Hur* (1959) were made since it is so clearly disclosed by the clothing, hairstyles and modes of speech. If unintentional details like these are amusing, the device can certainly be used intentionally to great advantage.

Anachronisms have been the subject of a heated debate among historians, which may explain why they have also been noticed by makers of comedy films. The Finnish historian Jorma Kalela writes on anachronisms:

Historians have become accustomed to thinking that the problem of anachronisms can be solved simply by proscriptions. They also generally agree about elements that cannot be a part of an acceptable description of historical events. Historians must be able to resist the temptation of observing their objects of study through the concepts and conceptual frameworks of later times [...] they must always make sure the starting points and fundamental assumptions of their research processes include no anachronisms. Contemporary patterns of thinking become widely internalised and not easily detected. The need to question the justification of such models of thought is easily forgotten –

unless one consciously reminds himself or herself of it. (Kalela 2000: 83–84, editor's translation)

Although the problem of anachronisms may appear straightforward, we are facing a fundamental problem. To what extent, we may ask, are modern theoretical tools part of the 'contemporary patterns of thought' Kalela mentions? At what point do the critical tools employed by a researcher become anachronistic? Undoubtedly this is one of the reasons why many historians are sceptical of highly theoretical approaches to history and instead emphasize the traditional empirical character of the discipline. Moreover, the question of anachronisms may be placed into the context of the historicistic tradition: historicism, a product of the nineteenth century, maintained that the past could and should only be examined by using the concepts of the era being studied. The scholar was assumed to be able to relinquish contemporary patterns of thought like so many pieces of excess clothing. But even if we abandon historicist thinking, and even if the present does leave its traces on our work, we cannot claim that all attempts at studying the past are always anachronistic. The hermeneutic philosophy of history has emphasized the understanding of historical research as a dialogue between two conceptual horizons, the past and the present. In this case, however, the scholar is aware of his or her contemporary views and – at least in principle – declines to unreflectively project modern concepts onto the past.

In any case the problem of anachronisms is a serious question for historians, a problem that may well arise from the generally humourless nature of our conception of history. It is assumed that one must reverentially bow down one's head before history, be serious and defer to the past, allowing it to speak with a voice of its own. There can be no doubt that this austerity has also affected the way historical films have been discussed over the past decades. Especially in the 1990s, filmed stories of the past suddenly became the objects of study of a number of historians, such as Robert A. Rosenstone, Peter C. Rollins, Robert Brent Toplin and Leger Grindon. However, only films that examined history with sufficient solemnity of purpose were deemed worthy of analysis. In *History by Hollywood. The Use and Abuse of the American Past* (1996), Robert Brent Toplin turns his magnifying glass on such films as *JFK* (1991), *Bonnie and Clyde* (1967), *Patton* (1970) and *All the President's Men* (1976). However, poking fun is not considered a valid 'use' of the past. Perhaps the selection of these films also reflects a sense of a distinction between 'high' and 'popular' culture: in other words, works that can be considered valid objects of serious study are those that have an explicit interest in examining the past seriously and not in ridiculing it. On the other hand, the premises and objectives underlying different genres of historical stories seem to vary: entertaining historical spectacles are often regarded as sources of data regarding audience preferences, not in order to understand what they argue about the past, while serious dramas merit attention as serious contributions to historical knowledge.

All this gravitas enables us to understand why the deliberate use of anachronisms has fascinated the makers of historical comedies: breaking the historical 'timeline' has been a taboo that has provided endless possibilities for fantasy. It appears, however, that the

use of anachronisms did not become prevalent before the end of World War II. In films produced before and during the war, a serious illusion of an unbroken epoch was usually maintained. Jacques Feyder's comedy *La Kermesse héroïque* (Carnival in Flanders, 1935), for example, follows the principles of other comedies of its time rather closely, but avoids any discrepancies in the way the epoch is portrayed. In terms of style the film is a comedy, but its laughter is never caused by the deliberate violation of period consistency and dramaturgy. The film depicts a seventeenth-century Flemish village that is forced to receive a gang of Spanish conquerors and provide lodgings for them. As the men of the community prove to be cowards, the women take the lead and save the village. In the end, the film never pokes fun at the past or historical nature of the events portrayed, but rather at the relationships between men and women. The film does in fact feature a small number of scenes that authenticate the period belonging to the seventeenth century: the Spanish, for example, bring with them a fork, and its use by the Flemish is a source of great amusement.

Apparently anachronistic humour was easier to employ when the entire film was built around a comedy star or a group of stars. Although *Duck Soup* (1933) by the Marx Brothers cannot be considered a historical comedy as such, the final scene of the film juxtaposes epochs with great success: as the imaginary states of Freedonia and Sylvania drift into a war, various historical eras are mixed resulting in a very amusing medley. Over the 1930s, 1940s and 1950s Bob Hope starred in many historical comedies where anachronisms are sometimes employed, although the primary raw material of humour is still word play. David Butler's *The Princess and the Pirate* (1944) is set in the eighteenth-century Caribbean, and no

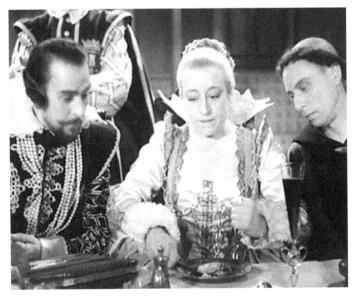

Introduction of the fork in Flanders, according to Jacques Feyder's *La Kermesse héroïque* (Films Sonores Tobis, 1935).

expense is spared in building the period background. Bob Hope plays the protean Sylvester the Great, who ends up as a variety performer in a pirate tavern. Hope's anachronistic humour, however, is verbal: the film's reproduction of an eighteenth-century milieu is not disturbed by mischievously introducing details from other eras. On the other hand, Sylvester never hesitates to disrupt the historical illusion at the level of dialogue. In the beginning of the film, he tries to charm Princess Margaret (Virginia Mayo) by showing her newspaper cuttings of the reviews of his shows. One of them, Sylvester boasts, is in Russian – directly from the Leningrad *Tattler*!

Since the 1960s, anachronistic humour has been an indispensable part of popular fiction, including not only cinema but also comic books and television shows.

René Goscinny's and Albert Uderzo's *Astérix* comics became famous of their hilarious anachronisms. Clearly, their enjoyable mixing of historical periods was a strategy to address different audiences and age groups. It seems that filmmakers also soon refused to be bound by the accepted forms and traditional narratives of historical epochs. Where in Bob Hope films the hero is still dressed in the period style of the epoch, in Woody Allen's *Love and Death* (1975), for example, Boris Grushenko (Woody Allen) situates himself outside the historical background of the film starting from the first images. Allen never even tries to situate himself within the historical diegesis: he merely plays against a historical backdrop. The dialogue is also spiced with incongruous reflections on problematic human relationships and philosophical humour, a regular feature of Woody Allen's comedies:

Sonja: Judgment of any system, or a priori relationship or phenomenon exists in an irrational, or metaphysical, or at least epistemological contradiction to an abstract empirical concept such as being, or to be, or to occur in the thing itself, or of the thing itself.
Boris: Yes, I've said that many times.

Anachronism is also a regular source of laughs in the comedies of the Monty Python group and Mel Brooks. In *Monty Python and the Holy Grail*, King Arthur (Graham Chapman) is looking for the Knights of the Round Table, but discovers an anarcho-syndicalist community instead. Riding on (without actual horses), they ponder whether the earth is shaped like a banana or not. The story of the knights also features a short witch-hunt episode, where Sir Bedevere (Terry Jones) must play the part of the judge. In *The Life of Brian*, by the same filmmakers, the Roman Judea is the home to a number of terrorist organizations: the film obviously touches on a topical political theme.

Mel Brooks' historical comedies include *The History of the World: Part I* and *Robin Hood: Men in Tights* (1993). The entire first part of *The History of the World: Part I* is built on an anachronistic examination of prehistoric times: in an episode that unfolds like a comic book the spectators witness the first artist in the world, upon whose cave painting his mates promptly urinate. The narrator (Orson Welles) explains: 'And of course, with the birth of the artist came the inevitable afterbirth – the critic.' In an episode portraying the French

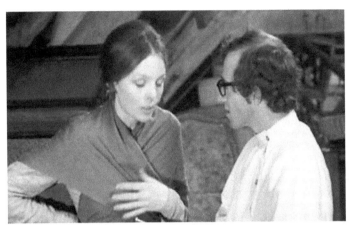

Philosophical humour in Woody Allen's *Love and Death* (Jack Rollins & Charles H. Joffe Productions, 1975).

Revolution, the characters appear to be aware that they are playing in an English-language film and know they are speaking in a dialect resembling a French star of early sound films:

Madame DeFarge:	We are so poor we don't even have a language! Just a stupid accent!
Fellow Revolutionist:	She's right! We all talk like Maurice Chevalier! [laughs] Au-haw-haw.
Crowd:	Au-haw-haw.

Endless references to film history may also be interpreted as anachronistic meta-humour. In *Robin Hood: Men in Tights* Little John introduces a person called Will Scarlet. He gives a laconic reply: 'My full name is Will Scarlet O'Hara. We're from Georgia.' As Maurice Yacowar points out in his article, drawing on film history is also typical of Woody Allen's comedies that refer to previous films, his own as well as others.

Anachronistic humour rarely projects modern-day phenomena directly onto the past: it more often tends to disrupt the harmony of the epoch by introducing elements from other historical contexts. The historical illusion is, of course, sometimes dispelled in serious films as well, unintentionally or by design. When in *The Gladiator* General Maximus (Russell Crowe) commands his troops saying 'At my signal, unleash hell!', the impression can be unintentionally comic, for an audience member who knows that talking about hell is inconsistent with the epoch portrayed (although the Christian religion was already making inroads). The detail has not, however, been intended as comical, nor can it be expected to arouse laughter. With Mel Brooks, on the other hand, there is never any doubt that all the anachronisms that appear are intentionally humorous. Films are always communicative events where the spectators arrive with a set of expectations formed by advertising and

Visual anachronisms in *Love and Death* (1975), *Monty Python and the Holy Grail* (1975) and *Deux heures moins le quart avant Jésus-Christ* (1982).

other information received beforehand. Spectators coming to see *The History of the World: Part I* are prepared to laugh from the start.

Anachronistic humour often relies on surprising juxtapositions. This comic impression has been explained by using a theory of degradation or psychological opposites (Theodor Lipps, Henri Bergson), which argues that comic effect is produced by the appearance of something other than the expected result (for example, something small instead of massive or vice versa). The transgressing of boundaries between epochs can be seen as utilizing the idea of degradation: the filmmakers thwart expectations by bringing in unexpected historical elements, resulting in bathos for spectator amusement. Bergson (2008: 49–50) also describes an important mode of situational and verbal comedy as 'reciprocal interference of independent series'. He writes: 'A situation is invariably comic when it belongs simultaneously to two altogether independent series of events and is capable of being interpreted in two entirely different meanings at the same time.'

By 'series' Bergson means separate chains of events that are developed within the drama and converge at amusing points in the narrative. In historical comedy, these series of events are not intrinsic to the drama but are derived from the historical memory of the spectator. The linking occurs when unrelated historical events suddenly come face to face with each other. This is one of the key strategies of the humour of the Monty Python films as well as the comedies of Mel Brooks.

Laughing at Conventions

In anachronistic humour laughter wells up from the spectator's historical awareness, that is the ability to identify incompatible elements. On the other hand, historical awareness is a problematic thing to pin down. There is every reason to doubt the existence of one horizon of knowledge about the past; the audience is always divided into different understandings of history. In his analysis on *Kalabaliken i Bender*, David Ludvigsson notes that the film actually includes many details, based on historical facts, but the audience is unlikely to recognize them as 'history', or may even interpret them as anachronisms intended to arouse laughter.

In one way the continuing attempts to make fun of the genre and the conventions of historical film can be understood as different forms of anachronism. In a television interview, members of the Monty Python group said that one of the first impulses for *The Life of Brian* was the amusement caused by serious ancient spectacles: in filmed epics, the characters always spoke slowly and solemnly, as if aware that they were living near the birthplace of Christ. In *The Life of Brian*, this parodic touch is already apparent in the first scene. The opening images are redolent of *Ben-Hur*: night sky, light falling on a lonely stable, the Wise Men from the East on their journey. The stark contrast is not revealed until the wise men enter the wrong stable and find Brian instead of Christ in the manger. The clash of styles is underlined by the harsh language of Mandy (Terry Jones), Brian's mother. It must be noted, however, that considerable effort went into the making of *The Life of Brian*: the film was shot

in Tunis, and the sets and costumes are so skilfully crafted they could have been used in a serious Bible epic. It is exactly this 'authenticity' that the spectator needs in order to grasp what it is, in the end, that is actually being parodied.

In his famous study on François Rabelais, Mikhail Bakhtin (1984: 145) noted the comic potential of what he calls 'the language of the marketplace'. Coarse language is one of the key devices of Monty Python's parodying of the genre of historical film: history, usually thought of as sublime and tragic, is constantly peppered with vulgar language, dialect, sometimes even brutal expressions. *The Life of Brian*, if anything, is a celebration of the Bakhtinian language of the marketplace: mass scenes, public insults and rowdy forums are all central elements of the film. Word play usually employs the clichés of the genre as the starting point, which can either be repeated until they become comic or suddenly be switched by the actors to an entirely different register. In *Monty Python and the Holy Grail* there is a scene in which King Arthur (Graham Chapman) is asked to explain how he became a king:

Arthur: I am your king!
Woman: Well I didn't vote for you!
Arthur: You don't vote for kings.
Woman: Well how'd you become king then?

[Angelic music plays ...]

Arthur: The Lady of the Lake, her arm clad in the purest shimmering samite held aloft Excalibur from the bosom of the water, signifying by divine providence that I, Arthur, was to carry Excalibur. THAT is why I am your king!
Dennis: [interrupting] Listen, strange women lyin' in ponds distributin' swords is no basis for a system of government! Supreme executive power derives from a mandate from the masses, not from some farcical aquatic ceremony!

When Arthur invokes the sword episode of medieval stories, Dennis replies using a style that is entirely different: the sublime is suddenly made commonplace as Dennis questions the authority of 'strange women lyin' in ponds distributin' swords' as a basis for government.

Situation comedy also often relies on a conventional setting that is exaggerated or taken into an unexpected direction. The scene where Arthur meets the Black Knight in *Monty Python and the Holy Grail* can be called a classic example:

Black Knight: Have at you!
Arthur: You are indeed brave, sir knight, but the fight is mine.
Black Knight: Oh, had enough eh?
Arthur: Look, you stupid bastard. You've got no arms left!
Black Knight: Yes I have.

Arthur: Look!
Black Knight: Just a flesh wound!

The encounter between the king and the knight turns into a grotesquely physical showdown when the by now limbless Black Knight refuses to acknowledge his defeat.

Especially after the classic studio era, poking fun at generic conventions has been one of the hallmarks of historical comedy. In the post-studio era, parody has often been employed in order to diverge from the conventions of classic style. While British makers of comedy films have been especially keen on history (proven by the Monty Python films, the *Blackadder* series, *Allo Allo*, etc.), Mel Brooks has parodied almost everything imaginable over the course of his career: *High Anxiety* (1977) mocked the Hitchcock thrillers, *Blazing Saddles* (1974) Westerns, *Space Balls* (1987) science fiction films and *Young Frankenstein* (1974) horror movies. In *The History of the World: Part I* Mel Brooks revelled in generic conventions until the very last images of the film, where the heroic couple escaping aboard a carriage notes it is time to give the final kiss, and the film ends with a long shot of a face of a mountain with 'The End' carved on it – a reference to the late 1950s/early 1960s marketing device of historical epics where the title of the film was shown in an enormous carved monument of stone or marble. The device was repeated in the advertisements and posters of films such as *Ben-Hur* (1959), *El Cid* (1961), *Barabbas* (1962) and *Genghis Khan* (1965). Even more zany transgressions of generic boundaries can be seen in *The Life of Brian*. In one scene, Brian is pursued by soldiers and forced to leap from a tower. Completely out of the blue, he is captured by a space ship of strange humanoids, who whisk him across outer

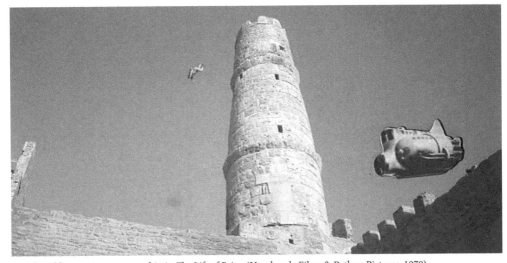

Brian's sudden rescue to a space ship in *The Life of Brian* (Handmade Films & Python Pictures, 1979).

space back to Jerusalem! Science fiction films operating on the fantasies of the future are the perfect antithesis of a historical film that deals with the past – and therefore, naturally enough, potential raw material for a comedy.

Humour that pokes fun at the predictable elements of historical films is often ironic – at least in the case of films by Monty Python and Mel Brooks. What is interesting is that the ironic style appears to be linked to historical narratives in a wider sense. In his book *Metahistory* Hayden White (1973) has noted that in historiography, rationalism and its concomitant attribute scepticism all express themselves as an ironic attitude especially characteristic of the historiography of the eighteenth century. As a style of comedy, irony usually relies on indirect ridicule built on opposites: in ironic style, deficiencies are portrayed as virtues. One of the famous ironists of history was Socrates, who often pretended ignorance and downplayed his own knowledge (Colebrook 2004: 45; Roth-Lindberg 1995: 21).

Ironic style, however, engenders one problem: it may cause the reader to lose his or her confidence in the author. Socrates himself had to admit the following: 'This is the most difficult thing of all to persuade some of you. For if I say that that would be to disobey the deity, and that, therefore, it is impossible for me to live quietly, you would not believe me, thinking I spoke ironically' (Plato: Apology, 37e). The important question, however, is at whom the ridicule is directed: the contemporary reader or the people of the past? In romantic irony, the narrator is alone. According to the notion entertained by German Romanticists, the artist could make a conscious intervention in his or her work, arrogantly thus disrupting the atmosphere of the work. This was a way for the artist, the genius, to underline his or her own importance. What else is the sudden transition to science fiction in *The Life of Brian* if not romantic irony, the artist's sudden intervention, although the persona of the 'artist' is never revealed? The mood is broken in a rather surprising manner also in *Monty Python and the Holy Grail* in the scene where the Knights of the Round Table arrive in Camelot and the constructed nature of cinema is flaunted:

Arthur: Look, my liege!

[trumpets play]

Arthur: Camelot!
Sir Galahad: Camelot!
Lancelot: Camelot!
Patsy: It's only a model.
Arthur: Shh!

An ironic attitude may be understood not only as the narrator's attempt to highlight his or her wit and scepticism, but also as a desire to differentiate between past and present: the narrator is aware of the difference of his or her own time in relation to history, and expresses this difference by taking an ironic stance towards the past. If the narrator plays

along and collaborates with the illusion of the past, it is only done in order to be able to dispel the illusion at some later point and emphasize the artificial nature of the past as we perceive it. This ironic stance can also be linked to the classic theory of comedy, the so-called superiority theory of Aristotle, Cicero and Descartes, which maintains that the comic impression is based on one's own sense of superiority (Stott 2005: 131–137).

As our examination of ironic attitude points out, laughing at generic conventions is not necessarily limited to laughing at clichés: it is simultaneously used to make a distinction between past and present. For the tradition of historical film, it may also be a more discreet way of processing or revising the prevailing notion of the past. In the 1920s and 1930s, Alexander Korda produced and directed several historical comedies where the protagonist is a historical figure firmly established by both historiography and fiction, such as *Helen of Troy* (1927), *Henry VIII* (1933) or *Don Juan* (1934). Deviating from the mainstream of historical films of his day, Korda wanted to extend the notion of history into the new area of private life, one that was rarely glimpsed in those sublime and serious films about great historical men produced at the time. From today's perspective, it may be difficult to understand how the King's bedroom talk made the film a blockbuster:

[Henry's fourth wedding night]

King Henry VIII:	My wife? Huh … not yet.
Anne of Cleves:	Poor mother told me … first he says the marriage is no good, and then he cuts off the head with an axe chopper!
King Henry VIII:	That is an exaggeration, madam.
Anne of Cleves:	Then why do you say I am not yet your wife?
King Henry VIII:	Well, madam, uh, a marriage ceremony doesn't make us one.
Anne of Cleves:	Mmm? [shows her ring]
King Henry VIII:	Oh, yes, yes, yes, 's all right, but you, uh, have to, umm, I have to …
Anne of Cleves:	What?
King Henry VIII:	Did your mother not talk to you about …
Anne of Cleves:	What?
King Henry VIII:	Oh Lord. Ohhhh, well, uh, madam, all that stuff about children being found under gooseberry bushes … that's not true …

The Private Life of Henry VIII laughs at serious historical films with its understated bedroom style: however, the illusion of the epoch remains unbroken. Korda never fractures the visual image of the sixteenth century, but instead has permitted the spectator to glimpse it from a surprising angle.

Another example of discreet humour and the revising of conventions can be seen in Woody Allen's *Zelig* (1983), a story about a fictional character made in the form of a historical documentary. The film does not really parody the genre; it is better described as internalizing the genre's stylistic devices so perfectly that it results in a comic effect. The

Henry VIII (Charles Laughton) and
Anne of Cleves (Elsa Lanchester)
in the Royal Bedchamber in *The
Private Life of Henry VIII* (London
Film Productions, 1933).

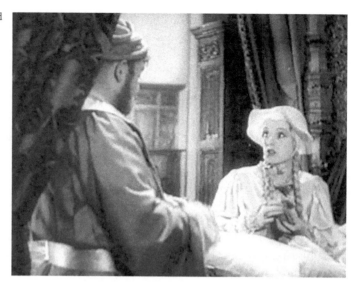

narrative devices are 'real', but the content is 'fiction'. *Zelig* also comments on historical films, as in a scene reporting on Zelig's adventures in Nazi Germany by using newsreels and photographs, which also features an insert from an imaginary biopic supposedly made later in the future. Immediately after the insert the interviewee denies that the events took place as the film later appeared to claim. This is how Woody Allen underlines the difference between the 'historical film' and the 'real' documentary, although even the documentary – as the viewer well knows right from the start – is just as fictitious. *Zelig* has probably taken the parody of different types of historical narration further than any other comedy so far.

Fictional Zelig in Woody Allen's *Zelig*
(Orion Pictures Corporation, 1983).

Humour and the Otherness of the Past

The humour of historical comedies may focus on the modes of narrating the past, as well as cinematic conventions or, akin to anachronisms, historical consciousness in general. Still, the interesting question is whether the past itself is also being laughed at and whether this laughter is compassionate or unsympathetic. This question cannot be answered in full without analysing the specific reception accorded a particular film. However, some remarks can be made.

In his analysis of the poetic devices used by nineteenth-century historiographers, Hayden White (1973: 7–8) subscribes to Northrop Frye's notion of four modes of emplotment (romance, tragedy, comedy and satire). Although White's analysis touches on comedy and satire, he is not ultimately analysing humour as such. White's analysis is more concerned with the overall form of narration, that is, the relationship between the protagonist of a drama and the circumstances that surround him or her. White classifies, for example, Leopold von Ranke's narratives as examples of comedic narration that are characterized by a tendency towards reconciliation or attempted reconciliation. In his books, Ranke wants to understand all sides. White's objective, however, is to link strategies of emplotment to ideological goals arguing that comedy is a conventional and conservative narrative form, while tragedy represents progressive narration. As a form of political analysis White's study constructs ideal types and categories that are not easily applied to film narration. In reality, very few historical comedies, it can be argued, try to understand all sides; on the contrary, their key elements are ignorance and the positioning of the narrator above all the characters and events portrayed. Perhaps Aristotle's notion of comedy as an imitation of 'inferior' people and tragedy as an imitation of 'decent' people is still worth considering. Historical comedies rarely find anything awe-inspiring or respectable in the people of the past. The Moses portrayed in *The History of the World: Part I* is a halfwit who drops one of the clay tablets, on which is inscribed five of the fifteen commandments given by God, and is left with only ten commandments to give to his people. In Feyder's *La Kermesse héroïque*, the seventeenth-century Flemish people live their lives in an everyday manner like contemporary people, devoid of any sublimity or high-mindedness. In *The Private Life of Henry VIII*, the troubles of the King of England appear almost endearingly unremarkable, although he does at times boast about his rank. What is sought from history in historical fiction is more often the well known rather than the truly unfamiliar. The tendency is reflected in the prologue of Michael Curtiz's *The Egyptian* (1954):

Today the glory of ancient Egypt is ruins and dust, and this greatest of the earth's early civilizations a thing of darkness and mystery. These mighty monuments tell us of a people who were rulers of the world, created a civilization never surpassed for beauty and splendour, but the Egyptians were not only builders of monuments. They were human beings no different from ourselves.

25

The silence of the monuments justifies the entire historical fiction that seeks to prove that the people of the past were 'no different from ourselves'. The past may look different, but people loved and hated as they have always done. Markku Ihonen (1992: 76–77), a literary scholar, has argued that linear and cyclic time often alternate in historical fiction: on one hand, what is being portrayed is the uniqueness of the past, while on the other hand its similarity with our own time is emphasized. The tendency of historical films to emphasize universal humanity is linked to this cyclic notion of time. Among historians, however, the search for similarity has always provoked dissatisfaction: nothing should be taken as a given in history. How can we, in the end, assume that people in the past loved and hated just like us? This criticism is certainly justified, but perhaps the historians have not always recognized fiction's genuine ambition to understand the past and to find a more human dimension than the schematic picture of the past created in textbooks. In modern historical comedies, however, this willingness to understand is often missing. Filmmakers can no longer naively portray the bedroom problems of great men or look for signs of empathic universal humanity in historical figures. Makers of comedies take often an ironically critical attitude to the smooth image of the past offered by historical studies and fiction. This sometimes results in a rather cynical form of humour. The picture of the medieval times as portrayed in *Monty Python and the Holy Grail* is grim:

Peasant 1: Who's that there?
Peasant 2: I don't know … Must be a king …
Peasant 1: Why?
Peasant 2: He hasn't got shit all over him.

If mainstream historical cinema tried to understand the past by identifying features that resemble the present, it is precisely the foreign elements that modern historical comedies find risible. Comedians laugh at the amusing details of the past together with the spectator. *The Life of Brian*, for example, constantly parodies the contemporary political reality of the Middle East. The Judea portrayed in the film is teeming with terrorist organizations that not only sometimes struggle against the Romans, but also spend most of their time arguing about the names of the groups. When Brian is trying to contact a terrorist organization in a circus arena, he has the following brief conversation with Reg (John Cleese), the leader of the organization:

Brian: Excuse me. Are you the Judean People's Front?
Reg: Fuck off! We're the People's Front of Judea.

The confusion regarding the names continues throughout the film and is repeated many times over. Perhaps the joke about the names reflects the difficulty European television viewers experienced in trying to understand the events in Palestine and Israel in the 1970s when *The Life of Brian* was made. *The Life of Brian* does not try to understand 'otherness'. Instead, it makes the television viewers' chaotic impressions an integral characteristic of the

Terrorist gathering in *The Life of Brian* (Handmade Films & Python Pictures, 1979).

people and events, constructing a formless situation where nobody knows what to do or for whom to fight.

In the comedies of past decades in particular, the past has been seen as strange, absurd and irrational. The objects of humour are the foreign customs a contemporary spectator 'cannot' understand. As L.P. Hartley wrote in his novel *The Go-Between* in 1953 – to be recycled by David Lowenthal (1985) and many other scholars – 'the past is a foreign country', an unknown culture that should never be assumed to be like our own. Although mainstream film often simply finds the customs of exotic cultures and people unfamiliar and strange, a more profound problem is implied. Is understanding even possible, and if it is, how should it be represented? (Ankersmit 1999: 91–92). The ethics of narration have been discussed extensively in connection with the theme of the Holocaust – and not only in terms of historiography, but also of narration in general. What has also been sought are new ways of discussing a theme that makes all tools of understanding seem inadequate. Is describing the Holocaust even possible? Limits of representing the past have been tested in fiction, the visual arts, film and even comics. The American cartoon artist Art Spiegelman has received international attention with his graphic novel *Maus* (1986, 1990). In *Maus*, the story of the Holocaust is presented as a fable using animal figures: the Jews are mice, the Germans are cats, the Poles are pigs, the Americans are dogs and the French are frogs. Spiegelman's graphic novel conflates the protagonist's relationship with his father Vladek and the attempt to comprehend the tragedy of the previous generation. The narration

Roberto Benigni, *La vita è bella* (Cecchi Gori Group & Melampo Cinematografica 1997).

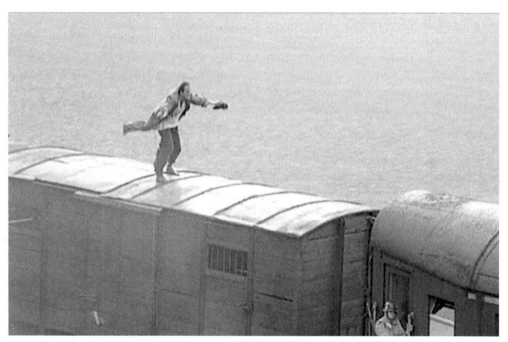

Radu Mihaileanu, *Train de vie* (Noé Productions & Raphael Films, 1998).

alternates between the present (the trauma of the father) and history (a survival story that takes place in the Mauschwitz concentration camp). Spiegelman has, in his graphic novel, merged memory and history: the past wells up from Vladek's memories, and even humour is not eschewed. The problem of Holocaust history and memory is addressed in this collection too: in the documentary *Pizza in Auschwitz*, analysed by Hagai Dagan, the real Auschwitz looks suddenly strange when the survivor explains his nostalgic feelings towards the concentration camp, feelings that his daughter has difficulties understanding.

In historical comedies, films about the Holocaust are conspicuously rare. Roberto Benigni's *La vita è bella* (Life Is Beautiful, 1997), however, is an interesting experiment in which this difficult theme is approached by using humour. The film was extremely popular but it also stirred public debate and controversy (Stott 2005: 120–127). Slavoj Žižek (2000) argued in *Sight & Sound* that the success of a 'camp comedy' was a sign of the 'obvious failure of the holocaust tragedy'. When the Jewish protagonist Guido Orefice (Roberto Benigni) is taken to a concentration camp with his family, he decides to explain it all away as a game to protect his son. Guido succeeds: the boy makes it through the camp with human cruelty never revealed to him. Benigni's humour is tragic-comic: it does not, in the end, provide any insight into what takes place – nor is it intended to. The laughter functions as a device underlining the difficulty of recounting the events. Guido's inability to tell the truth to his son points to the wider problem of talking about the *shoah*: the humour clearly discloses the distance between the story told and the 'untold' story very visible.

La vita è bella, in a similar vein to Radu Mihaileanu's *shoah* comedy *Train de vie* (Train of Life, 1998), testifies to the great potential of historical comedy. It is not only that the past could, in the words of Mikhail Bakhtin, after all be just a *festa stultorum*, a feast of fools. Instead, the register of comedic narration provides alternative ways of perceiving the past and of shaping both our own and the spectators' relationship with history. Many articles in this book examine difficult themes, such as the role of humour and irony in an Auschwitz documentary or the function of comedy in tragic films portraying the Spanish Civil War. The humour, however, always confers a certain levity that gives us the freedom to move backward and forward in time and to transcend barriers between eras. Historical comedy grants us an opportunity to perceive the past as something more than a predetermined and prefabricated entity. History is, ultimately, just as opulent a land of opportunity as the present and the future.

Bibliography

Ankersmit, Frank R., 'Remembering the Holocaust: Mourning and Melancholia' in Anne Ollila (ed.) *Historical Perspectives on Memory*, Helsinki: Finnish Historical Society, 1999, pp. 91–113.

Aristotle, *Poetics,* trans. with introd. Joe Sachs, Newburyport: Focus Publishing, 2006.

Aristotle, *Rhetoric,* trans. W. Rhys Roberts, Stilwell: Digireads.com Publishing, 2005.

Bakhtin, Mikhail, *Rabelais and His World*, trans. Helene Iswolsky, Bloomington: Indiana University Press, 1984.

Bergson, Henri, *Laughter: An Essay on the Meaning of the Comic*, Rockville: Arc Manor, 2008.

Carr, Edward Hallet, *What Is History?*, New York: Random House, 1961.

Colebrook, Claire, *Irony*, London: Routledge, 2004.

Hartley, L.P., *The Go-Between*, London: Hamish Hamilton, 1953.

Ihonen, Markku, *Museovaatteista historian valepukuun. T. Vaaskivi ja suomalaisen historiallisen romaanin murros 1930–1940-luvulla*, Helsinki: Finnish Literature Society, 1992.

Kalela, Jorma, *Historiantutkimus ja historia*, Helsinki: Gaudeamus, 2000.

Lowenthal, David, *The Past Is a Foreign Country*, Cambridge: Cambridge University Press, 1985.

Plato, *Apology, Crito, and Phaedo of Socrates*, trans. Henry Cary, Middlesex: Echo Library, 2009.

Rosenstone, Robert A., *Visions of the Past: The Challenge of Film to Our Idea of History*, Cambridge, MA: Harvard University Press, 1995.

Roth-Lindberg, Örjan, *Skuggan av ett leende: Om filmisk ironi och den ironiska berättelsen*, Stockholm: Hischer & Co, 1995.

Stott, Andrew, *Comedy*, New York: Routledge, 2005.

Toplin, Robert Brent, *History by Hollywood: The Use and Abuse of the American Past*, Urbana: University of Illinois Press, 1996.

White, Hayden V., *Metahistory: The Historical Imagination in Nineteenth-Century Europe*, Baltimore: Johns Hopkins University Press, 1973.

Žižek, Slavoj, 'Camp Comedy', *Sight & Sound*, 71:4 (April 2000), pp. 26–29.

PART I

Comedians and Comic Representations

Chapter 2

Buster Keaton's Comedies of Southern History: *Our Hospitality* and *The General*

Susan E. Linville, University of Colorado Denver

During the silent era of American cinema, the South was the topos of home and history. As home, it was a perennial space of innocence where stories began and where their protagonists wanted to return, as Linda Williams (2001: 28) explains. Again and again, and most notoriously in D.W. Griffith's epic film *The Birth of a Nation* (1915), silent melodrama depicted some version of the 'old Kentucky home', lost and longed for, an imagined, chivalrous, prelapsarian place. As history, the South was synonymous with a specific sense of an American past that had vanished – a pre-modern, rural, not yet mechanized world, and as Alan Bilton (2006: 491–492) argues, it was less a geographical place than an idea, one that conflated 'the paternal and the pastoral', and that 'drew upon an inexhaustible reserve of homesickness and nostalgia crucial to [the silent film] period'. For Bilton, this nostalgic perception of the past underpins the sense of history in Buster Keaton's features with Southern settings, including the historical comedies *Our Hospitality* (1923), with its overtly melodramatic frame, and *The General* (1926/7), a film now revered, but one which was not initially well received due to a view that war, and perhaps especially the American Civil War, was no laughing matter. Doubtless, Keaton's own experiences as a soldier at the end of World War I gave him a different perspective, one attuned to wartime absurdities, but putting aside the question of *The General*'s initial reception, a critical question remains: By what process did Keaton transform the sense of a vanished time and place, and the trajectory of melodramatic return into the stuff of comedy? That is to say, how did the South as topos of history and home become the site not just of the nostalgic, melancholic and elegiac, but also of the comic? And to what extent does Keaton's comedy alter and disrupt the melodramatic depiction of the South as lost, pre-modern home?

Keaton's Southern comedies envision a comic counter-history by undermining not only the familiar safety, security and innocence of home but its oldness, too. Keaton generates laughter by blurring the line between a remembered rural South and modernity. Similarly, he calls into question the narrative of historical progress that co-existed with the era's nostalgia, as he spoofs and mechanizes the conventional heroism which powered that narrative. Moreover, by relying on patterns and motifs that intertwine the comic and the uncanny, such as the pattern of circularity, and by twisting the formulas of American melodrama, Keaton translates the silent era's dominant sense of the American past into something strange – and funny.

Circularity is frequently coded as modern and equated with new technologies in Keaton's films, yet it signals the illusory nature of historical progress as well. The spinning reels, disks, wheels and boat paddles of Keaton's movie projectors, phonograph records, trains, bicycles

and boats are circular signifiers of technological modernity and, as such, are indispensable resources of humour. Yet that humour is often also based on the suspicion that for all its movement, modernity was going nowhere. In his reading of Keaton's *The Navigator* (1924), which ends with just such an image – of a submarine repeatedly rolling over in place – Daniel Moews (1977: 107) argues that the trope of circularity is central to Keaton and also shapes 'the classic comic move, a circular progression going nowhere, and the circle itself is so symbolic of comedy that is has often been explicitly used in comic titles'. For Rollo, *The Navigator*'s aptly named protagonist, however, the result of the film's circular patterns is that he himself is mechanized and, in Moews's words, 'reduced to an automaton, wound up and turned loose but never going far' (1977: 108). Circularity, moreover, defines not only the technologies of 1920s modernity, but also the Keatonian vision of the past, in several ways. Not only does history as narrative repeat itself, but it is also shaped by uncanny, mechanical replication, and by the unconscious, obsessive/compulsive return to a former site of crisis and entrapment. Thus, in Keaton's parodic 'mythic ages' film, *The Three Ages* (1923), gags are replayed with variations in three historical periods, the Stone, Roman and Modern Ages, to underscore the idea that *plus ça change, le plus c'est la même chose*, while in the Modern era, one particular gag – the film's best and most elaborate – returns Keaton's character to the jail where he was only recently held, after an astonishingly maze-like trajectory of illusory escape.[1]

During film's silent era, then, history is not only an idealized entity steeped in nostalgia for a more patriarchal agrarian past, but also, obversely and covertly, an infernal machine,

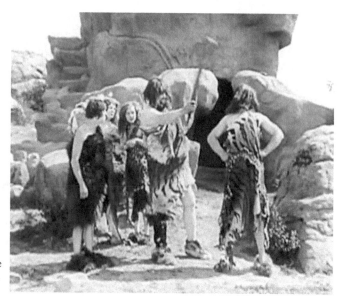

The stone-faced comedian in the Stone Ages in *The Three Ages* (Buster Keaton Productions, 1923).

as Keaton's films at times suggest. His historical comedies render history uncanny as they engage a repressed past re-encountered as something not familiar and idealized but alienated, disturbing and strange – or as weirdly familiar. In this way, they call up and then disperse through laughter the feelings of dread that such history can generate. Critical to his engagement with repressed history is Keaton's critique of history's heroic ideal of masculinity, for as Kathleen Rowe Karlyn (1997: 112) observes, his comedies repeatedly bring into focus the heroic ideal's contributions to culture's social ills. By engaging and unsettling conventional history and conventional heroism in this way, Keaton's comedies also dovetail with Freud's essay on the Unheimlich (unhomey, uncanny), which appeared in 1919, at the time of Keaton's early collaboration with Roscoe Arbuckle. In his essay, Freud (1919: 220) defines the Unheimlich (literally, the 'unhomey'), as 'that class of the terrifying which leads back to something long known to us, once very familiar', but which has become disturbing through the act of repression. The ultimate example of this, for Freud, is our human origin in the womb, 'the former heim [home] of all human beings [...] the place where everyone dwelt once upon a time and in the beginning' (1919: 245). Once a source of pleasure, it becomes dread-inducing only through the act of forgetting and repression, and as it retrospectively gives rise to fantasies that signal the unstable relationship between the homey and the unhomey/uncanny and the ease with which one category slides into the other, the self into the mother, and in Freud's eyes, fear of castration as well. Freud further identifies a number of dread-inducing uncanny motifs, motifs that make frequent appearances in Keaton's silent films. These include but are not limited to: doppelgangers, twins and mirror images; castration symbols such as severed limbs; involuntary repetition, the pattern of moving in circles, including the return to the womb; and the blurring of identity boundaries – for example, between animate and inanimate, the quick and the dead, the human and the puppet, the living and the mechanical.[2]

With regard to this last example, we could further say that, whereas for Henri Bergson (1956: 84), the basis of comedy is 'something mechanical encrusted on the living', for Freud, a basis of the uncanny is something living encrusted on the mechanical, an organicism that is only apparent or skin deep (or only voice deep, if we extend the concept to include *2001's* Hal). Wylie Sypher's introduction to Bergson's *Laughter* hints at such a connection between the comic and the uncanny when he observes that comedy requires 'an insensitivity on the part of the beholder, an "anesthesia of the heart," which numbs our pity and allows us to examine, unsociably, someone who suddenly looks like a puppet' (Sypher Introduction 1956: xii). Conversely, the experience of the uncanny may entail a response to a puppet that suddenly looks too human. But this formulation is also an oversimplification, as Keaton's films amply reveal, for when mannequins, dummies, cigar store wooden Indians and ventriloquist dolls come to life – or appear to do so – motivating his characters' frightened reactions, the effect for the audience is humour and cathartic laughter. For that matter, when Keaton's remarkably expressive eyes animate his 'stone face' in a double take, for example, and comedy ensues, it becomes clear that the interface between the animate and inanimate, like that between the original and the copy, can be the basis of both uncanny and comic

effects working in tandem, as the borders between them slip. It may well be for this reason that Bilton (2006: 496), for one, claims that Keaton's best gags are 'funny-peculiar rather than funny-hilarious'.

Additionally, Keaton's dedication to realistic detail – whether in never faking stunts or in making the historical details of mise-en-scène so accurate and real that 'it hurts', as he said (Blesh 1996: 271) – also makes an essential contribution to his uncanny humour. For, as Freud (1919: 251) observes, uncanny effects retain their character in works of fiction 'so long as the setting is one of material reality'. The importance of material realism, or at least a forcefully realist aesthetics, to the uncanny can also be illuminated and illustrated with a contemporary instance. Writing about twenty-first-century robots, John Seabrook (2003: 58) explains that when a robot looks too human, it can:

> fall into the 'uncanny valley' [a vaginal valley?], a concept formulated by Masahiro Mori, a Japanese roboticist. Mori tested people's emotional responses to a wide variety of robots, from non-humanoid to completely humanoid. He found that the human tendency to empathize with machines increases as the robot becomes more human. But at a certain point, when the robot becomes too human, the emotional sympathy abruptly ceases, and revulsion takes its place. People began to notice not the charmingly human characteristics of the robot but the creepy zombielike differences.

In Keaton's comedies, an uncanny aesthetics can co-exist and interact with melodrama and fairy tale conventions due both to his grounding of even the most cartoon-like gags in the material reality of his performance and, especially important in the present context, to his dedication to a historically accurate mise-en-scène.

Perhaps most critical to an understanding of how the uncanny, melodrama and American history work in concert during the silent era, and particularly in Keaton's historical comedies, is a recognition of their shared rootedness in a sense of the lost home. Indeed, it follows from Freud's analysis of the unhomey that one of the magnets which orient the unhomey elements of Keaton's comedies into a sustaining structure is melodrama, the mode that underlines American cinema generally, in Williams's view, including not only women's films, family melodramas and biopics, but also war films, Westerns and history films. Fundamentally 'fueled by nostalgia for a lost home' (Williams 2001: 58), by a desire to return to an imagined locus of lost innocence, often associated with childhood or with some point in a nation's past, melodrama can idealize home only through a process of the repression of memory, and when the idealized home is the Southern ideal that served as a synonym for history, a broader resonance within American silent film is the result. When repressed memories return in Keaton's comedies, their uncanny guise can assume the form of Keatonian haunted funhouses, weird womb-like enclosures, inhospitable mansions, ambivalent abodes and dangerous structures that foil sentimental yearning. In the films of the unsentimental Keaton, the uncanny/unhomey is released by just such a revelation or re-discovery of home's inhospitable spaces, by the deconstruction of hominess and through

imagery, like that in *Our Hospitality*, of twinning and umbilical cords, or like that in *Sherlock Jr.* (1924), of the weird womb-like cage for thwarted detectives or like that in *The Playhouse* (1922), which focuses on a matched pair of old Civil War veterans in the audience, each missing an arm, the two clapping their single hands together in applause when they agree that something is funny, and stubbornly blocking the applause of the other when one of them is not impressed by the Zouave guard act before them. The cantankerous pair forms Keaton's 'funny-peculiar' counterpoint to a sentimental, homey sense of the American past. This essay will explore Keaton's feature-length comedies of Southern history, *Our Hospitality* and *The General*, through a detailed examination of how melodramatic convention and the uncanny become springboards of comedy.

Way Down South: *Our Hospitality*

In classic melodramatic fashion, *Our Hospitality* begins and ends in a pair of Southern homes that are figured as spaces of innocence lost and innocence recovered. For innocence to be recovered, the feud that divides the Canfields and McKays, the inhabitants of these homes, must cease and the emphatically phallic violence be laid to rest. After exposing the legendary hospitality, civility and elegance of the South as the double of murderous custom, the film realizes the healing by means of a series of rebirthing gags in sequences that recall and spoof the climactic river rescue of D.W. Griffith's immensely popular *Way Down East* (1920).

The prologue title of *Our Hospitality* sets up the dilemma as follows:

Once upon a time in certain sections of the United States there were feuds that ran from generation to generation. Men of one family grew up killing men of another family for no other reason except that their fathers had done so. Our story concerns the old-time feud between the Canfield and McKay families as it existed about the year 1810.

The narrative's back story is thus a cyclical history of mindless, automatic, regional American violence, inspired by the notorious Hatfield-McCoy feud of the late nineteenth century, which Keaton moved to the antebellum South, perhaps to link it with an older era of blood ties and primitive vengeance, and certainly so that he could add to his story the first steam train, Stephenson's 'Rocket', which contrary to history he routes from North to South.[3] The film's setting is then established as the one-room cabin that is, as another title tells us, 'The humble home of John McKay, the last of his line except his infant son'. Outside that cabin, in fulfillment of the prologue's words, Jim Canfield shoots and kills John McKay, as lightening streaks the stormy night sky. This paternal legacy of violence leaves the infant son Willie (played by Keaton's own son), fatherless, and he is raised innocent of the feud, due to a contrasting, protective inheritance that another title identifies as 'mother-love', a love that also motivates Mrs McKay to flee with Willie to the North. Developing a series of parallels

between the Canfields and McKays, the film further associates this maternal love with the motto on a sampler that appears in the Canfields' home, 'Love thy neighbor as thyself.' The needlework from the sampler is the first appearance of a motif of thread, cord and rope, tied to the maternal, that runs throughout the film and that counterpoints a tradition that links Southern virility to killing.

After the prologue, *Our Hospitality* shifts its tone to comic and its location to New York, specifically, an intertitle tells us, to 'Broadway and Forty-Second Street as it was in 1830. From an old print.' Humour arises from the shock of the old, as this New York appears as an utterly rural looking place. (When a horse-drawn cart and horse-drawn carriage are tangled at an intersection, and Willie, now played by Keaton, approaches on a proto-bicycle – a Gentleman's Hobby-Horse, as they were called – a traffic cop exclaims, 'This is gettin' to be a dangerous crossin''.) The film presents Willie here as he reaches his twenty-first birthday, a pale-faced orphan, like Anna Moore in *Way Down East*, and a maternally-identified Yankee dandy who is ignorant of the past and eager to travel south to the site of his ancestral home. Psychologically, he needs to grow up and transcend excessive maternal identification without adopting the kind of masculinity that perpetuates automatic violence. To achieve that end, Willie must be reborn through a series of gags, structured through unhomey imagery. Hence, after arriving in the Southern town of Rockville – by way of a surreal trip on 'The Rocket' – he discovers that his lost home is not the magnificent mansion he imagined or even a cozy cabin but merely a dilapidated shack. The Canfield home, however, is a mansion, and thanks to an invitation from Willie's newfound love interest, Virginia Canfield (played by Natalie Talmadge, Keaton's then pregnant wife), Willie is a visitor there, until he discovers that her virile brothers and father intend to kill him the minute he sets foot off their property

Intertitle from Buster Keaton's *Our Hospitality*
(Joseph M. Schenck Productions, 1923).

and their hospitality codes will allow it. Unlike Keaton's unstable modern homes – consider the weird mobility of home in *One Week* (1920), *Cops* (1922) and aboard *The Navigator*, for example – the Canfield home has the appearance of stability and civility, but as the prologue has made clear, this well-armed home is the basis of a mechanized, self-perpetuating, mindless enmity, whose moves are as automatic as those of the train.[4] To escape the gun-toting Canfields, Willie first disguises himself as a woman with a parasol, and later escapes his enemies on horseback in the same costume, then lets the backside of the horse sport the same womanly outfit, complete with parasol, the horse itself now impersonating Willie's female impersonation.

This vein of humorous doubling continues as intertitles introduce the idea of 'family ties', and Willie, no longer finding protection by hiding in or behind a woman's skirts, is reborn through a series of gags that twin him with a Canfield son of similar age. Indeed, the 'family ties' that are developed at this point are among the best gags of the film, and they involve what David Bordwell and Kristin Thompson (2008: 157) aptly identify as 'umbilical-cord linkage'. A Canfield son offers to pull Willie up from a cliff face by means of a long rope that each of them has tied around his waist, but he soon takes aim to shoot Willie instead. Willie pulls down hard on the rope in self-defence, sending the Canfield son plunging toward the river far below, but then realizes in a hilarious moment that he will soon be following behind. The two remain entangled in this umbilical linkage within the birthing waters of the river, and only separate after they emerge and Willie manages to have the cord severed by stretching it across the tracks of the primitive train – a conventional phallic engine, to be sure. Willie soon tumbles back into the water, still attached to the rope, and is swept downstream, leaping up once in the flow as if he had atavistically changed into a fish – ontogeny recapitulating phylogeny. The film now crosscuts between Willie and Virginia, who attempts to rescue Willie in a small boat but spills into the river among the rapids and needs rescuing herself. In one of Keaton's most marvellous and difficult stunts, Willie succeeds in saving her just in the nick of time, just before she would have plunged over a waterfall, and he does so by means of the rope that still hangs from his waist. Tied at one end to the end of a log and at the other end to Willie, the rope creates a striking fishing pole image even as it makes the dramatic last-second rescue possible.

The parody of *Way Down East*, which itself was based on a late nineteenth-century play, is all the richer because of the resonant imagery of birth and the uncanny motifs remade in comic fashion. As Lucy Fischer (1996: 67) observes, the narrative climax of *Way Down East* is itself uncanny in the way it replays both its heroine Anna's defloration by the cad who seduces her into a mock marriage and her giving birth to his illegitimate child. That is, the ice breaks in the film's frozen river mimic the hymen's rupture, and the rushing waters, the waters of birth.[5] In Williams's view, the threatening ice also serves as a melodramatic villain, exacting a punishment for the heat of Anna's sexual ardour and for her technical violation of patriarchal law (Williams 2001: 37). In *Our Hospitality*, the comic umbilical cord linkage implies that the Canfield and McKay sons are paternal twins, born into the same lethal enmity, literally pulling each other down with it, when they should instead see that their

prospects are intertwined and threaded together through the maternal love expressed in the sampler and the 'saving grace' that figures in the film's final scene, when a parson ties the knot between the two families.

In that final scene, the three Canfield men return home to discover that Willie and Virginia have been married by the Parson, a bed forming the backdrop to the scene. The father accepts the marriage only when he glimpses the maternally identified sampler commanding Christian love of one's neighbour that hangs on the bedroom wall. The new union between the Canfields and McKays thus represents a transformation of their linkage through marriage, and its night-time setting recalls and answers the melodrama of night-time killings from the film's prologue. Yet the blocking contrasts with (and parodies) the bilateral symmetry of the wedding scenes from *Way Down East*, for here, Willie is by himself on the left, and the Canfields on the right. Balancing things out is Willie's disarmament, after the Canfield men disarm. Specifically, Willie retrieves no fewer than six guns from under a wrap he has borrowed from the Parson, and one from his boot, in a final gesture that undercuts the sentimental piety and sense of innocence recovered with a reminder of the history of violence that initially triggered the film's action and that has counterpointed the idealized vision of Southern hospitality throughout the film. It is violence that Willie is now 'man enough' to wield, if necessary, in his and his new bride's defence. But the gag also goes further. The comic escalation or overkill of Willie's über-phallic arsenal ultimately focuses *Our Hospitality* on the 'mechanical encrusted on the living'. For just as Keaton undermines the 'oldness' of the old Kentucky home with a pre-war setting for the post-war Hatfield-McCoy history and an unhistorical routing of the fledgling Rocket's journey southward, he disrupts the sense of progress toward a newer, more benevolent social order with his focus

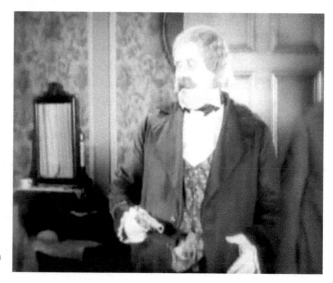

The final scene in *Our Hospitality* (Joseph M. Schenck Productions, 1923).

on these lethal mechanisms, uncloaked as extensions of Willie's reborn and transformed heroic body.

Although this film's final vision of the metaphorical old Kentucky home lacks the sense of circularity, entrapment and outright visual weirdness of the contemporary homes in Keaton's shorts *One Week* (1920), *The Scarecrow* (1920), *The Haunted House* (1921) or *The Electric House* (1922), it nonetheless illustrates how Keaton engages elements that melodramatic endings characteristically repress, in order to inject the conventional historical imagery of the South with his signature ironic, unhomey humour. Moreover, with its representation of domestic abuse, acted out briefly by a couple whom Willie witnesses shortly after arriving in Rockville – where Willie is attacked by the set-upon wife as soon as he tries to defend her – *Our Hospitality* also hints at another kind of repressed: namely, that white womanhood was most likely to fall victim to the violence of a husband or father, to the very man whose honour rested in protecting it, and that crazily enough, the abuse could also happen with the woman's complicity.[6] Thus, even in this fleeting gag, *Our Hospitality* undermines the myth of a bygone chivalrous and benign patriarchal order.

Double Chase: *The General*

More rooted in a particular history than *Our Hospitality*, and far more centred on a historically accurate train as well, *The General* begins in the spring of 1861 in Marietta, Georgia, and is roughly based on an incident narrated in William Pittenger's *The Great Locomotive Chase* from the North's point of view, which Keaton retells from the South's. (Keaton explained, 'You cannot make a villain out of the South' (Gillett and Blue 1996: 29), an idea that speaks to the South's status in the silent era as a synonym for home and history). It is the story of young Johnnie Gray (Keaton), an engineer on the Western and Atlantic Railroad and the fictional counterpart to train conductor William A. Fuller, a man who took it as a personal affront when Northern raiders stole his train, 'The General', and who made it his personal mission to get the locomotive back. *The General* was shot to capture as realistically as possible the look of the Mathew Brady photography that recorded the war, the first war in history to be documented comprehensively with photography, and it used Civil War-era engravings as models for the town sets of Marietta, Georgia, as well. Keaton's principal characters, however, are named for more generic effect: 'Johnnie Gray' evokes both 'Johnny Reb' – a signifier for a Confederate soldier and for the Confederate Army as a whole – and the Confederate grey uniform, while Johnnie's sweetheart Annabelle Lee (Marion Mack), with an eerie resonance, recalls Poe's poem about the death of a beautiful woman and a love that transcends it, as well as Confederate General Robert E. Lee.

In its sharply satiric attitude toward the military, the film surely also draws on additional historical sources, in particular, Keaton's army experience in World War I: Johnnie's rejection by the Confederate Army when he first attempts to enlist and his suspicion that his small stature excluded him echoes Keaton's experience of having first volunteered for service

and been turned down due to his flat feet and lack of a trigger finger, only to be drafted later anyway. Once he was in the army, he was issued shoes a full *two sizes* too large – a counterpart to the too-large accoutrements which Johnnie attempts to soldier with in the film and perhaps the inspiration for a gag with a bag full of shoes that trip him up, as well. Commenting on Keaton's military experiences, Tom Dardis (1979: 53) affirms that, 'Buster always saw his army days as a complete farce, for he was issued military uniforms that never fit him properly, and size-eight shoes for his size-six feet.' Finally, it is possible that Keaton's misadventures in the military also inspired the comedy of bureaucratic incompetence depicted in the film, as when a virtual committee of utterly befuddled Northern military officers stands around a rail switch Johnny has bent to delay them. Some time later, a single whack from an axe wielded by a lone civilian engineer fixes the problem, but only after the Northern army has lost critical time.

If *The General* is thus more historically based and more wedded to visual realism than *Our Hospitality*, it nonetheless shares with that earlier Southern comedy smart parody and a familiar melodramatic trajectory. The Southern coward film, embodied in Thomas Ince's *The Coward* (Reginald Barker, 1915), is Keaton's target here. Ince's story begins in Virginia in 1861 and follows the fate of Frank Winslow (Charles Ray), son of an honour-obsessed, wealthy, retired colonel, Jefferson Beverly Winslow. When enlistment frenzy hits their town, Frank has been innocently courting his girl, with the couple, in an image of homey warmth and innocence, observing a hummingbird in its egg-filled nest. Despite his girl's encouragement, Frank is too seized by terror of going into battle to enlist. His proud, old father, however, threatens to shoot him if he does not. Frank enlists, but soon deserts due to his cowardice and hides in the attic of his home. When Union troops take over the home, he overhears officers making strategic plans around the family table, in a scene picked up and reworked by Keaton. Disguised as a Union soldier, Frank escapes to take vital information about a Union vulnerability to the Confederate side, and he succeeds, despite being shot by mistake en route by his father, who has meanwhile taken over the post his son deserted. Frank's news enables the South to win the battle, and father and son are reconciled. The coward's transformation, the film implies, results from his discovery of the innate Winslow courage which he had never previously tapped. In the traditional style of nineteenth-century melodrama, this son of the wealthy classes must be jolted into action for self-realization to be possible and for his innate inner nobility and 'true self' to emerge.

Johnnie Gray, in contrast, as *The General*'s opening images reveal, is a man who works for a living, and whose social identity is defined by the valuable labour he performs. An engineer on a train, he inhabits a far more baffling world than Frank does. With no class ties or family connections, he must come up with his own ingenious solutions – the basis for brilliant solution gags – and what he is is the product of what he does, how he interacts with his work and with other people, rather than being innate. Although a reflection of twentieth-century ideas, Johnnie Gray is also the perennial victim-hero of melodrama, an individual whose virtue and innocence are initially misrecognized but ultimately made legible and rewarded, after scenes of spectacular action and suffering. The initial misrecognition results

Johnnie Gray (Buster Keaton) in the opening scene of *The General* (Buster Keaton Productions & Joseph M. Schenck Productions, 1926/27).

partly from his passivity when enlistment hysteria hits: sitting in Annabelle's home in a posture that is coded feminine, he makes no move to join up until spurred on by Annabelle. The misrecognition stems most directly, however, from the failure of the Confederate recruitment system to make public the reason that Johnnie, despite repeated earnest efforts, is not enlisted: he is 'too valuable to the South as an engineer', as an intertitle explains. Due to this Kafkaesque system failure, Johnnie is cast out of Annabelle's home, the site of their innocent courtship, and dismissed by her manly brother as a coward and 'a disgrace to the South'. At home, her father Mr Lee even tosses his picture out with the junk mail (a comic escalation of General Winslow's act of turning his craven son's portrait face down). A year later, to add insult to injury, Yankee raiders steal 'The General', his other love – and, unbeknownst to him, with Annabelle on board.

For Johnnie's innocence of the false charges, Annabelle's love and, last but not least, his locomotive all to be recovered, he must assert himself, survive a double locomotive chase and prove his worthiness to wear a soldier's uniform and wield a sword. Johnnie, of course, achieves these goals. He rescues 'The General' and (accidentally) Annabelle. Echoing Frank Winslow's heroism, he warns the Confederate army of a massive surprise attack in the nick of time. He also slows the North by setting a bridge ablaze, and accidentally fires a cannon that destroys a dam and releases floodwaters that sweep away Northern troops, helping to assure a Southern victory – all of which win him a lieutenant's uniform and Annabelle's love. Moreover, just as *Our Hospitality* uses melodramatic convention to raise questions about traditional, automatic masculine violence, *The General*, through its satiric treatment of the military and its hero's blend of uncommon pluck and dumb luck, raises doubts as to whether

this last goal of being a soldier is, in fact, a worthy one, and whether the uniform is merely one of the less life-affirming manifestations of the 'mechanical encrusted on the living'.[7]

Whereas birthing imagery is the primary basis of the uncanny humour in *Our Hospitality*, in *The General*, such humour stems from what Bilton (2006: 491) calls 'the uncanny symmetry of the film' – that is, the film's doubling of its entire chase plot, first with Johnnie's race North to recover the locomotive, and second his flight South, to bring it and Annabelle home and to protect that home from the invading Union forces. This symmetry is brought to comic life through numerous parallels, phallic gags and double entendres, involving, for example, a wayward cannon, saber and pistol, and waterspouts that squirt when and where they should not. These motifs also reinforce what Bilton (2006: 495) refers to as 'the dreamlike symmetry of this long comic palindrome'. In effect, Lisa Trahair pushes the palindrome idea further in her analysis of the film's plot. Drawing on Tom Gunning's concept of the operational aesthetic, she argues that *The General*'s mirror image chases, along with other elements, transform the film *as a whole* into a 'mechanical imitation of organic narrative', wherein 'narrative is [...] made into a subset of the machine, simply one machine among many, and narrative meaning is reduced to little more than an effect of basic operationality' (Trahair 2007: 85). For Trahair, Keaton's narrative is not organic because 'coincidence and chance undermine the functions that causality and character agency have in [classical Hollywood] narrative' (2007: 67). From this point of view, not only are there double chases, but also Keaton's entire film is an uncanny double of organic narrative, including historical narrative as it was conventionally inscribed in silent film. While Trahair's argument is compelling, if Williams's analysis of melodrama is correct, then narrative plays a supporting role to scenes of pathos and action and the drive toward moral legibility in American cinema, and what ultimately matters most is not a cause and effect narrative chain but rather cause and affect, 'felt truths'. And Keaton, of course, unsettles these emotional dynamics as well.

Accordingly, the uncanny humour is also rooted in Johnnie's twin loves – Annabelle, whom Johnnie at times treats as a thing, as when he stuffs her in a burlap bag and tosses her in a boxcar, and 'The General', whom he loves as if it were a living thing.[8] It is rooted, as well, in the twinning of the scenes of loss and recovery, and above all, in the exquisitely choreographed, materially real interplay of the mechanical and the human. The identification of Johnnie and his 'General' is primary, and the interface between the two finds expression in two of the most poignant sight gags in the film, twin gags that round out the double love story. At the end of the setup, immediately after Annabelle has told Johnnie that she does not want him to speak to her again until he is in uniform, a small, still, dejected and depressed Johnnie sits on the connecting cross-bar or coupling rod that spans the wheels of the huge locomotive. Unbeknownst to him, his assistant has started up the engine, and he is borne aloft, puppet-like, in a series of three arcs, before he realizes, with surprise and sad amusement, what is going on, and the train enters the darkness of a roundhouse. Tom Dirks (website) points toward 'the comfort he is receiving from his animated, responsive train' in this scene. In his reading, it is as if Johnnie's puppet-like, mechanistic side were complemented by the anthropomorphized capacities of the beloved train – a more responsive love object, at this

juncture, than Annabelle. We might also say that the image is not of a boy with a train but of a train with its own toy boy, in an image that blurs the comic and uncanny, the alarming and the charming.

At the end of the film as a whole, Johnnie is similarly situated on the coupling rod of the wheels of his 'General', but now he is a newly minted lieutenant, wearing the uniform he has just been awarded, sitting in the sunshine and kissing his girl. He suddenly realizes he should also salute a passing stream of soldiers coming from a nearby tented encampment. Again the interaction between the mechanical and the human is remarkably choreographed, as Johnnie repeatedly offers tender kisses and robotic salutes, his locomotive at his back, his girl at his side, a long train of his fellow Johnnie Rebs parading before him – not comrades in arms, for there is no male-bonding in this combat film, but virtual replicants on parade. (In contrast, Keaton begins the film with the companionship of two young boys, who follow him, like cars on a miniature locomotive, from the Marietta train station to Annabelle's home, and Annabelle, unbeknownst to Johnnie, joins them as the caboose.) Bilton (2006: 493) argues that the film's opening shot, which shows 'The General' steaming toward Marietta against a backdrop of pine forests and mountains, renders moot 'the conflict between the wilderness and industrialization in Griffith's work', insofar as the train there 'is not trespassing but rather forms part of the landscape'. The final shot takes this concept further, by revealing that, insofar as it had been defined by its proud military tradition, Southern culture itself was also already mechanized as well.

What makes *The General*'s weird-funny happy ending possible finds representation in the most expensive, spectacular and spectacularly uncanny action sequence in the film: the destruction of the Rock River Bridge and, along with it, the Union pursuit train, 'The Texas', which gets caught exactly half-way across. To set the sabotage in motion, Johnnie and Annabelle comically manage to light the trestle bridge ablaze and get 'The General' and themselves safely out of the way. The befuddlement of the Northern officers over the aforementioned bent switch rail delays the North just long enough that when 'The Texas' approaches the high Rock River Bridge, it is too damaged to support the train's weight. Monumentally misjudging the situation, Union General Parker orders the engineer of 'The Texas' to cross the bridge. It weakens, sways and then collapses, an engineer (doubled by a dummy) at the controls. The spectacle is filmed in long shot, in the most expensive single shot from the history of silent cinema (Keaton and Vance 2001: 147), and its realism is palpable and haunting. Given the film's anthropomorphizing of trains, the effect of the image is visceral – a sagging of the train's 'belly' before its collapse into the river far below, 'belching' smoke and spraying water.[9] Freud's assertion that, 'Many people experience the feeling [of the uncanny] in the highest degree in relation to death and dead bodies' (Freud 1919: 241), is illuminating here, as the line between the quick and the dead also comes into play, and a mournful, melancholic, dreadful feeling is evoked. At the same time, however, given the film's emphasis on phallic gags, and especially locomotive-driven ones, the image is also a spectacular cutting off of Union penetration; more accurately, it is a castration not just of the enemy but more generally of the military apparatus, and thus it exemplifies

another one of the uncanny motifs central to Freud's theory, namely castration. This reading of the sequence is reinforced by the reaction shot of the disbelieving General Parker and his men, who cannot believe their eyes. Weakly waving his sword, Parker next orders his men forward, and the phallic motif continues as an old goat of a Southern general soon appears, giving orders and waving *his* sword, engendering Johnnie's inept imitations with a wayward saber he has found, which keeps flying off the handle.

In the melodramatic scene in which his innocence of the false charges of cowardice and his virtue, as manliness, are most fully recognized, Johnnie is ultimately granted Union General Thatcher's sword. After the South's victory over the Union troops, made possible by Johnnie's efforts, Johnnie delivers the captive Union General Thatcher to a Confederate general, with Annabelle and her father watching him behind a picket fence. The Southern general then orders Johnnie to take off his grimy, oversized Confederate uniform, which, Johnnie acknowledges, is not actually his but was a necessary disguise. Slumped and dejected at having apparently been stripped of a false identity and publicly humiliated, yet again, Johnnie suddenly realizes that the general's aide is now rewarding him with a new officer's uniform – and with General Thatcher's sword, no less. Johnnie not only takes the sword and puts on the jacket, but also strikes a proud pose worthy of Napoleon, and Annabelle rushes happily to his side. He is then enlisted, by the same bureaucrat who had earlier turned him away, creating another doublet.

This moment is illuminated by Linda Williams's arguments about time and affect in melodrama, as are the film's prolonged chase and rescue sequences, which engage the melodramatic temporal dynamics of 'too late' or 'in the nick of time':

Union General Thatcher's sword is granted to Johnnie in *The General* (Buster Keaton Productions & Joseph M. Schenck Productions, 1926/27).

Melodrama offers the hope [...] that it may not be too late, that there may still be an original locus of virtue, and that this virtue and truth can be achieved in private individuals and individual heroic acts rather than, as Eisenstein wanted, in revolution and change. For these reasons the prolonged play with time and timing so important to the last-minute rescue should not be attributed to the linear cause-effect outcome of classical realism or to the naturalism of scenery, sets, or acting. The rescue, chase, or fight that defies time, and that occupies so much time in the narrative, is the desired mirror reversal of the defeat by time in the pathos of 'too late.' (Williams 2001: 35)

The audience of *The General* already knows that even if Johnnie's individual efforts help win the battle, the South lost the war, and the pathos of 'too late' and of the lost agrarian, patriarchal home remains in this historical comedy. But it is tempered by laughter, a cathartic laughter born in part from the dynamic between the mechanical and the living, and the resulting exposé of the dehumanizing realities of the military machine, the film's unmistakable villain.

Moreover, lest the film seem too nostalgic about a South that has been lost, it is also important to note that, despite his troubles with 'The General', Johnnie is an accomplished engineer, and his difficulties with weaponry are of a different order from those with the train. As in *Our Hospitality*, Keaton's character here is not invested in violence, until convinced that it has been forced upon him as a means to another end. In relation to silent-era Southern film types, he remains a most unconventional Johnnie Gray, one who inflicts death on others largely by accident and who manages to survive and triumph primarily through ingenuity, tenacity and dumb luck, in the process earning the viewer's admiration and sympathy far more than the men of the film who come closest to fulfilling the more familiar codes of courage. In this way, Keaton's comic character is an antidote not only to Southern historic ideals, but also more broadly to the American history film genre's investment in conventional masculine heroism as its driving force. You cannot make a villain out of the South, Keaton said, but you can create a comic counter-history.

Keaton's comic recounting of the past is not limited to the historical comedies with Southern settings. As Charles Wolfe has shown in an inspired essay, Keaton's *Go West* (1925) borrows the American narrative of national migration, settlement and supposed progress from popular histories, then updates and parodies it. In the process, *Go West* 'synthesizes elements of physical comedy with a sentimental story, exposing qualities of estrangement and unsettlement at the tap root of both Western melodrama and urban slapstick' (Wolfe 2007: 299). Like Keaton's American South in *Our Hospitality* and *The General*, his West in *Go West*, contrary to melodramatic convention, is 'no idyllic space, no world apart' (Wolfe 2007: 306), and like the protagonists of the Southern comedies, *Go West*'s Friendless lacks the traditional masculine heroism of historic film narrative. Responding to a cowboy's challenge to smile – the challenge borrowed from Owen Wister's *The Virginian*, its hero a veteran of the Confederate Army of Northern Virginia – Keaton's character can only copy Lillian Gish's gesture of forcing a smile with her fingers in *Broken Blossoms*. At home

neither on the range nor in the urban spaces that bracket it, east *and west* (New York and Los Angeles), Friendless also lacks the options of the eponymous protagonist of Keaton's short *The Pale Face* (1922): he cannot become a 'little chief' of an Indian tribe 'in the heart of the West', or call a teepee home, or kiss his squaw sweetheart for 'two years' in the happy ending, as the titles comically explain the Pale Face does. Friendless' only friend is not a woman or a horse but rather an unproductive Jersey dairy cow named Brown Eyes, and he gives her his loyalty and tenderness. The small, lonely greenhorn and the pretty little cow are near doubles, who share 'patient, sympathetic dispositions, wide-eyed gazes, a marginal status among the male ranch hands and steers, and names that echo those of the heroines from D. W. Griffith's […] historical epic *Intolerance*' as Wolfe (2007: 304) explains.

Thus Keaton comically rewrites two major narrative accounts of the so-called birth of a nation, the Westward expansion and the Civil War, and in the process transforms the home of the brave into an unforeseen landscape, reframes its spaces and reclaims legendary and epic names for such unlikely protagonists as Johnnie Gray and Friendless. His comic histories not only lambast the American dream, but also make the dream strange, even as they invite us to laugh at the nation's investment in its conventional stories of its progress and its past.

Acknowledgements

I wish to thank Kent Casper, Michelle Comstock, and Philip Joseph for their comments on earlier versions of this essay.

Notes

1. For an extended and invaluable discussion of *The Three Ages*, see Sweeney (2007).
2. For an extended analysis of the uncanny in recent American history films, see Linville (2004).
3. On Keaton's time shift and unhistorical routing of 'The Rocket', see Bilton (2006: 496–497). On the inspiration for a retelling of the story of the Hatfield-McCoy feud, see Blesh (1966: 224). *Our Hospitality*'s love story is roughly inspired by the disastrous romance between Roseanna McCoy and Johnse Hatfield.
4. Implicitly, the Canfield's incivility and primitive violence erode the ideology of white supremacy, insofar as it was based on an opposition between white civilization and black primitiveness. Willie's earlier, accidental appearance in black face (a result of soot from the train) reinforces these implications.
5. Fischer (1996: 67) compares the developments in the film with Freud's argument likening a young woman's ritual defloration by someone other than the husband – a means of avoiding the bride's anger toward her spouse – with the greater happiness Freud believed that women sometimes find with a second husband. She sees an uncanny resemblance between Anna's fate and this pattern.
6. As the son of a father who abused his wife and children, Keaton was not likely to insert the incident without a special awareness of its ironies. Bilton offers a relevant discussion of Keaton's experience

of the Deep South in 1907, when Keaton was twelve, the family act was struggling, and his father's drinking and domestic violence escalated. Bilton (2006: 488–489) writes, 'Certainly southern imagery appears in many of Keaton's films as a way of dealing with the anxious and traumatic movement from childhood to adolescence, seizing upon Griffith's use of a southern paradigm as somehow signifying a loss of innocence, but deploying this imagery in a much more personal way.'

7. The terms 'pluck' and 'luck' stem from the Horatio Alger stories which were popular in America during the late nineteenth and early twentieth centuries. Alger's plots centre either on a lad who recovers his rightful inheritance, the family homestead, for his aging mother and himself or on an urban waif who gains respectability and financial security. Both types of hero achieve success through traditional virtues ('pluck') and a series of fortuitous circumstances ('luck'). As Johnnie's 'dumb luck' and wildly inventive solutions imply, Keaton parodies these story conventions, just as he parodies the conventions of melodrama in general. For further discussion of Keaton and the Horatio Alger myth, see Rapf (1984).

8. The mechanical way Johnnie treats Annabelle when they steal back 'The General' works as follows: He stuffs her roughly in a burlap bag, carries her like an inanimate sack of potatoes over to the train he is about to take back – where she can secretly uncouple the first and second boxcars – and then deposits her in the first boxcar, shuddering as other boxes, bags and crates are loaded on top of her. This, one of the film's most outrageous funny/awful anti-romantic moments, doubles Annabelle's earlier, inadvertent capture aboard the train by the Northerners, except that in their hands, Southern womanhood fared considerably better.

9. I borrow 'belly' and 'belching' from Dirks' wonderful description of the scene, which reads as follows: 'When the train is half-way across, the bridge weakens, sways, and then gives way. The belly of the train droops and falls downwards through the burning portion of the bridge as it opens wide under its weight. Both the train and collapsing bridge plunge into the river, a mass of hurtling metal, exhaling/hissing smokestack steam, burning bridge logs, spraying water and a geyser of belching smoke' (Dirks, website).

Bibliography

Bergson, Henri, *Laughter*, in *Comedy*, introduction by Wylie Sypher, Baltimore: Johns Hopkins University Press, 1956.

Bilton, Alan, 'Buster Keaton and the South: The First Things and the Last', *Journal of American Studies*, 40:3 (2006), pp. 487–502.

Blesh, Rudi, *Keaton*, New York: Macmillan, 1996.

Bordwell, David and Thompson, Kristin, *Film Art: An Introduction*, 8th edn, New York: McGraw Hill, 2008.

Dardis, Tom, *Buster Keaton: The Man Who Wouldn't Lie Down*, Minneapolis: University of Minnesota Press, 1979.

Dirks, Tom, review of *The General*. Available at: http://www.filmsite.org/gene.html.

Fischer, Lucy, *Cinematernity: Film, Motherhood, Genre*, Princeton: Princeton University Press, 1996.

Freud, Sigmund, 'The "Uncanny"' (first published 1919) in *The Standard Edition of the Complete Psychological Works*, vol. 17, trans. James Strachey, London: Hogarth, 1953.

Gillett, John and Blue, James, 'Keaton at Venice', *Sight and Sound*, 37:2 (Spring 1966), pp. 26–30.

Karlyn, Kathleen Rowe, 'The Detective and the Fool, or, The Mystery of Manhood in *Sherlock Jr.*' in A. Horton (ed.) *Buster Keaton's 'Sherlock Jr.'*, Cambridge: Cambridge University Press, 1997, pp. 89–117.

Keaton, Eleanor and Vance, Jeffrey, *Buster Keaton Remembered*, New York: Harry N. Abrams, 2001.

Linville, Susan, *History Films, Women, and Freud's Uncanny*, Austin: University of Texas Press, 2004.

Moews, Daniel, *Keaton: The Silent Features Close Up*, Berkeley: University of California Press, 1977.

Rapf, Joanna E., 'Moral and Amoral Visions: Chaplin, Keaton, and Comic Theory', *Western Humanities Review*, 37:4 (1984), pp. 335–345.

Seabrook, John, 'Department of Special Effects: It Came From Hollywood', *The New Yorker* (1 December 2003), pp. 54–63.

Sweeney, Kevin, '*Three Ages*: Keaton's Burlesque of the "Mythic Ages" Genre', *New Review of Film and Televisions Studies,* 5:3 (2007), pp. 285–297.

Trahair, Lisa, *The Comedy of Philosophy: Sense and Nonsense in Early Cinematic Slapstick*, Albany: State University of New York Press, 2007.

Williams, Linda, *Playing the Race Card: Melodramas of Black and White from Uncle Tom to O.J. Simpson*, Princeton: Princeton University Press, 2001.

Wolfe, Charles, 'Western Unsettlement: Transcontinental Journeys, Comic Plotting and Keaton's *Go West*', *New Review of Film and Television Studies*, 5:3 (2007), pp. 299–315.

Chapter 3

Comedians and Romance: History and Humour in *Kalabalik*

David Ludvigsson, University of Uppsala

Introduction: The Historical Film Comedy

In the early 1980s, Swedish filmmakers produced a number of highly acclaimed films set in the past. The best-known one is probably Ingmar Bergman's *Fanny and Alexander* (1982), that would eventually receive four Oscars, but there were more historical films hailed by audience and critics alike.[1] While history was not in vogue in Swedish culture as such, it was a major media event when, in 1983, a big-budget historical film comedy had its premiere: *Kalabaliken i Bender*, or *Kalabalik*, as it is referred to in this chapter (Viking Film/Europa Film). Producer Bosse Jonsson had assembled a group of very popular comedy actors with plans to conquer Sweden and Europe with this costume drama set in 1713. However, while the film gathered an audience of 170,000 Swedes, which made it the fourth biggest hit of that year, it ultimately failed as a commercial enterprise. Many critics were extremely negative to the film, and it did not become the hit it was hoped for. Rather, its disastrous economic result helped ruin the film company, Europa Film, which was bought soon after by its long-time competitor Svensk Filmindustri. A remarkable piece of Swedish film history, *Kalabalik* has been strangely forgotten by film historians. If mentioned at all, scholars have condemned it as a failure (cf. Furhammar 1991: 350).

But no matter what criticism was levelled at the film at the time of its release, *Kalabalik* is still an interesting historical comedy. This comedy subgenre is often popular with audiences, although little has been done to systematize our knowledge about it. The aim of this article is to analyse how humour interacts with history in *Kalabalik*, but in doing so I hope to shed light on the historical comedy genre. I will argue that while historical comedies make us engage with the past, the specific demand of the genre – to make history work as comedy – tend to result in films that build extensively on historical myth.

Film comedy is a varied phenomenon. Typically, comedy is light and amusing, marked by a happy ending and a concern with trivial, everyday aspects of life. In order to make us laugh it trades upon 'the surprising, the improper, the unlikely, and the transgressive'. It plays on deviations from norms, creating comic surprise when aesthetic or socio-cultural expectations are contradicted (Neale and Krutnik 1990: 3; Palmer 1987: 44). This very generalizing characteristic certainly does not capture all traits of comedy, which can encompass a range of forms. But it pins down a very significant element that offers a key to explain why, in the case of comedy, certain things seem to work and others do not. For comedy to work, the spectators must understand the norms from which it deviates.

In the case of a historical film comedy, what are the norms from which the film might deviate? As with all comedies these norms may be (1) aesthetic norms or (2) today's norms of behaviour. Spectators are well acquainted with what is normal behaviour, at least in their own culture, and they usually know what aesthetics to expect in a film. One such aesthetic norm, for example, is that the film follows a narrative structure. Whereas incidents in a regular narrative are there only if motivated by the logic of cause and effect, in comedy normal causal chains are broken and coincidence may play an important role. The unexpected is to be expected in comedy. Furthermore, comic scenes are often allowed to expand out of proportion; spectacle tends to have priority over narrative.

When it comes to historical comedy, a third element must be brought into the discussion, namely that of the specific, historical content. A historical film is always based on some knowledge about the past, and in various ways refers to that past, whether it be actual events or historical myths. Deviations from that past make up humorous effects. Of course, today's spectators have only limited knowledge about specific periods, events and people in the past, as well as historical myths.[2] Whereas it is only natural that the audience has limited knowledge about the past, this bring us to an important conclusion, namely that the audience will often find it difficult to understand a film's references to a particular past. This is one reason why, in comparison with other kinds of comedies, it is difficult to make historical film comedy work. What may work, however, are references to popular historical myths that the audience recognizes.

Before going deeper into historical film comedy, and ultimately the relationship between humour and history, it is necessary to look more deeply into film comedy in general. In classical Hollywood films, the major comedy traditions were comedian comedy and romantic comedy. While these traditions have since developed in many directions, it is useful to bear the two basic ingredients of comedian and romance comedy in mind. Comedian comedy was originally constructed around a popular comedian character that was already well known to the audience. Because the character was already established, the commercial success was more or less guaranteed. Very often, these films were variations on the theme of the imperfect integration of a comedian into the adult social order. For example, the comedian makes mistakes while trying to conform to social roles. An early example is Buster Keaton, who made endless comic mistakes in *The General* (1926) and in other films. Other famous star performers in the old comedian comedy tradition were Charlie Chaplin and Harold Lloyd (Seidman 1981). A more recent example is the British actor Rowan Atkinson, whose character Mr Bean has become a worldwide favourite for his inability to behave as a normal person. Atkinson's mini-series on members of the Blackadder family is especially interesting here, as it is set in various historic periods (Badsey 2001: 113–125). Clearly, in the Blackadder episodes the past provides little but settings in which the comedian can act out his role. The comedian, not the past in which he acts, is what matters most.

In classical cinema, a heterosexual love story was frequently added to the main story; once the male hero had completed the adventure, he would win the woman as a kind of reward (Bordwell, Staiger and Thompson 1985: 16–17). In romantic comedy, the love story

is at centre stage. The film relates numerous complications in the relationship between a man and a woman, but finally the complications are overcome and a resolution is reached. The spectator is supposed to identify with one or several characters only to a limited extent, because laughter often pulls the spectator away from the world represented. There is a 'play between identification and distantiation' (Neale and Krutnik 1990: 149). While the film leads to a happy ending, it also plays down the serious connotations of marriage.

Many historical comedies unite the traditions of comedian comedy and romantic comedy. *Kalabalik*, which I shall turn to below, does just that, and thus can be seen as a typical historical comedy.

It is useful to distinguish between some different kinds of comic elements that are often featured in comedies. Most common are elements that are comic in themselves, for example, jokes and gags. Jokes are verbal comments, anecdotes or stories that are meant to be funny. Sometimes they result from a person's intended wit, but in other cases jokes depend on misunderstandings or stupidity. Whether intended or not, self-contained verbal humour is what we mean by jokes. Gags, on the other hand, are non-linguistic comic action or visual comic effects. They may consist of single pratfalls or be developed into series of gags, either as variations that follow directly one after the other or as a gag running throughout a story. For example, as is popular in cartoons, one character may find repeated occasion to make another character slip and fall. While the difference between joke and gag is clear in principle, in practice there are many occasions when they are combined.

A third kind of comic element is comprised of 'comic events', which are comic not in themselves, not in a self-contained way, but only in the context of a certain narrative. These events may be verbal or non-verbal, but they become comic first in relation to the persons or events figuring in the narrative that the film offers (Neale and Krutnik 1990: 44f). In the case of historical comedies, the characters or events may be known from an actual past or from historical myth. In this sense, the narrative can be thought of as extending out of the film itself, and the comic event becomes an element of special interest when we try to understand the genre of historical comedies.

King Karl XII in Swedish Historical Culture

A historical film relates to events and people in the past, but also to representations of that past, including other historical films. In the case of *Kalabalik*, the story is set in the eastern Balkans in 1713, where a group of soldiers travel from Constantinople to deliver a Turkish princess to the Swedish king Karl XII, who has his headquarters at the village of Bender. The story is contrived, but the film actually uses a number of historical facts. The historical Karl XII was based in Bender in 1713, negotiated with the Turks and actively corresponded with the royal council in Stockholm, just as occurs in the film. Furthermore, the names of the king's men in the film are the names of men who served in his army, and many other historical details are correct as well.

Karl XII is the most legendary and controversial of the Swedish kings. Born in 1682, he became king at the age of fifteen and spent most of his life at war. After victories over the Danes, Poles, Prussians and Russians, his army suffered terrible defeat at the hands of the Russian tsar, Peter the Great. The king then spent a period of exile in Turkey, with an independent camp located at Bender in present-day Moldavia (where the film finds him), before returning home and thereafter being killed in a trench in Norway in 1718. Ever since, it has been disputed whether he was shot by the enemy or assassinated by Swedes tired of war (From 2005, Upström 1994). Voltaire and dozens of other authors posed the question about the warrior king: Was he a brilliant leader and hero, or was he a mad warmonger? Latter-day historians have revised our views of the king by pointing to his remarkable abilities as a military strategist. For example, while in exile in Bender the king initiated a number of reforms of the Swedish military, and after his return to Sweden he worked out the advanced logistical plan for the attack on Norway in 1718. He was also very successful in communicating to the Swedes the reasons for the war effort (Lindegren 1992: 200ff; Ericsson 2002). But what needs to be emphasized here is that in 1713 the king's position was weak. His enemies were intriguing to force him out of his Turkish safe-haven. Finally, when Karl XII refused to leave, on 1 February 1713 Turkish forces attacked Bender and the rout (*kalabalik*) took place. The Swedes defended the camp for several hours, but finally the king was captured. He left Turkey the following year after the political situation changed.

Ever since his death, Karl XII has been the object of interest in the Swedish historical culture; he could even be called a central figure in the country's national cultural heritage. In the age of nationalism, a statue was erected in central Stockholm that shows the king holding out his rapier towards Russia. Also, he was depicted in magnificent historical paintings. The most famous of these paintings, reproduced in numerous schoolbooks, depicts the dead hero being carried home over the snowy mountains from Norway. The king is dressed in a simple soldier's clothing and wears no wig, which signals that he was simply a warrior. In fact, the king did most often dress in a simple uniform, but apart from that detail the painting is lavish in its romantic representation.[3] Perhaps, the most important celebration of the king's warrior saga was an epic war film *Karl XII* (1925) that told the story of the king's life. The film was made by military officers, and a major reason for its making was that the officers sought to gain support for a strengthened military defence and used Karl XII as an important symbol in that struggle, appealing to a sense of national pride. It is an interesting film, one of the very few war films made in Sweden, where heroic Swedes fight the enemy on all fronts. The king, played by the prominent actor Gösta Ekman (the elder), is always ready for new adventures. One odd detail in the film is that the king, who never married, seems to be afraid of women (Gustafsson 2005: 1). The film was shown in schools for decades, which means that still in the 1980s many Swedes would have some of its imagery in mind when thinking of Karl XII.

The nationalist view of Karl XII and his time, which in Swedish historiography is referred to as the Great Power Era, was never unchallenged, however, and the dominant view changed during the twentieth century. With democracy, other historical symbols became more useful

than the warrior king. Sweden has stayed out of war since 1814, and, not least, in the decades after World War II the country's warring past seemed little to be proud of (Zander 2001; cf. Linderborg 2001: 296ff). One scholar suggests that Karl XII was not consistent with the ideas of the Welfare State (Qvist 1995: 427), and indeed, politically radical generations had trouble identifying with this symbol of the conservative cultural heritage. A shifting focus of historical research also led to an increased awareness of the population's tremendous suffering during the Great Power Era (Lindegren 2000; cf. Ludvigsson 2003: 172–186). In the 1980s, when *Kalabalik* was made, popular notions of Karl XII were certainly different than they had been half a century earlier. It had become possible to joke about the old hero. It should be mentioned that in 2000, perhaps inspired by *Kalabalik*, students in a small town set up a students' farce on the king's experiences in Bender, and in early 2006, a television comedy made the absurd suggestion that the young Karl XII had burnt down the royal palace in Stockholm.[4] This light-hearted treatment should not hide the fact that Karl XII and his time continue to be controversial. Among contradictory uses of the past, the warrior king made a significant return to the central stage of historical culture in the 1990s, when neo-Nazis crowded around his statue in Stockholm, paying him respects as the ultimate defender of the country. Thus, once again the brave warrior became a useful metaphor.

Kalabalik – A Swedish 'High Concept' Film Production

Kalabalik was made by high-profile members of the Swedish filmmaking community. According to producer Bosse Jonsson, the idea for the film came from one of his friends, who claimed to have read that the Turks tried to get rid of Karl XII by offering him a Muslim princess to marry, whom he, as a Christian, would have to refuse. This episode, says Jonsson, could not be resisted. Thus, he gathered director Mats Arehn, who had recently been successful with *Mannen som blev miljonär* (To Be a Millionaire, 1980), scriptwriter Rolf Börjlind, who had written the script for the popular film comedy *Varning för Jönssonligan* (Beware of the Jonsson Gang, 1981) and comedian Lasse Åberg. Jonsson and Åberg had worked together on two extremely successful comedies, especially *Sällskapsresan* (The Package Tour, 1980) that drew an audience of more than 2 million Swedes (roughly a quarter of the Swedish population), thus setting a national record and making cinema history. In this and other comedies Åberg played a shy and old-fashioned male character who goes on holiday and meets various everyday phenomena that he has problems dealing with (Marklund 2004: 106–116). These films combine the traditions of comedian comedy and romantic comedy. Because of Åberg's previous success, a large part of the Swedish cinema audience could be expected to show up for a new film comedy featuring a Lasse Åberg character.

Jonsson gathered actors, arranged financing and assisted Börjlind with reading books about the past and writing the script. Furthermore, he recalls that they talked to a couple of experts on the period, the professional historian of science Tore Frängsmyr and amateur historian and historical novelist Lars Widding. Actors prepared for their roles by learning

to fence and to master horseback riding. Costumes were sewn. In all, from the first proposal until screening, the production process took about two years.[5]

Kalabalik was a very large production by Swedish standards. It involved a Swedish crew, as well as a Hungarian team and more than 30 actors. Exteriors were shot in Hungary rather than Moldavia where Bender is located, because the republic, then a part of the Soviet Union, would not allow a foreign film team to work within its borders. Hungary's Magyar Film offered a great place for outdoor filming near Budapest. Some buildings already in place could be used for Bender, and furthermore, the Hungarians easily got hold of numerous horses and stuntmen that were needed for some scenes. Hungarian experts built a rope-bridge, whereas the Swedes brought high-quality lamps and filming equipment from Sweden.[6] Oddly, the production used 200 sheep, 80 horses, 50 pigs, 50 geese, 25 goats, twenty rabbits, twenty rats, ten oxen and twelve frogs.[7] Interiors were shot in Sweden, such as the scenes set in the palace of Constantinople in a mock-up that was built at Europa Studios in Stockholm. The film cost 12 million Swedish crowns to make, which was a very large film budget (for Sweden) in 1983. Jonsson's Viking Film put up half the sum, and Europa Film the other half (Åhlander 1997: 264–267).

Some of the actors were non-Swedish, among them Briton Walter Gotell, who played the Turkish grand vizier, and the Turkish actress Ayse Emel Mesci Kuray who played Princess Serina. But more interesting is that the film featured several members of the elite of Swedish comedy actors: Brasse Brännström, who played Åberg's companion in the film, and Gösta Ekman (the younger), who played King Karl XII. Ekman had created a comic clumsy character that, like Åberg's, was very popular with the Swedes.[8] The group of prominent actors suggests that *Kalabalik* was something of a Swedish 'high concept' film. The expression 'high concept' has been used to characterize the aesthetics and marketing strategies for big Hollywood productions, such as the use of star actors, who are attractions in themselves, a very basic-formula narrative with stock situations, music 'matched to a marketable concept behind the overall film', visually attractive compositions and intertextual references (quoted in Wyatt 1994: 40). Because *Kalabalik* was not marketed in the sense that big Hollywood productions have been in later years, the comparison is partly misleading. But it is striking how many popular actors play in the film. In addition, the basic action is very simple, there are visually attractive scenes, and there are intertextual references to other films. Thus, it seems reasonable to call it a Swedish example of high concept.

The Swedish film title *Kalabaliken i Bender* not only refers to the historic event when the Turks attacked Karl XII; it also reflects the exact term that has been used to depict this event in Swedish popular history. In addition it helps categorize the film as a comedy, because the word 'kalabaliken' signals that things are somehow out of control. The film is also marked as comedy in the opening text that says the film is based on a 'fake diary', and goes on to describe the strategic situation of Karl XII: 'The king himself and some of his loyal officers have managed to flee to the little Turkish village of Bender, out of reach from the furious Czar Peter. In Turkey the king is among friends. Or so he thinks …' The fact that the king

'thinks' he is among friends strongly suggests the opposite. Misunderstandings being a fundamental element in comedy, we are thus ready for the film.

The film is set in Constantinople, at the court of the Turkish grand vizier, in Bender further north, where Karl XII has his headquarters, and at various sites in between these two places. In brief, the story goes as follows: the grand vizier decides to send Princess Serina to the king to marry him, while the Swedish king and his ambassador try to stop the princess from reaching Bender. Their prime move is to entrust the princess to the incompetent Ensign Lagercrona, who with his batman Kruus and a few other soldiers are chosen to escort her. Secondly, the king's men commission Tartar bandits as well as Swedish soldiers to kill the princess and her escort. The trip turns into a veritable road movie of spectacular (and comic) adventures, with explosions and constantly new threatening scenes. Despite the king's efforts to stop them, Lagercrona, Kruus and Princess Serina finally complete the journey. However, by then the Turkish army threatens to storm Bender. Faced with this threat, Karl XII finally agrees to leave Turkish soil on condition he can have his body's weight in gold. However, before the treasure is delivered Lagercrona and Kruus steal it and put the princess in its place. The king's surprise is complete when, instead of the treasure, the princess appears before him. He has cannons fired at the Turks and thus the historic 'kalabalik' at Bender begins, with fighting between the Swedes and their Turkish hosts. Meanwhile, in the film's final scene, Serina catches up with Lagercrona and Kruus and rides off into the sunset.

The time and place of the film is established by help of the opening text, by music and by props. A musical piece that accompanies the soldiers' journey is 'Marcia Carolus Rex', which is traditionally associated with Karl XII and thus serves to anchor the film in that specific historical context. When it comes to physical settings and props, there is a general absence of modern artefacts; instead, historical artefacts are used such as rapiers and period clothing. The presence of pigs and hens near houses also help to establish the time as 'the past'. Actors specially prepared their teeth to look old.[9] A number of details help the audience see that it is the early 1700s, especially the soldiers' blue uniforms and triangular hats that signal Swedish soldiers of the period.

The film is interesting from a number of perspectives. First, there is the transformation of the grand historical narrative of King Karl XII into a film comedy. Second, there are the elements of comedian comedy and romantic comedy that come to the fore, especially through the story of the heroes, the soldiers Lagercrona and Kruus, and the slowly evolving love story between Kruus and the princess. In the following, I shall discuss the film from these perspectives.

Converting Grand Narrative History into Comedy

The rout at Bender and the story of Karl XII are part of the traditional grand narrative of Swedish history. In *Kalabalik*, it is transformed into comedy. The dominant historical character, of course, is Karl XII, whom the film represents as a comic character with a

peculiar physical appearance. He appears as a short, fat man with incipient baldness, a strong underbite and a very long nose dominating his face. The king's way of standing with his large belly extended and the waistcoat buttons fastened only above the belly continually draw attention to his body; in a gag scene he tries in vain to fasten his lower waistcoat buttons. This pathetic physical appearance signals nothing of his being a king. Rather, his appearance is contrary to all stereotypes of a king, and in its grotesque exaggerations, especially his nose, underbite and belly, add a comic touch. In fact, although grotesque, there is a historical basis for these physical traits. The king did have an underbite, and a painting made in Bender indicates the king had put on weight.[10] Similarly, whereas the long nose is clearly exaggerated, it is modelled on the death mask made from the king's dead body. It can be added that there are similarities between the king's looks in this film and in the one from 1925. The actors in the two films were Gösta Ekman the elder and his grandson Gösta Ekman the younger, who share many physical characteristics. Both kings were given a long nose, but it was only in *Kalabalik* that attention was given to the king's underbite and his belly.

The king becomes funny not least because his actions cause him to deviate from our norms of behaviour and our sense of how a king should look and behave, that is, the stereotype of a wise, dignified leader. Rather, the king seems childish, which is partly conveyed through his body language. In the first scene he appears sitting on a rocking-horse, while an artist paints his portrait. Learning the unpleasant news that a princess is on her way to him, he clumsily tries to walk away from the horse over its head, almost falling to the floor. It is far below the dignity of a king to sit on a rocking-horse in the first place, as he does, but the development of the scene with his disembarking from it demonstrates his inability to use his own body agilely, and thus turns the scene into a gag. On another occasion, when learning that the grand vizier plans to hand him over to Tsar Peter, the shocked king leans back against a model of his Stockholm palace, which eventually leads to his pratfall. On other occasions he farts and belches. Thus, his childish lack of body control shows itself time and again, functioning as a running gag. It should be noted here that the comedian Ekman uses some of the body language that had already made him a popular actor.

One spectacular gag scene results from the agreement between the king and the grand vizier, that the king will leave Turkey, if he can have his body weight in gold. The king's men make Karl carry a lot of gig iron-chains under his coat, which leads to an entertaining, hesitating walk as he stumbles out in the yard to the weighing. Drums provide the soundscape, while fires, animals and even a dwarf make the scene into a visually absurd spectacle.[11] Soldiers load cannonballs onto a wooden container that is a counterweight to the king, as an officer bellows 'one hundred and ten cannonballs', etc. Finally the barrel upon which the weighing takes place breaks down, followed by an outburst from the hens and geese present.

An important aspect of the king's appearance is that he makes comic insults to his men. For example, twice he pulls a button from the uniform of his close advisor, Colonel Grothusen. After the first occasion, Grothusen demands that a helper put it in place by using steel wire, but that does not stop the king from pulling it loose again. On another occasion, the king

playfully pulls the wig from Grothusen's head. In the context of the film these acts serve a comic purpose. Social conventions dictated that the upper classes in society, and especially the king, should be well acquainted with good manners. Therefore, the king's aggressive acts, making fun of people around him, are the more remarkable as a transgression of norms. In fact, these actions may give us a reasonable idea of the king, as there is some historical evidence that he actually pulled a button from a visitor's coat[12] – but of that the regular spectator can know nothing.

One of the king's more peculiar character traits in the film is that he spies on his officers. In one scene he stands outside the officers' house and tries to overhear their conversation inside. Meanwhile, his hand can be seen through the door, and his profile is vaguely visible through the window. Thus, he fails to act as a skilled adult even when spying. There is also a scene where the king sits and studies a model of the new palace in Stockholm. In view of the king's other childish activities, this scene can easily be interpreted as the boy-king playing with a dollhouse. While Karl XII actually saw drawings of the new palace at Bender, there is also historical evidence that he did spy on his officers through the windows.[13] While these details do contain a grain of truth, the film transforms them into comic elements.

However, the king not only plays a crazy figure, but he also proves himself to be a powerful political actor. He plans how to defeat the grand vizier and Tsar Peter. Furthermore, when posing for a portrait he actually performs a part in his propaganda war, because the portraits had an important function in signalling to the world what the king represented. The tough leader is also visible on other occasions, as in the late scenes when he waits for the Turkish attack on Bender, but seems calm and prepared for war. He is more worried when it comes to the issue of getting married. Partly, the king's worries must be understood as strategic considerations, because in order to win the war he needed an army rather than a wife. The fear of a Turkish wife may also be based in religious worries, namely that as a Christian king he could not marry a Muslim princess. But it is noticeable that the headquarters at Bender offer a purely male milieu. Thus, *Kalabalik* plays on the same fear of women that was visible in the 1925 film, and that is part of the myths surrounding Karl XII, that he was the boy-king who never married and who was possibly sexually inexperienced. In fact, in the scene where Princess Serina unexpectedly comes to stand face to face with the king, there is no sexual tension at all between them. Rather, the composition of the scene, with a grey sky, a muddy ground, the king's pale face and generally unattractive appearance all help emphasize the idea that he could not attract a woman. This is all the more striking as the sultan's mother calls the distant king 'mon lion', or her lion. Apparently, she had never met him but made him the man of her dreams. Historically, the sultan's mother did have great sympathy for Karl XII, and even wrote letters to him (Stafsing 1960: 16, 23, 40).

Taken as a whole, the king is portrayed as both comical and complex. His physical appearance, his manners and remarks are those of a laughable fool who fails to conform to a normal adult role. In many details, the representation is based on historical sources, and therefore it should not come as a surprise to the audience. But mythology is strong. In fact,

the portrait gets much of its comic effect from the audience's preconceptions about Karl XII as a great warrior and leader.

In various ways, both people and settings in Bender serve to bring out the king's appearance and crazy manners in full relief. In many scenes the king is supported by and contrasted with Colonel Grothusen. Physically, Karl is short and Grothusen is very tall, which is emphasized by their standing close to each other, the king always looking up at Grothusen. (The historical Karl XII was not a short man, but 178 cm, which was above average height in the early 1700s; however, the 1925 film makes the king a short man which thus added this characteristic to the historical myths.) The physical contrast between them is also the basis for a joke in the scene when the princess arrives in Bender and turns to the tall, king-like Grothusen instead of the short, bareheaded king. But especially, the two men are contrasted in the dialogue. The colonel represents realism because he repeatedly brings up the issue of the lack of money. The king proposes he should sell another palace, but Grothusen answers that there are no more palaces to sell. A practical treasurer, Grothusen then negotiates with a Turkish merchant and sells a Swedish warship, Vasa, which actually had sunk in the harbour at Stockholm. (The audience will have understood this joke, because it is well known that Vasa sank in the middle of town on its maiden voyage; the ship was retrieved in the 1960s and became a major tourist attraction.) In a comical deviation in the negotiation scene Grothusen describes the true facts about the ship, while the translator changes every sentence to make the deal more favourable for the Swedes. Although Grothusen sometimes appears to be in touch with reality, that is not always the case. At one point a courier from Sweden arrives who complains about the hard times in the country. The colonel says people will be forced to use bark in their bread, but the courier answers that they have already had to do so. When the king demands a new army, the courier answers (quite vehemently) that there are no soldiers left at home. Thus, the dialogue indicates that both the king and his closest advisor have lost contact with reality.[14]

There is one particular scene that is odd in that it allows close-up shots and a very intimate conversation between the king and Grothusen. It is late at night, and the king is not sober. Helping the king go to bed, Grothusen poses the crucial question of why is it so important to defeat Russia? The king answers that it is his fate and adds that history will judge him: 'What shall our posthumous reputation be? How shall time judge us? Will we stand shoulder by shoulder with Alexander the Great, or will we stand alone, shit on by seagulls in a windy park?' After this philosophical, self-centred reflection the king starts snapping his fingers and sings, repeating the phrase, 'Hereafter this [war] shall be our music.' Finally, he beats the back of his head rhythmically into the wall, drunk and crazy. Although this head banging dominates, there is a wealth of detail in this scene. For example, the king's imagery of standing alone in a park is an allusion to the modern-day statue found in a Stockholm city park. Furthermore, the phrase, 'Hereafter this shall be our music' has been attributed to Karl XII in popular culture.

The Swedish headquarters at Bender consist of a group of rather primitive buildings, where hens and pigs run around. The presence of animals is an interesting detail, because it

helps connect the place to a peasant society, and indirectly it links Karl XII to peasant life. In the scene where he stands on the steps listening outside the house that forms the officers' quarters, there is a goat standing next to the king, which metaphorically reduces him to the level of the goat or elevates the goat to human status.[15] The presence of simple farm animals certainly helps contrast the milieu at Bender with conventional ideas of how a king should live. Impressive ceremonies are also lacking. When the king sits down for a meal, his officers are at the table; they eat as he eats, drink as he drinks. This visual manifestation of power, which is a travesty of a scene in the 1925 film, becomes ridiculous when contrasted with life at the grand vizier's court. At Bender there are no luxuries and especially no women, while in Constantinople there seems to be constant entertainment, including dancing women.[16]

As mentioned, the king's men have the names of men who, according to the historical records, were with him in his exile.[17] However, the film often portrays them as comical and sometimes treacherous. The film's priest Agrell has a black patch covering one of his eyes, a visual marker that signals that he, like a pirate or a criminal, is not to be trusted. The ambassador, Poniatowski, is very short and heavyset and speaks Swedish with a German accent, which adds to his odd appearance. The historical Agrell and Poniatowski were both based in Constantinople at this time, but their looks were nowhere near what the film

The bareheaded Karl XII seeks advice from the cunning priest Agrell. Photo: Jacob Forsell. Kalabaliken i Bender (c) 1983 AB Svensk Filmindustri.

suggests. In reality, Agrell was a very honest man, perhaps naive, but always loyal to the king.[18]

The officers at Bender act mostly in realist ways, talking about their hope to return to Sweden. But at times they also help create comic scenes. Once, trying to convince the king to leave Bender, they use not words – but show him the numerous scars on their naked stomachs and buttocks. Standing undressed before their king, they turn the scene into a surprising spectacle. The most important person in the officers' crowd perhaps is the aged General Lagercrona, the father of Ensign Lagercrona who is given the mission to escort the Turkish princess. Overall, he plays the stereotypical role of an old confused soldier, his perception perhaps warped by long years at war, adding to the impression of an army that is only a shadow of its splendid past.[19] In one scene the officers celebrate the general's fortieth birthday (which is a joke because an older actor and not a forty year old plays the general). The birthday cake is decorated with numerous little candles, which makes it all resemble a children's party and adds to the impression that the general has returned to childhood. In addition the top of the cake is decorated with a small decorative sculpture of the king with a rapier – an anachronistic copy of the statue of Karl XII now standing in central Stockholm. The camera zooms in on the little sculpture, and thus it is a very conscious little comic event.

Looking carefully at historical detail in the film, there is much that follows the historical record. Swedish soldiers of the period wore blue and yellow uniforms as they do in the film; although, one might add, at the time of Bender, after years of war, the soldiers would have picked up clothes along the way, and it is unlikely that they would have had complete uniforms. One scene has General Lagercrona train a horse to make it accustomed to the noise of combat. Such training was done, although probably not by high-ranking officers.

Some of the film's changes of history can be attributed to demands of the medium. One such adjustment is that the king demands the firing of cannons towards the Turkish army, whereas historically there was no artillery in Bender. The thunder of cannons was needed to provide effect, when introducing the rout. Further, it is unlikely that such a small group would have escorted a princess to Bender, as it was such an important mission. But the small size was necessary for aesthetic reasons, because the plot demanded that in time, the escort would be diminished and consist of just Lagercrona, Kruus and the princess. Finally, the film continually refers to the Russian tsar, Peter the Great, as Sweden's enemy, whereas the enemy intriguing in Constantinople was really the Prussian king, August the Strong. The medium would demand simplification, but the reason for choosing Peter as the enemy probably was that he is more well known to today's cinemagoers; the famous battles of Narva and Poltava were fought against Peter, whereas the Swedish wars against August are less known.

Comedians, Romance and History

Whereas the towering historical figure of Karl XII and the men around him provide the crucial historical reference point, the film's main characters are really Ensign Lagercrona

and Batman Kruus. We first meet them out on the steppe, somewhere in Eastern Europe. Caught in a close-up shot, the exhausted Lagercrona cries that he cannot make it any further, while Kruus urges him to hold on. This dialogue becomes a joke when the camera suddenly reveals that Kruus carries Lagercrona on his back. Assumedly fleeing from Russian enemies, their travels 'towards Sweden' are abruptly interrupted when they meet slave hunters. Lagercrona prepares to defend himself and his own and draws his rapier, which turns out to be just a broken, useless stump. This metaphoric sign of helplessness, of course, is a signal of comedy. In the following scene the two men are brought to the bustling slave market in Constantinople, where Sweden's ambassador accidently finds them. From this picaresque beginning, they are drawn into the story of big politics where they are entrusted to bring Princess Serina to Bender.

Two soldiers, Lagercrona and Kruus, between them incorporate all the traits that make them unsuited to military work. The absentminded Lagercrona is a brave fool, whose stubbornness puts the entire expedition at risk; the ambassador in Constantinople defines Lagercrona to the spectators by calling him 'the most useless officer in the army'. Kruus is the more practical of the two, but constantly expresses his fears of what might happen. Well founded as the fears are, they are not what would be expected from a brave soldier. Thus, both men are inconsistent with the norms of a good soldier. Notably, they arrive out of nowhere, several years after the fatal battle of Poltava, and in the end they leave again just at the moment when Swedish soldiers would be needed to defend their king. This can be seen as the ultimate proof that they are bad soldiers. Instead, background figures perform in accordance with the norms of a soldier: riding along, fighting the enemy, dying, etc.[20]

Lagercrona, whose name literally means 'laurel crown' and thus hints at an academic degree,[21] does not have the appearance of a regular soldier. He is unusually tall, and unlike other soldiers in the film he wears glasses and has a moustache. Some of the film's comic incidents are generated by his failure to control the performance of his body, which is in direct conflict with the regimentation required by the army. For example, when Lagercrona gets his dangerous mission he turns around swiftly, and in the process, before marching out of the room, his rapier sweeps numerous chessmen from the ambassador's chessboard. Later, Lagercrona rides off into the misty forest to fight the enemy, but incompetently falls from his horse. He gets up, rapier in hand, ready to take on the enemy. Moving backwards he feels something pointing against his back and thinks an enemy has caught him, although it is just a tree branch. Taken together, these gags suggest that Lagercrona's body is not that of a soldier.

Otherwise, his most striking feature is his passion for science. A Swedish woman in Constantinople, who flirts with Kruus, asks Lagercrona if he longs for someone – a woman? – back home, but the ensign answers that his longing is to explore the wilderness in the far north. Physical passion does not seem to be his cup of tea. Instead, he manifests his botanical interests throughout the film. When Kruus kills a large insect that has crept under his shirt, Lagercrona decisively takes it and puts it in a little container with liquor (an act that makes Kruus complain about the drink being wasted).[22] Later, the ensign fishes for crayfish

in a river, Kruus holding a torch to help him, and twice, Lagercrona leaves the escort to hunt butterflies with his butterfly-net. He even creeps on the ground, trying to catch a frog; this idyllic scene is juxtaposed with a Tartar attack on the camp where Kruus desperately shouts for the missing ensign. There is an element of historical truth in Lagercrona's activities in the sense that there were many soldiers in the eighteenth-century Swedish armies who had scientific ambitions and who gathered all kinds of species. The filmmakers were much aware of this, as they had discussions with a historian to get this aspect of the portrait right.[23] But most spectators only see the ridiculous Lagercrona running around with his butterfly-net. Thus, Lagercrona's passion serves two functions, namely to transmit historical knowledge and, paradoxically, to make him appear odd and comical. But the ensign's hunt for butterflies also plays an important part in the narrative. First, his hunt is the reason for his absence at the moment when the Tartars attack the escort. Secondly, he is also away hunting butterflies when a lone enemy attacks the princess. On this second occasion, Lagercrona uses the butterfly-net to catch the enemy before Kruus gets there and manages to knock the attacker down with a piece of wood. Lagercrona's awkward use of the butterfly-net, a bad weapon to say the least, is a comical visual detail that adds to the picture of the incompetent soldier.

Batman Kruus in many ways is the opposite of the ensign. It has already been mentioned that he is scared as a hare and has a weakness for alcohol. (His name means 'jug'.) Both characteristics are manifested in an early scene when Lagercrona drags him to the barber-surgeon Dr Skragge, who is to see to his ear, which 'received a wound at Poltava'. Because the famous battle of Poltava was fought four years earlier, this comment creates a small comic event, because it is unlikely that Kruus's ear has gone unattended for all this time. When Lagercrona drags Kruus into Skragge's room, we hear screams and see a hen walk on the table. Dr Skragge himself wears shabby clothes, sports a big beard and is not sober. He picks up a saw, commenting that the long war has made it dull. Faced with this terrible milieu, Kruus, scared to death, definitely wants to leave. However, when Skragge takes a drink and suggests that Kruus do the same, the latter is immediately convinced that he should stay. The scene is a comical spectacle and is not needed from the strict perspective of the narrative,[24] although it helps illustrate the batman's fears and his weakness for alcohol, elements that are used again later in the film to create humorous scenes. Immediately after the scene above, for example, we meet Kruus who is very drunk and who tells Lagercrona: 'Dr Skragge is a very able doctor', a remark that is comical because it is clearly founded only on the fact that Kruus has been offered a few drinks.

Stuttering, stammering and by means of physical contortions, the comedian Brännström's misfit loses control over both body and language. Running away from a bridge about to explode, he throws his gun away. Later, running from a suspension bridge Kruus drops his hat; he first turns back to fetch it, then hesitates and lets it be. The scene suggests the hesitant personality of Kruus. However, at times he also shows a fair bit of drive. He is a practical person who takes care of both Lagercrona and the princess. When Lagercrona forgets their mission, Kruus suggests that they should be moving. He is the realist who helps fend off the enemy.

Throughout the film, the contrast between Lagercrona and Kruus is the basis for humour. When the impractical Lagercrona tries to use a spyglass, the more practical Kruus leans forward to pull the cover from its end so the lieutenant can see something. When sharing a bed, Lagercrona turns over and takes the entire blanket, so Kruus has to do without. Often, their dialogues break down and thus create little comic events in the context of the story. This pattern is established once the two men arrive in Constantinople. They sit next to each other and offer completely different interpretations about their adventures thus far, their stories being interpolated and thus creating a very strange story. On other occasions it is Lagercrona who fails to hear what Kruus has to say. Preparing for the expedition Kruus has a drink and worriedly suggests that it will be a dangerous mission, but Lagercrona does not listen and instead talks to himself and (symbolically) puts a magnifying glass into his pack. Later, by the campfire, Kruus is anxious about a missing scout, while Lagercrona keeps talking about his botanical findings. When the scout finally returns, he dramatically falls off his horse in the middle of the camp with a bunch of intertextual, Western-like arrows sticking out from his back. A particularly interesting joke is that, walking across the steppe, Kruus exclaims that the world is flat. The educated ensign answers that science has discovered it is round, but Kruus laughs and insists on its being flat. This exchange of words becomes a joke because the modern audience knows that the self-confident Kruus is wrong. But the joke has the additional function of highlighting the differences in world-view between then and now, thus informing us about the past.

Just as in Skragge's surgery, the protagonists must often go past ducks, hens, goats or pigs. As a running gag, in some scenes the animals are used for directly comic purposes. When Lagercrona, Kruus and Princess Serina try to flee from imprisonment, they stumble straight into a henhouse, which, of course, leads to enormous cackling instead of the silence that a professional escape would have implied. Thus, passing the henhouse becomes a gag that underlines the general incompetence of Lagercrona and Kruus. The gag continues as they escape through a barroom, and Lagercrona greets a sleeping man with 'good morning' instead of just keeping quiet.

There are incidents in *Kalabalik* where realism is stretched so far that the scene reminds the spectator of the constructed character of what is seen. One example is the scene with the returning scout. Another is the spectacular crossing of a rickety suspension bridge high above a ravine. The princess and one soldier go first, but during their crossing the bridge begins to break apart. When it is Kruus's turn to cross, he chooses to do it as if walking a tightrope with a long stick in his hands, resembling a circus acrobat.[25] Finally, when Lagercrona is half-way over, an enemy appears and cuts off the ropes, so the hero plummets. After he disappears from sight and Kruus and the princess cry out, the camera focuses on the rim until finally Lagercrona's summoning voice shouts, 'Kruus!' Then a hand is seen reaching up over the rim. This incident is so fantastic that it cannot but remind the spectator that it is only a film. Another detail that calls attention to the construction is Lagercrona's strange habit of sending away his soldiers, one after the other, to fetch help. For example, as soon as the princess and one soldier have crossed the suspension bridge,

Looking for Bender. Batman Kruus points out the way for the incompetent Ensign Lagercrona. Photo: Jacob Forsell. Kalabaliken i Bender (c) 1983 AB Svensk Filmindustri.

Lagercrona sends the soldier away – although that leaves the princess all alone on her side of the bridge![26]

During the journey the heroes meet both new milieus and new people. The Balkan setting provides local colour and scenery. One night by the campfire, Lagercrona and Kruus get an opportunity to talk with the Turkish soldiers escorting Princess Serina. Kruus and one of the Turks exchange pieces of food and try to explain to one another what it is, namely crayfish and stuffed cabbage rolls, respectively. The exchange leads to a joke when the Turk insists that the stuffed cabbage roll be called 'dolme' (stuffed roll) whereas Kruus suggests it is 'kål' (cabbage), and finally proposes the compromise of stuffed cabbage roll. This dish was brought to Sweden as a result of Karl XII's stay in Turkey, which thus brings the scene in touch with historical fact. At the same meal, Lagercrona tells Kruus that there is nothing wrong with Turkish crayfish, an anachronistic joke because it refers to the fact that Turkish crayfish comprise a big import to modern Sweden.[27]

The Turks add exoticism to the film, their colourful clothes helping to anchor the film in its foreign location. The grand vizier's palace is represented as something like a sensual paradise. In the opening scene, the grand vizier is reclining, greeting his foreign guests in a room with burning torches, half-naked slaves and a belly dancer. Later in the film, the grand

vizier lays at rest in his harem, with numerous lightly dressed women around him. Thus, the exotic setting allows a level of voyeurism. The Turks function as the counterpart of Karl XII, and in a sense they provide the norm against which the Swedes break. But even the Turks behave a little strangely sometimes. When the escort is attacked, one of the Turks shouts to their leader that he should ride for help (rather than stay to defend the princess). Returning much later with new soldiers, the Turkish leader thinks he sees the princess's dead body at the bottom of a ravine. But instead of fetching the body, which is actually just some clothes, they leave and ride back to Constantinople, thus demonstrating rare incompetence.

The most important meeting of the journey is, of course, that between the Swedes and the princess. The unusual circumstances of the journey offer a chance for them to get to know each other, whereas they would normally live in completely different worlds. Kruus immediately shows an interest in Serina. They first meet in Constantinople, when standing next to one another outside her covered carriage. This brief, wordless scene is accompanied by slow romantic tunes on the soundtrack, which hints at emerging attraction. However, a princess is unreachable for a common soldier. During the early part of the journey she travels in a white wagon drawn by white horses, soldiers on dark horses riding before and after it; the imagery is very beautiful. On the first evening, in the scene by a campfire in the dark, the princess sings a song. It is historically unlikely that a princess would sit next to commoners by a campfire and sing, but nevertheless her singing creates a magical, exotic atmosphere, and it definitely makes Kruus react. While she is meant for his king, Kruus is drawn to the princess, and whereas Lagercrona is the leader of the escort, it soon becomes obvious that Kruus is the one really protecting her. When the Tartars attack their camp, he first defends the princess and Lagercrona, rapier in hand, and then resolutely heaves the princess over his shoulder and runs for safety.

Serina remains mute throughout most of the film, epitomizing the exotic woman as passive and pliant. Some comic effect comes from the fact that she understands little or no Swedish. At one point, after they have lost the other escort and the three heroes have wandered on foot all day, Kruus urges the ensign to wait for the princess, while it is obviously he himself and not her who is tired from walking. But the princess soon starts to learn and say words and phrases in Swedish. Thus, when Kruus talks to Lagercrona about liquor and 'women' in Sweden, Serina embarrasses him by asking about the unfamiliar Swedish word. The element of romantic comedy comes forth quite forcefully here. On another occasion, when Lagercrona has disappeared in the forest and Kruus seems upset, she asks him: 'Kruus sad? The ensign gone?' Meanwhile, the slow romantic theme music plays in the background. The feelings between Kruus and the princess grow during the journey. In the scene when Kruus tries to cross the ravine and is close to falling, she anxiously cries out 'Kruus', which helps create an air of serious passion. Finally, when a lone hunter attacks the princess, Kruus saves her from the threat, and she falls into his arms, crying out his name. On this latter occasion, he comically does not seem to know whether to hug her back or not. As Lagercrona points out, she is their future queen, and for the time being this keeps Kruus from declaring his love.

The 1925 film held a parallel to the story of Kruus and Serina, namely that of the Swedish soldier Lasse and the Turkish woman Aysha, who helped the Swedes and even asked if she could come along to Sweden. In *Kalabalik*, when the three of them are caught, Kruus suggests that the princess come with them to Sweden in a scene also accompanied by the romantic theme. However, Serina's faith in the mission is heroic, and, despite the king's attempts to have her killed, she urges Kruus and Lagercrona to move on to Bender. However, both she and Kruus are sad when they are apart, as when she is going to meet the king. It is one of few scenes shot as close-ups. Kruus says that he will miss her, and they both have tears in their eyes and hug, Lagercrona allowing it to happen. Serina's dilemma, of course, is that she is a princess, poising on the margin between the sacred and the profane, and she cannot step down from her throne. Yet, the need for a happy ending necessitates a change. Towards the end of the film the heroes' long line of unchanging failure is suddenly transformed into success. First, Lagercrona and Kruus in Robin Hood style steal the Turkish treasure and decide to take it home to 'the Swedish people'.[28] Then, after her failed meeting with Karl XII, Serina escapes from Bender and rides after Kruus. In the film's concluding scene, she for the first time pulls down her veil and offers him a big, happy smile. The last-minute reversal thus completes the romantic story and confirms the structure common in romantic comedy. Leaving the king to fight his own battles, the heroes ultimately reject the absurd rules of a past society, instead riding into the promising sunset.[29]

Conclusion

In many ways, *Kalabalik* is a typical comedy. Comic effects are created via gags and as verbal jokes. There is an element of romantic comedy, although it plays a minor role in the film. More important, the film features several comical characters, such as Karl XII, Lagercrona and Kruus, who behave in entertaining ways and fail to conform to expected social roles. It should be noted that several of the actors were well known for particular comic role characters, which they partly play in this film and which qualifies *Kalabalik* as a comedian comedy. Probably, the audience came to see certain comedians in action, and that is also what they got. Further, the film features a number of amazing scenes that expand into real spectacles, thereby breaking against the aesthetic norm of the narrative. The scene where Princess Serina, Kruus and Lagercrona cross the rickety suspension bridge falls into this category, as does the scene where Karl XII is weighed against cannonballs. Among other spectacular effects, the camp is destroyed when the princess's wagon explodes, a bridge is blown up, there are scenes with noisy animals and the exotic opening scene with a belly dancer at the grand vizier's palace. All these expansive scenes, rarely necessary to take the action forward, indicate that spectacle is privileged over narrative.

A point could be made of the references to the 1925 film about Karl XII. These references, most notably manifested in that actor Gösta Ekman plays Karl XII which his look-alike grandfather did in the earlier film, in the first place hint at the 1925 film, but also, indirectly,

to the golden age of Swedish film. As a sign of high concept, this makes the film quite typical of the 1980s. Whatever was marketable was packed into the film.

In terms of comic events, the film derives part of its humour from trading on the clichés of popular or schoolbook versions of history. Especially, the film's portrait of Karl XII draws from the popular version of the king as a war maniac. This mythical view of Karl XII was part of the cultural heritage of young and adult Swedes in the 1980s and could thus work with the audience. The grand narrative of Swedish history makes the king a serious (if ruthless) warrior. Because the film so clearly has him deviate from this narrative, his words and actions are easily recognized as jokes and gags. Seen as political satire, the portrait is an attack on the conservative cultural heritage. Very likely, the spectators also understand the film's references to modern historical culture, such as the Karl XII statue in central Stockholm appearing as a marzipan figure on a birthday cake, the king playing with a model of the royal palace in Stockholm or Colonel Grothusen's selling the wreck of the royal ship Vasa. As the audience recognizes the planting of elements from the present in the past, these details create comic effects.

If references to the mythical past worked to create comedy, it is, however, more uncertain when it comes to the film's references to the real past. Early in this essay I argued that the audience will find it difficult to understand a film's references to a particular past, and, as a consequence, it will be difficult to understand that the deviations from that past are intended as jokes. My analysis of *Kalabalik* generally confirms the argument. A historian could laugh at the roles of historical figures such as Agrell and Poniatowski, but the ordinary spectator would only see them as characters in a film. When it comes to the king, the film makes fun of his being fat, but there is historical evidence indicating he did indeed put on weight while in Bender, and this dimension of the gag can only have been known to a small number of experts. Another detail is that Ensign Lagercrona collects butterflies and other little creatures instead of protecting the princess. The awkward behaviour of the ensign seems funny in itself, but, as military officers at this time often were amateur biologists, it is another example of how historical information that is included in the film – is not explained. This point could also include the war activities of Karl XII, which the film makes fun of by suggesting that the war went on because the king saw it as fate. The film does not communicate the insight that Sweden's future as an independent kingdom was threatened. In sum, the film does not explain the complex past, but rather makes it the basis for humour. It is unlikely that many spectators understand these references to the early 1700s. If these episodes function as comical they rather do so as deviations from the mythical idea of Karl XII and his soldiers as fit, disciplined soldiers – a widespread stereotype in the Swedish historical culture.

In the film the past is mainly established on the surface through the physical surface world, by means of clothes and unfamiliar living conditions that distance the characters from the audience. However, far from all the norms of eighteenth-century life are followed by the characters. Nothing indicates a fear of religion, so typical of the period, but rather, people act and talk much like modern people. Somehow it is taken for granted that the

Muslim Princess Serina will cross the religious and cultural barrier and run away with Kruus. Unhistorical as it is, their behaviour opens for identification, but not for a better understanding of the past.

Coming to a close, what new can be said about the historical comedy genre? What are the functions of historical comedies, and how does humour influence our ways of understanding the past? A major function of historical comedy is to provide entertainment. Furthermore, while a historical comedy is not necessarily conservative or radical, it will carry with it values about behaviour, gender and race, and ultimately it also has a moral function (cf. Palmer 1987). In addition, and importantly, the historical comedy will always provide information about the past. The appearance of various historical persons may help to strengthen the spectators' sense of historical chronology, thus serving the cognitive function. And a joke, such as the one when Kruus refused to believe that planet earth is round, may remind the spectators just how much we have learned, thus illuminating both the past and the present.

Scholars such as Robert Rosenstone (1995) and Robert Toplin (2002) have urged us not to look askance at historical films, but rather to take them seriously and to see their potential to add to our historical understanding. I readily agree that historical films may be used both to illuminate the record of the past and to show us how we are different from what we were. But most historical comedies will have difficulties living up to the high standards envisioned by Rosenstone and Toplin. Humour is produced when we feel incongruity between what is expected and what actually takes place in the joke or gag. Because most of us have very limited knowledge about specific periods in the past, it becomes difficult to sense when the film deviates from (our vague expectations of) the past. As the case of *Kalabalik* indicates, correct references to the past may be hard to grasp. In conclusion, the comedy genre will have problems relating to that real, 'historians' past'. The solution, used in *Kalabalik* and perhaps more successfully in a film like *Monty Python and the Holy Grail* (1975), relates not to the historians' past but to historical myths and historical-cultural stereotypes. Popular culture rarely makes a clear distinction between knowledge and myths about the past. Therefore, in order to make the comic events work, the comedy filmmakers must talk about the past the audience thinks it knows.

But historical comedies may add to our historical understanding in yet another way. It should not be forgotten that humour activates our feelings. When films let us meet individuals, and encourage our identification with these individuals, the viewing may actually stimulate our ability to empathize with people in the past. While such emotional reactions are hard to measure, we should acknowledge that feelings do play a part in the development of our historical understanding. Thus, historical comedies help us create meaningful relationships with people and events in the past.

Notes

1. Three other historical films released in 1982 were Jan Troell's *Ingenjör Andrés luftfärd* (The Flight of the Eagle), Hans Alfredson's *Den enfaldige mördaren* (The Simple-Minded Murderer) and Anja Breien's *Förföljelsen* (Witch Hunt), the latter a Swedish-Norwegian co-production. For an introduction to Swedish film in the 1980s see Bono and Koskinen 1996. Notably, the expensive historical film comedy *Sverige åt svenskarna* (The Battle of Sweden), Europa Film, 1980), which was compared with Monty Python, was a commercial disaster.
2. People mostly meet history in popular forms, which are rarely updated with the latest research. Cf. Roy Rosenzweig and David Thelen, *The Presence of the Past*, New York: Columbia University Press, 1998; David Ludvigsson, *The Historian-Filmmaker's Dilemma*, Uppsala: University of Uppsala no. 210, 2003.
3. Gustaf Cederström's painting is now in Nationalmuseum in Stockholm (Ludvigsson 2003: 200).
4. *Nisse Hults historiska snedsteg*, SVT1, 2 November 2006.
5. Interview with Bosse Jonsson, 18 May 2006. Cf. programme on SVT, 5 June 1984. Notably, in an early script version frequent usage was made of a voice-over narrator, which was later abandoned. Swedish Film Institute, M2484 (Kalabaliken i Bender, Script II).
6. Interview with Bosse Jonsson, 18 May 2006.
7. The numbers are given by Lasse Åberg in a television interview on SVT, 5 June 1984.
8. The character Papphammar appeared in *Från och med herr Gunnar Papphammar* (TV series 1980, movie 1981). Mats Arehn, who directed the series/film, also directed *Kalabalik*.
9. Preparation of teeth is shown in the SVT programme, 5 June 1984.
10. Axel Sparre's portrait of the king was made in 1712 (cf. Strömbom 1943: 372f).
11. In an early script version, the dwarf – and a 'giant' – featured in several scenes, indicating absurd elements were central to the filmmakers' vision. Swedish Film Institute, M2484 (Kalabaliken i Bender, Script II).
12. This happened to preacher Rhyzelius, who met the king in Lund some years later (quoted in Villius 1993: 179).
13. Letters from Feif to Tessin, and notes from Seigneur A. de la Motraye (quoted in Villius 1993: 136–142).
14. Actually, while Sweden was poor from the long wars, the kingdom was not without resources and certainly did not lack defences, which makes the information in these dialogues exaggerated.
15. Simon Critchley (2002: 36) notes the humorous effect achieved through the overstepping of the boundary between the human and the animal.
16. Historically, women accompanied the Swedish armies and some women will have been present in Bender (cf. Sjöberg 2008). However, this was probably not known to the filmmakers.
17. It should be noted though that some important people, such as Feif and von Müllern, were cut out.
18. Another significant change of person is Hultman, who was Karl XII's personal servant but in the film has been transformed into an artist and officer.
19. There was a historical Lagercrona, an unfortunate soldier who failed to gather enough food for the army and therefore indirectly forced it into the battle of Poltava. In a sense, therefore, the portrait of Lagercrona as an old failed officer seems sensible. But only experts could make this connection.
20. If it were not for the other soldiers and the scenes of serious action, *Kalabalik* could be considered a generic parody on the war film; another historical generic parody is the parody Western *Blazing Saddles* (1974) (cf. Neale and Krutnik 1990: 18).

21. In an early script version, he explicitly says that he studied at university from the age of eight. Swedish Film Institute, M2484 (Kalabaliken i Bender, Script II), scene 25.
22. In an early script version, this gag continues in another scene, when Kruus drinks the liquor and, incidentally, the large insect with it. Swedish Film Institute, M2484 (Kalabaliken i Bender, Script II), scenes 30, 83–84.
23. Letter from Tore Frängsmyr, 19 May 2006.
24. The Skragge role is played by actor Nils Ahlroth, who was very popular at the time. This confirms the filmmakers' ambition to populate the film with big names as to draw a large audience, and thus confirms the idea of *Kalabalik* as Swedish high concept.
25. In an early script version of this scene, Kruus was bare-chested and carried the princess on his shoulders, her skirt falling over his eyes. Swedish Film Institute, M2484 (Kalabaliken i Bender, Script II), scene 78. Another detail from the same scene is that one of the soldiers should fall from the bridge. While this was omitted, it explains why the soldier disappeared. Cf. SVT programme on 5 June 1984.
26. Neale and Krutnik (1990: 32) suggest that comedy is a prime site for all unlikely actions.
27. Producer Jonsson says the crayfish and stuffed cabbage roll were put into the film because of modern immigration from Turkey to Sweden, as a means to emphasize historical ties between the countries. Interview with Bosse Jonsson, 18 May 2006.
28. There is a political-cultural resonance in this act of solidarity, typical of the '68 generation that made the film.
29. The end is a visual reminder of the Western stereotype, for example in *Stagecoach* (1939).

Bibliography

Åhlander, Lars, 'Kalabaliken i Bender' in *Svensk Filmografi 8, 1980–1989*, Stockholm: Swedish Film Institute, 1997.

Badsey, Stephen, 'Blackadder Goes Forth and the "Two Western Fronts" Debate' in Graham Roberts and Philip M Taylor (eds) *The Historian, Television and Television History*, Luton: University of Luton Press, 2001, pp. 113–125.

Bono, Francesco and Koskinen, Maaret (eds), *Swedish Film Today*, Stockholm: Svenska Institutet, 1996.

Bordwell, David, Staiger, Janet and Thompson, Kristin, *The Classical Hollywood Cinema*, London: Routledge, 1985.

Critchley, Simon, *On Humour*, London: Routledge, 2002.

Ericsson, Peter, *Stora nordiska kriget förklarat*, Uppsala: Studia Historica Upsaliensia no. 202, 2002.

From, Peter, *Karl XII:s död*, Lund: Historiska media, 2005.

Furhammar, Leif, *Filmen i Sverige*, Stockholm: Swedish Film Institute, 1991.

Gustafsson, Tommy, 'Nationell ära och manlighet i Karl XII (1925)', *Scandia*, 71:1 (2005), pp. 46–76.

Lindegren, Jan, 'Karl XII' in Anders Florén et al., *Kungar och krigare*, Stockholm: Atlantis, 1992.

Lindegren, Jan, 'Men, Money, and Means' in Philippe Contamine (ed.) *War and Competition between States*, Oxford: Clarendon Press, 2000.

Linderborg, Åsa, *Socialdemokraterna skriver historia*, Stockholm: Atlas, 2001.

Ludvigsson, David, *The Historian-Filmmaker's Dilemma: Historical Documentaries in Sweden in the Era of Häger and Villius*, Uppsala: University of Uppsala, 2003.

Marklund, Anders, *Upplevelser av svensk film*, Lund: Critica Litterarum Lundensis 7, 2004.

Neale, Steve and Krutnik, Frank, *Popular Film and Television Comedy*, London: Routledge, 1990.

Palmer, Jerry, *The Logic of the Absurd: On Film and Television Comedy*, London: BFI Publishing, 1987.

Rosenstone, Robert A., *Visions of the Past: The Challenge of Film to our Idea of History*, Cambridge: Harvard University Press, 1995.

Qvist, Per Olov, *Folkhemmets bilder*, Lund: Arkiv, 1995.

Seidman, Steve, *Comedian Comedy*, Ann Arbor: UMI, 1981.

Sjöberg, Maria, *Kvinnor i fält 1550–1850*, Hedemora: Gidlunds, 2008.

Stafsing, Ivar, *Kalabaliken vid Bender*, Stockholm: Gothia, 1960.

Strömbom, Sixten, *Index över svenska kungliga porträtt*, Stockholm: Nordisk fotogravyr, 1943.

Toplin, Robert Brent, *Reel History: In Defense of Hollywood*, Lawrence: Kansas University Press, 2002.

Upström, Rolf, *Mysteriet Karl XII:s död*, Gothenburg: Dept of History, 1994.

Villius, Hans (ed.), *Karl XII*, Stockholm: Wahlström & Widstrand, 1993 (1960).

Wyatt, Justin, *High Concept: Movies and Marketing in Hollywood*, Austin: University of Texas Press, 1994.

Zander, Ulf, *Fornstora dagar, moderna tider*, Lund: Nordic Academic Press, 2001.

Chapter 4

From Ideal Husbands to Berserk Gargoyles: A Survey of Period Comedies Representing the British Past in the 1950s and 1960s

Harri Kilpi, University of Helsinki

Introduction

One of the treats offered to the picturegoers in Britain in 1948 was Alexander Korda's adaptation of Oscar Wilde's *An Ideal Husband* (Korda, 1948).[1] The film did fairly well at the box office (*Kine Weekly* (hereafter *KW*, 16 December 1948: 15) with its upper-class idioms and aristocratic costumes, wit, eloquence and understatement. Nearly twenty years later, *The Amorous Adventures of Moll Flanders* (1965) – a 'Defoe-inspired saga of sin and sex' – took up a different literary classic and brought chirpy prostitutes, their travails and a whole 'Rollicking Story of a Ribald Century That Really Should Have Been Ashamed of Itself' (*KW*, 12 November 1964: 11; 17 June 1965: 47) to the screen with aplomb that would have been unimaginable in the late 1940s. Not only did the films like *Moll Flanders* re-introduce to the film culture the bawdiness and sexual innuendo of old classic British period comedies, such as *The Private Life of Henry VIII* (Korda, 1933) and *Nell Gwyn* (Wilcox, 1934), they also took it much further in terms of cleavage, nudity, innuendo and socio-cultural irreverence. What had happened to the comic representations of the British past in the intervening period between *An Ideal Husband* and *Moll Flanders*? What kinds of comic histories were on offer to the British audiences in these two decades?

In this article I will provide a survey of the period comedies released in Britain in the 1950s and the 1960s. Space does not allow for a full analysis of the production contexts, national backgrounds and differences and authorial or industrial intentions, which is why the approach will remain descriptive and synoptic. The main goal is to chart the overall landscape of comic representation of the British past and give a sense of its multifaceted richness.

Survey Criteria

In the research of the history of historical and period films that depict the British past, the silent cinema, 1930s and 1940s and the era after 1980 have been well covered. The intervening period, however, while thoroughly researched in terms of overall British film culture, has not yet been charted in terms of these genres. Thus, the survey period will run from the end of the World War II to the end of the 1960s.

As for genre, a working definition of a period comedy is needed. Like the contributors of *British Historical Cinema*, I want to emphasize 'the *multiplicity* of period film genres and the distinctions between them', to 'resist the blanket use of the term "historical film" as a

catch-all genre label' and to 'move towards a more complex and less reductive mapping of "films set in the past"' (Monk and Sargeant 2002: 3). Both films based on real events and on fictional narratives are therefore included in my survey.

How far is the past, then? Here, this rather arbitrary limit is set at the onset of World War I, and all comic narratives set before that qualify. Furthermore, the film has to deal extensively with British history, that is, it is set either in the United Kingdom or in the Empire or both, and concerns predominantly British main characters. Only films made in the English language, be they British or American made, have been included. This inclusion is not meant to suggest that the differences in size, approach and traditions that exist between British and American film cultures and industries can be overlooked or disregarded. What it seeks to do is simply to lay out the composition of the comic representation of the British past in its entirety, which is why Hollywood's contribution cannot be excluded.

Only feature-length films have been accepted, the minimum being as low as 60 minutes, due to the rich and varied nature of the 1950s film culture. Finally, the film has to be comical in nature. While Marcia Landy defines comedy simply as a genre (1991: 329), other researchers such as Andy Medhurst point out the complex and vague nature of comedy. Comedy can be seen as a 'jumble of texts and pleasures' that span a number of genres, evolve over time and through cultural change and evade definition (2007: 9–25; see also Dacre 2009). With this in mind, my survey of comedies within the specific environment of the period film understands comedy as a mode of expression that can be applied to an array of narratives, ranging from literary adaptations and musicals to genre parodies. Therefore, any film that fulfils all the other criteria and has a formal and narrative system that is intentionally and primarily constructed to cue laughter in the audiences, for whatever reason (comedy of manners, satire, parody, situation comedy, etc.), is a period comedy relevant to this survey.

With these criteria in mind I have examined Dennis Gifford's *British Film Catalogue* (1986) for these years. However, in order to include also American films, I have also gone through all issues of two key sources on British film culture – *Kinematograph Weekly* and *Monthly Film Bulletin* – for the most of the period. I have examined all issues of *Kinematograph (or Kine) Weekly* (1000+ issues) and *Monthly Film Bulletin* (240 issues) for 1950–1970. For the years 1945–1949 I have checked *Kine Weekly's* annual box-office reports and monthly trade show listings while otherwise I have relied on secondary sources as regards these years. *Kine Weekly* was the central publication of the British film industry and provides illuminating access not only to most of the films on release and their reviews but also to crucial debates of the post-war era and to changing organization and mindset of the industry. Magazine's annual box-office survey was impressionistic and based on vaguely defined and changing categories, but since it is the only one around for the whole span of this period it is indispensable. *Kine Weekly's* terminology is introduced in Tables 1 and 2. *Monthly Film Bulletin*, published by the British Film Institute, was on its part a review magazine by and for film buffs and connoisseurs but also one that tended to cover most of the films on offer.

From these sources a comprehensive survey of period comedies on release in Britain during the post-war decades can be extracted. In what follows I will first examine some of

the general features of the body of period comedies and then provide a more detailed look at the films in two chronological batches. Although I will emphasize the most successful films I will also propose how period comedies might be grouped according to loose family-resemblant features that mutate over time and respond to the cultural and economic constraints in their environment (see Altman 1999; Neale 2000).

General Features of Period Comedies 1945–1970

Based on the examination of the sources mentioned above, at least 40 period comedies depicting the British past were released during the era stretching from the end of the war to 1970. As probably could be expected the films did not spread out evenly across the timeline. Instead they form a distinctive tripartite picture about the development of the comic representation of British history during the post-war era. First, a fairly continuous batch of 22 films was released during the years between 1945 and 1957 inclusive. Second, there is a four-year gap between 1958 and 1961 when no period comedies are on offer. Again, it deserves to be mentioned that comic histories dealing with European, non-European or Ruritanian pasts might have been on release while the British past, which is relevant here, were not. Third, the period comedy returns to the screens during the 1960s (1962–1970) with eighteen films.

Furthermore, both the first and the third phases present varied approaches to comedy and the past, so much so that it is necessary to break both groups into smaller subsections or subcycles. In the case of early 1950s these include the comedy of manners, episodic comedy and farce, and generic parody, all constructing their pasts and laughs in slightly different ways. As for the 1960s, the bulk of the period comedy consists of spectacular, universal comedies, period sex comedies and again generic parodies.

The first and the third phases are also characterized by certain, dominant kind of ideological tendencies that span all the subcycles. In the early 1950s, conservative caution, relative reverence, gentle satire and inclusive all-family appeal come across as dominating features of period comedy, an interpretation that is further supported by the overwhelmingly consistent U-certificate profile of the group.

After the reappearance of the period comedies in 1962, however, their overall ideological composition seems different, more varied. Although the conservative element is to some extent reproduced in the spectacular roadshows, a powerful, and I would argue dominant, sense of the past as a place of carnival, carefree sexual licence and disrespectful ridicule of the anachronistic and/or corrupt authority figures is (re-)introduced to the comic representations of the past via generic parodies but mostly via numerous and daring period sex comedies. This content is reflected in the censorship profile, which in a marked contrast to the early 1950s, is now dominated by A and X certificates. Therefore, it can be argued that the comic representation went through a considerable change as it developed from the 1950s to the 1960s.

Tasteful Laughs at the Past with the Aristocracy and the Middle Classes: Period Comedies 1945–1957

In this section I will introduce the first batch of films released between 1945 and 1957. These films are listed with additional details in Table 1.

Table 1: Period Comedies Released in Britain, 1945–1957

Year	Title	Country	Prod. Comp	Director	Cert.	B-O
1947	When You Come Home	UK	Butcher's Film Service	John Baxter	U	
1947	The Ghosts of Berkeley Square	UK	British National	Vernon Sewell	A	
1948	An Ideal Husband	UK	London Films	A. Korda	A	KWrup
1949	The Cardboard Cavalier	UK	2 Cities Rank	Walter Forde	U	
1949	Kind Hearts and Coronets	UK	Ealing	Hamer	A	
1949	Yankee in King Arthur's Court, A	US	Paramount		U	KWona
1950	Double Crossbones	US	Univ.-Int.	Charles R. Barton	U	
1952	Soldiers Three	US	MGM	Tay Garnett	U	KWomm
1952	The Card	UK	BFM	Ronald Neame	U	KWona
1952	The Importance of Being Earnest	UK	BFM, Javelin, 2 Cities	Anthony Asquith	U	KWona
1952	The Pickwick Papers	UK	Renown	Noel Langley	U	KWona
1952	Isn't Life Wonderful!	UK	ABPC	Harold French	U	
1952	The Beggar's Opera	UK	Imperadio	Peter Brook	U	
1952	John of the Fair	UK	Merton Park	Michael McCarthy	U	
1952	Where's Charley?	US	Warner Bros.	David Butler	U	
1953	The Million Pound Note	UK	Group	Ronald Neame	U	
1953	Hobson's Choice	UK	London Films, BLPA	David Lean	U	KWomm
1954	The Man Who Loved Redheads	UK	British Lion	Harold French	A	
1955	The Court Jester	US	Dena / Paramount	Norman Panama, Melvin Frank	U	KWomm
1956	Three Men in a Boat	UK	Remus	Ken Annakin	U	KWoim
1957	The Admirable Crichton	UK	Modern Screenplays	Lewis Gilbert	U	KWoim
1957	Truth about Women	UK	Beaconsfield	Muriel Box	A	

Terminology is adapted from *KW*. The abbreviations are as follows: 'rup' = runner-up; 'ona' = other notable attraction; 'omm' = other money-maker; 'oim' = film was listed in 'others in the money' category. None of the films in this batch qualified for *KW*'s highest category of a 'winner'.

Even within this short period the annual distribution of films is remarkably uneven. The year figures refer to the year of the film's production as quoted by *Monthly Film Bulletin*, which is the only constant and coherent source spanning the whole research period for all films considered here. Therefore, what appears to be a massive cluster of period comedies in the year 1952 alone, was in reality more evenly spread over 1952 and 1953 in terms of their actual release dates. *KW* lists release dates only for about 75 per cent of the films in this sample, while Gifford (1986) excludes all American films, which are included in my sample.

Nevertheless, these years seem to be not only productive but also the most prosperous ones in the box office: over a half of the period comedy hits registered in *Kine Weekly*'s annual surveys are from 1952 or 1953. Generally, the cycle seems to have been fairly successful with almost a half of its films reaching the status of a minor hit. One factor contributing to this outcome could be the consistently inclusive censorship profile – 'U' for universal access – which enabled the distributors and exhibitors to target the whole range of cinemagoers in their advertising and programming. Since this certificate sets certain limitations for the film's content interesting questions emerge: what kind of comedy and the representations of the past provide for this profile? What is emphasized and what is excluded?

Five films, three of which can be seen as generic parodies, were made by American companies, the rest were domestic productions. As for the source texts, almost a half of the period comedies were adapted from popular and classic literature or drama. Writers, such as Oscar Wilde (*An Ideal Husband, The Importance of Being Earnest*), Charles Dickens (*The Pickwick Papers*), Mark Twain (*The Million Pound Note*), Rudyard Kipling (*Soldiers Three*), John Gay (*The Beggar's Opera*), Harold Brighouse (*Hobson's Choice*) and J.M. Barrie (*The Admirable Crichton*) presented the filmmakers and marketers with pre-sold materials already familiar with the audiences and, in the case of classics, gave an added cultural prestige to the productions. The choice of Victorian and Edwardian source texts for several films means that these periods dominate the comic portrayal of British past; only generic parodies and *The Beggar's Opera* deal with more distant periods.

Although literature has been utilized in other periods as well, I would argue that in the late 1940s and the early 1950s the chosen texts and their subsequent adaptation tends to concentrate in a specific fashion around three general themes or modes of comedy. Furthermore, all modes seek to maintain an atmosphere of light-hearted decency compatible with their censorship certificate.

Comedy of Manners

The first cluster of films engage in lightly satirical comedy of manners of usually upper-class idiosyncrasies. Two Wilde adaptations, *An Ideal Husband* and *The Importance of Being Earnest* are the prime examples of this approach. In addition to depicting the past as sumptuous costume and prop spectacles, they also treat the original texts with faithful accuracy and reverence. There are no significant departures from the plays nor are there any

conscious attempts at hinting towards possible contemporary connotations of Wilde's satire of the aristocratic customs and habitus.

Although less refined in terms of its literary pedigree *Isn't Life Wonderful!* caricatures the upper-middle-class eccentricity and plays it for laughs, all wrapped around a loose narrative of courtship. The past constructed here is indeed wonderful in the perpetually sunny and green environs of a large country house. One could argue that it borders on self-satisfaction and obnoxiousness, qualities seemingly embodied in Cecil Parker's central father character. Although a few class-flavoured quips are allowed at his expense (courtesy of the pragmatic gardener), the mannerisms and slapstick always remain gentle, managing only to make the grumpy and thrifty father shift his habitus into a more benevolent one. Although a musical, Warner Bros' *Where's Charley?* can be also viewed as an affiliate of the period comedy and a comedy of manners. This due to the film's Oxford locations and upper-middle-class protagonists engaged in romances much in the same general fashion as the films mentioned above.

Following David Bordwell's terminology these films could be called the central or prototypical cases of comedy of manners, while the rest of the group appears more peripheral and generically mixed (1988: 148). They also introduce minor, yet recognizable themes of subversion or social critique to their picture of the past. In Ealing's *Kind Hearts and Coronets*, the handling of the noble D'Ascoyne family and its eccentricities veers towards black humour as an ambitious heir Louis Mazzini proceeds to kill all the relatives that stand above him in the line of family and inheritance. Although the D'Ascoynes, all except Louis played by Alec Guinness, could be seen as commentary on the stagnant and backward nature of the aristocracy, the schism in the film is totally within that class and does not seem to concern or connect to other classes and the rest of the society of the period.

Released eight years later, *The Admirable Crichton* ventures into this territory. The story pits the hapless and helpless aristocratic family onto a desert island where they can only survive thanks to their resourceful butler Crichton and their other servants. By the end of the film, the professional skills have comprehensively prevailed over birth-rights, privileges and idleness as to make the latter look totally obsolete (see Lacey 2003). *The Million Pound Note* approaches and criticizes the high society, its wealth and customs from a different angle. Comedy rises from the fact that a poor sailor with no connections or education and armed only with a million pound note, suddenly gets access to all areas of power and riches. Although it satirized the money-induced sycophancy to satisfying effect, it did not win hit audiences to its side.

Towards the end of the 1950s, themes relating to sexuality start to spice up the past depicted in comedies of manners in ways that differ from the usual, eloquently framed routines of courtship. An autobiographical story of an upper-middle-class womanizer and his pre- and extramarital sexual exploits were themes deployed in two period comedies *The Man Who Loved Redheads* and *The Truth about Women*. However, neither figured in *Kine Weekly*'s annual box-office survey, even though the latter employed the talents and charisma of such rising stars as Laurence Harvey and Diane Cilento.

Therefore, the double guises of the past and comedy could be used to gently criticize the class structure and moneyed power-elites and to add new and less attractive attributes to their representation. However, the comedy of manners was mostly preoccupied with the spectacle, the bygone grandeur of the aristocracy and the harmless, 'good-hearted' fun with which it poked and only occasionally pricked that grandeur.

Loose Generic Parodies

Four period comedies contain enough converging elements to be called loose generic parodies. In these films the comedy arises from the humorous commentary of generic and clicheic ways other period genres construct their narratives and views of the past. In Two Cities' *Cardboard Cavalier* Margaret Lockwood of Gainsborough fame plays Nell Gwynne, the king's mistress, while the music hall legend Sid Field's barrow boy rises to the occasion and overthrows Cromwell and his cronies, poking fun at the pomp and circumstance of the 'proper' historical film in the process.

American comic vision of the British past in the early 1950s is most notable in generic parodies. Universal-International's *Double Crossbones* played the tropes of pirate and sea adventure for laughs, while *The Court Jester* made by Paramount handled the swashbucklers, the most successful form of the period film in the early 1950s (Kilpi 2006: 51, 96–98) with similar disrespect. Starring Danny Kaye, Cecil Parker and Angela Lansbury in a suitably overdriven mood, this 'Arthurian' film, complete with convoluted romances and fighting

Hank Martin (Bing Crosby) and Sir Sagramore (William Bendix) in *A Yankee in King Arthur's Court* (Paramount Pictures, 1949).

dwarfs, sent up the clichés, solemnities and social tropes of chivalry and pageantry with a refreshing efficiency. The group is topped by *A Yankee in King Arthur's Court* (also by Paramount), which stretched the representation of the past even further by introducing Bing Crosby to the court of Camelot via time travel. Despite these glaring discrepancies with history, the generic mishmash of musical, swashbuckler, generic parody and star vehicle seen in these films was relatively successful: both *Yankee in King Arthur's Court* and *The Court Jester* were registered as minor hits in *Kine Weekly*'s box-office round-ups.

Episodic Comedy and Farce

In the next five films, the past diegesis is more or less characterized by episodic narratives and slapstick farce. They also differ from the comedies of manners in that they focus on middle- and working-class characters rather than the upper-(middle) class. Epitomizing this cluster of films, *The Pickwick Papers* was dominated by the episodic antics of a group of males. Adapted from Dickens' sprawling novel the main characters roam around Southern England in picaresque fashion, stumbling from one situation to another. Although the funny adventures and the perennial comic problem of marriage dominate the plot, there is also a nod towards the darker side of the past during the scenes within the debtor's prison. In a similar vein *The Card*, which depicts a rags-to-riches story in a Northern industrial town, presents a brief and gently satirical cross-section of society from working-class austerity to aristocratic ballrooms. Despite this sociological tour, however, most of the screen time was devoted to the entrepreneurial middle class, the virtues of which the main protagonist comes to embody (see O'Sullivan 2002).

Such themes are absent from *Three Men in a Boat*, which recounts the accident-prone boat trip of three men seeking refuge from the drudgery of work and marriage. Slapstick is continuous as is their nervous and disastrous flirtation with women – themes which seem to have outsold the men-of-the-world of the light satire. Alternatively, the episodes could be spread over a far wider time span and give the past a supernatural tinge. *The Ghosts of Berkeley Square* follows the ghosts of two army officers who haunt the same house and its changing tenants from the eighteenth century to the present. As with the comedy of manners, the attractions of the past as well as comedy arises from the decorous sets and costumes and the colourful, varied and inept characters that use them.

Finally, *Hobson's Choice*, David Lean's multiple award-winning adaptation of Brighouse's play about a tyrannical shop-owner, was less episodic in its composition, but like other films in the category, relied on caricatures. Although Charles Laughton's virtuoso but near-grotesque performance as Mr Hobson threatens to subvert the film into a farce, and although its broad ideological lines are, in the end, conformist, it still presents class and gender resistance and negotiation as plausible and as having positive results (Landy 1991: 326–327). In effect, comedy can open up pockets of dissent in otherwise conservative tapestry of the past.

Charles Laughton in David Lean's *Hobson's Choice* (London Film Productions, 1953).

Other Period Comedies

The remaining four films defy even the rather loose groupings suggested above. For example, MGM's *Soldiers Three* takes up some of the tropes of the armed forces comedy and applies them to the subject matter of Edwardian British empire adventure. Based on Gay and Brecht, *The Beggar's Opera* constructs a musical out of the dangerous, yet raunchy lives of the merry outlaws and prostitutes – without forgetting the basic 'decency' implied by the film's U certificate. A film aimed at child audiences, *John of the Fair* follows a young boy John in an episodic tale set in an eighteenth century fairground. In contrast, *When You Come Home*, starring raucous Frank Randle as himself, deploys more adult content as it recounts Frank's exploits as a cheeky and naughty music hall star in the Edwardian era. However, even in this context the content was toned down so that a U certificate could be secured.

Unlike in the comedies of manners, the pasts seen in episodic comedies and slapstick farces tended to focus on more middle-class and to a lesser extent on working- and under-class protagonists. However, just like the narratives about the upper class, the comedy arises from the caricatured portrayal of courtship, flirtation, marriage and slapstick situations involving exaggerated eccentric characters. On the one hand, these features are the age-old functions of comedy, but on the other hand, in a manner specific to the early 1950s, they are carefully controlled and not allowed to cross into subversion and too hard or cynical criticism of the institutions, such as marriage. With the exception of *The Beggar's Opera*, sex and sexuality seem to be repressed even more tightly as compared to the light satires and are associated with dread, nervousness and ridiculous sure-fire failure.

Although the parodies did subvert and ridicule some ossified conventions used in representing the past, they tended to target genres which were relatively light-hearted and stylized to begin with, such as the historical adventures, and to exaggerate those features for laughs rather than picking them apart in critical or satiric fashion. At the same time, the U certificate and inclusive family atmosphere ensure that nothing too critical, subversive or adult-minded is slipped in the semantic mixture. In any case, period parodies managed to reach two minor hits at the box office. The most popular period comedies were the straightforward satires of the aristocracy and middle-class episodic comedies and farces.

The Gap Years: 1958–1961

After 1953, the flow of period comedies becomes a trickle, which peters out after 1957 and does not revive until 1962. Although no period comedies depicting the British past were released in the late 1950s, and although the era was bleak for cinematic portrayal of British history in general as compared to the early 1950s, it was by no means completely dead and without innovation. In particular, Hammer Films revitalized the representation of the British past with period horror films set in 'dislocated but quintessentially Victorian Gothic hinterland' (Meikle 1996: xiii) and sprinkled with bright Eastmancolor blood. Although sexuality referred to in these films was still associated with unease, horror and evil (Harper and Porter 2003: 139–140), it was frequently made thrilling and exciting as well, as evidenced in two box-office winners, *Dracula* (Terence Fisher, 1958) and *The Mummy* (Fisher, 1959), both X certificate.

Similar shifts were taking places in other genres as well. The dearth of period comedies coincides with the emergence and the brief blossoming of the British New Wave and social realist aesthetics in general during the years between 1958 and 1963, usually seen as bookended by *Room at the Top* (Jack Clayton, 1958) and *This Sporting Life* (Lindsay Anderson, 1963) (Hutchings 2009). Even though these films were in many ways antithetical to Hammer horrors – they tended to deal with contemporary social problems, settings and characters in serious or angry fashion – they, too, engaged in forthright portrayal of sexuality, thus contributing to the changing climate of censorship and tolerance. However, the New Wave had all but fizzled out by the mid-1960s, giving way to more fanciful and fantastic films cycles – period comedies being one of them (Murphy 1992: 23–26, 37; Walker 1974: 145–167).

Towards Bawdy, Irreverent Past: The Diversification of Period Comedies 1962–1970

The revival of period comedies that depict British pasts began conventionally enough. Released in 1962, *The Girl on the Boat* (1962), adapted from a novel by P.G. Wodehouse, tried to resuscitate the career of comedian Norman Wisdom, whose contemporary roles in Rank

Corporation's films had made him a household name in the 1950s. Although transported into the past and upgraded into aristocracy, his puerile, happy-go-lucky antics did not turn into box-office gold as something new and more daring was expected by the ever more youthful audiences. Eighteen period comedies, which were released in the 1960s responded to this demand by supplying a group of films which was again varied, yet significantly different from those of the early 1950s. The films are listed in Table 2 below.

Generally, the films are distributed more evenly throughout the period as compared to the early 1950s. The cycle seems to have been quite popular as well; nearly two-thirds of the films were registered at *Kine Weekly*'s annual surveys. The box-office success, however, is clearly located in the first half of the era; the only 'winner' hit of the latter half is *Carry On … Up the Khyber*. In contrast, there are four 'winners' in the years 1963, 1964 and 1965 – two

Table 2: Period Comedies Released in Britain, 1962–1970

Year	*Title*	*Country*	*Prod. Comp*	*Director*	*Cert.*	*B-O*
1962	*The Girl on the Boat*	UK	Knightsbridge	Ken Annakin	U	KWoim
1962	*The Waltz of the Toreadors*	UK	Independent Artists	John Guillermin	X	KWomm
1963	*Tom Jones*	UK	Woodfall	Tony Richardson	X	KWwin
1964	*Carry On, Jack!*	UK	Adder	Gerald Thomas	A	KWomm
1964	*My Fair Lady*	US	Warner Bros	George Cukor	U	KWwin
1964	*Mary Poppins*	US	Disney	Robert Stevenson	U	KWwin
1965	*The Amorous Adventures of Moll Flanders*	UK	Winchester	Terence Young	X	KWomm
1965	*Those Magnificent Men in Their Flying Machines*	UK	20th Century Fox	Ken Annakin	U	KWwin
1965	*Fanny Hill – Memoirs of Woman of Pleasure*	US	Famous Players	Russ Meyer	A	
1966	*The Wrong Box*	UK	Salamander	Bryan Forbes	U	KWbor
1966	*Don't Lose Your Head*	UK	Adder	Gerald Thomas	A	
1967	*Jules Verne's Rocket to the Moon*	UK	Jules Verne ltd	Don Sharp	U	
1967	*King's Pirate*	US	Universal	Don Weis	U	
1968	*Assassination Bureau*	UK	Heathfield / Param.	Basil Dearden	A	
1968	*Sinful Davey*	UK	Mirisch / Webb	John Huston	A	
1968	*Carry On … Up the Khyber*	UK	Adder	Gerald Thomas	A	KWwin
1968	*The Best House in London*	UK	Bridge Films	Philip Saville	X	KWbor
1969	*Lock Up Your Daughters!*	UK	Domino	Peter Coe	X	KWbor

Terminology as in Table 1, with following additions: 'win' = a box-office winner; 'bor' = film was listed in 'best of the rest' category.

American roadshows, one American runaway production and one British surprise hit, *Tom Jones* – and four lesser hits. The most important pattern, however, is found in the certificate column. While the early 1950s was almost exclusively dominated by the U films, in the 1960s eleven films out of eighteen carry the A and X certificates. This indicates a clear shift in the content of the films and changes in the comic representation of the past.

Yet one feature spanning the group seems unchanged. With well over a half of the films based on old or contemporary classics, literary adaptation is still a major source for period comedy. From Jean Anouilh (*The Waltz of the Toreadors*) to George Bernard Shaw (*My Fair Lady*), from John Cleland (*Fanny Hill*) to Robert Louis Stevenson (*The Wrong Box*) all kinds of literature or previous adaptations are marshalled into action in order to create amusing images out of history. What had changed in the handling of the adaptations and the period comedy material in general? What kind of content had brought about the new censorship profile? To answer these questions, it seems reasonable to divide the films into three loose, family-resemblant groups: universal attractions such as large roadshow presentations, A- and X-certified sex comedies and genre parodies.

Spectacular Road-Shows and Other Universal Attractions

As the example of *The Girl on the Boat* attests, not all period comedies suddenly turned into bawdy romps. The past as nostalgic, old-fashioned entertainment for the whole family was alive and well, and evident in three large-scale and very successful roadshow presentations. It is in these films where Hollywood's financial muscle, rediscovered taste for spectacle and glossy finish make their clearest mark on the period comedy of the 1950s and 1960s.

The first of these was Disney's blockbusting children's musical *Mary Poppins*, which starred Julie Andrews as the magical nanny for a London family before World War I. The past is again structured around a well-off upper-middle-class family, to which Mary signifies a selfless, flawless servant and dedicated surrogate mother (Babington 2001: 192, 194, 202–203). Other, less wealthy denizens of London, such as Dick van Dyke's cockney chimney sweeper, conjure up a past society in which cheery, tap-dancing and happy working class is contrasted with boring middle-class formality. According to *Kine Weekly*, the film was so popular, that it inspired carnival numbers and hairstyles and contributed to a revival of general interest in Edwardiana (*KW*, 3 September 1964: 19; 5 August 1965: 23).

A stylized Edwardian London is the set for a fairy tale riven with class issues in Warner Bros' *My Fair Lady*, which was based on a stage version of G.B. Shaw's *Pygmalion*. A middle-aged linguist (Rex Harrison) tries to educate a working-class flower girl Eliza (Audrey Hepburn) to speak with Received Pronunciation and act 'properly'. The bi-polarity of these two classes is confronted repeatedly in speech, dress, manners, world-views, types of songs and environments. Through the leadership of Stanley Holloway, who plays Eliza's father, the working class emerges as funny, cunning and relaxed, but also as uneducated and rough. Harrison as the frontispiece of high society is rich and cultured, but also liable to satire

because of his immersion in science and his rigid adherence to the behavioural codes of the upper and middle classes. As a further twist, the appearances of Hepburn in shining white costumes and gorgeous hats connect easily with the modern, glamorous, urban upper-middle-class haute couture chic she had helped to create from *Roman Holiday* (William Wyler, 1953) to *Breakfast at Tiffany's* (Blake Edwards, 1961) (see: *KW*, 7 May 1964: 40; 17 December 1964: 22; 7 January 1965: 16; 17 June 1965: 14), thereby mixing the class status of Eliza, and introducing intriguing anachronisms into the film's depiction of the past. The happy rags-to-riches story, whatever its class ambiguities, was a massive world-wide success, and one of the special presentation winners for two years before its equally successful general release (*KW*, 28 January 1965: 10; 4 March 1965: 7).

The third of the roadshow successes, 20th Century Fox's runaway production *Those Magnificent Men in Their Flying Machines* was not a musical, but a lavish attraction predicated on the exotic appeal of antiquated flying machines, comedy surrounding early and clumsy attempts at flight and spectacular aerial photography of Southern England (see *KW*, 25 June 1964: 16–18). On the one hand, given the cost of flight and the social exclusivity that it implies, the film's Britons are exhaustively upper class, from dapper James Fox to the typically caricatured, caddish Terry-Thomas, all quite traditionally depicted. On the other hand, one internationally flavoured gimmick reveals change has happened even in the field of machine nostalgia since the 1950s successes of *Genevieve* (Henry Cornelius, 1953) and *Titfield Thunderbolt* (Charles Crichton, 1953). Irina Demick plays several cameo roles emblematically named as Brigitte, Ingrid, Marlene, Francoise, Yvette and Betty, which together comprise a modest acknowledgment of the more explicit, continental style of sexuality making inroads into the representation of the past on film and into the British film culture in general.

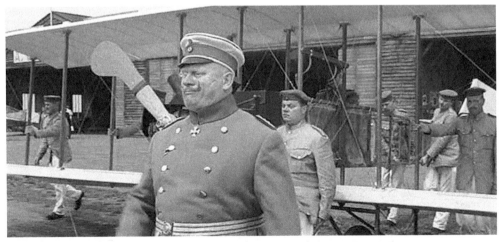

Ken Annakin, *Those Magnificent Men in Their Flying Machines* (Twentieth Century-Fox, 1965).

Three other films with U certificates were less successful. *Jules Verne's Rocket to the Moon* reprised both the technological nostalgia and the upper-middle-class buffoonery of *Those Magnificent Men ...*, but although lot of time and visuals was spent on building a comic past out of the quaint Victorian gadgetry and slapsticky accidents they caused, the film did not repeat the box-office performance of its predecessor. *The Wrong Box* infused R.L. Stevenson's thriller with humorous treatment without significant box-office results, while *Assassination Bureau*, an A-certified story of Edwardian club of murderers, whose humour was 'satiric, ironic, urbane', (Director Basil Dearden quoted in *KW*, 3 February 1968: 16) falls into the periphery of this group as its attractions could be considered more limited than other films with broader, familial appeal.

In many respects the films in this cluster continued the dominating trends of the early 1950s as regards their representation of the British past. They focused mainly on the aristocracy or the upper middle class, kept their satire relatively harmless and aimed their sumptuous visual attractions to the universal (U) familial audiences. However, even in this group the stirrings of change are felt as the roguish and shrewd cockneys re-emerge in *My Fair Lady* and as Demick's multiple continental roles concretize the rising tide of a new, more candid kind of sexuality within the period comedies and in the British film culture.

A- and X-certified Period Sex Comedies

The next group of films are characterized by two distinct features. First, their censorship profile composed of As and Xs, sets them apart from the family comedies. Second, central and frank preoccupation with sexuality and themes close to it, which invite the restrictive certificates, shape and in many cases dominate their content, hence the term 'period sex comedy'. (It should be noted that this term is chosen in order to emphasize the relative

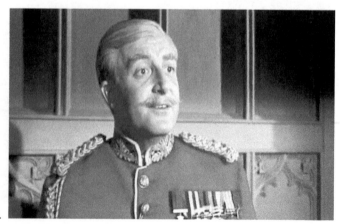

Peter Sellers as General Leo Fitzjohn in John Guillermin's *The Waltz of the Toreadors* (Independent Artists, 1962).

novelty of the sexual frankness in the context of period comedies and that it should not be confused with the cycle of sex comedies of the 1970s, which take sex and nudity to a more explicit level.)

Peter Sellers of the Goon Show and comedy film fame starred in *The Waltz of the Toreadors*, a candid story of an old general's marital and sex life, based on a contemporary play by Jean Anouilh, but set in the Edwardian era. An upper-class country house complete with servants, salons and libraries provides the principal setting – and presumably the class licence – for a narrative that presented an intensified depiction of sexuality when compared with Sellers' earlier films and other comedies of the time (Johnson 1963: 53). Although ending in a rather downbeat fashion – the general does not get to requite his passion towards his French mistress – the film performed well, and was, in *Kine Weekly*'s terms, 'another money-maker'.

This was nothing, however, compared to another combination of a New Wave star, comedy and straightforward sexuality. Albert Finney, known nation-wide as Arthur Seaton of *Saturday Night and Sunday Morning* (Karel Reisz, 1960), took the title role in *Tom Jones*, a picaresque and bawdy adaptation of Henry Fielding's classic novel, directed by another New Wave alumnus, Tony Richardson. The film, in 'which everyone is grimacing and posturing and romping like berserk gargoyles'(*Sunday Express*, 30 June 1963) was released for the summer market in June 1963 in the immediate aftermath of the sex-ridden Argyll and Profumo scandals. The rambling, fast-paced tale of an eighteenth-century rake and bon vivant took off right into the box-office stratosphere and became one of the greatest hits of the decade (Walker 1974, 133–147; Battestin 2002, 88–97; Finler 2003, 359).

One indicator of *Tom Jones*' significance was the number of cinematic spin-offs that it spawned. First among them was the adaptation of Daniel Defoe's classic novel in the form *The Amorous Adventures of Moll Flanders*, made by Winchester. The explicit, X-certified sex garnished Moll's upward social climb from lowly orphan origins to servanthood, and, in the end, to a great inherited wealth at the top level of society. Despite the film's comical nature it is worth noting the relatively large portion of screen time allotted to the lower-class elements such as servants, criminals and prisoners as well as to the plight of a woman in the eighteenth century, which in the earlier 1950s comedies did not receive this much attention. Like all subsequent spin-offs, *Moll Flanders* did not reach the profitable heights of *Tom Jones*, but it still garnered big enough audiences to be considered a 'money-maker'.

Another bawdy, and this time scandal-mired, novel to be adapted was John Cleland's *Fanny Hill*, a life story of an eighteenth-century prostitute. It seems that producer David Pelham's promising plan never came to fruition (*KW*, 4 June 1964: 15), while Albert Zugsmith's and Russ Meyer's American-German *Fanny Hill – Memoirs of Woman of Pleasure*, billed as 'a Female Tom Jones' (see: *KW*, 19 August 1965: 2) was panned by the critics, and originally banned by the BBFC. Although it did not make it to the top of the box office, its novel presentation of farcical nudity and sexploitation style returned at least satisfactory revenues in provincial theatres (see: *KW*, 2 December 1965: 5; Hummings 1966: 137). Other films trying to reproduce the *Tom Jones* formula included John Huston's picaresque romp *Sinful*

Davey and a musical directed by Peter Coe *Lock up Your Daughters!*, which qualified in *Kine Weekly*'s 'best of the rest' category (Richards 1992: 229).

Although clearly less successful than their cyclical predecessor, these films repeated and reworked the past with similar central parameters: hapless, libidinous, yet lovable young men getting into comical trouble with their elders and cuckolded husbands in their chase of young, beautiful, provocatively clad and none-too-reluctant women. In effect, the past that in the 1950s used to centre on reverence and bourgeois decency, shifts in the 1960s towards a jolly and naughty bedroom farce, in the style of Restoration comedy, Rabelais and Boccaccio.

The most extreme example of the tendency within this group of films is Philip Saville's *The Best House in London*, which details the story of a government-sponsored brothel in Victorian London. While this premise might have caught some of the hypocrisy and double standards of the period, the film's portrayal of scantily clad women as taking up prostitution with willingness, joy and gusto provides a striking instance of the late 1960s values and the gender politics of assertive maleness affecting the depiction of the past.

Thus, this group of films embodies and articulates some of the seminal changes in the period film after the hiatus in the late 1950s. In contrast with the happy and relatively innocent, day-dream pasts of the roadshows and the early 1950s period comedies, here the past is a place of hedonistic abandon, of carnevalistic licence, and in much greater degree than in earlier cycles and genres related to the past in this fashion (see e.g. Cook 1996). Sex, previously omitted or only coyly implied, is now perceived as fun and life-affirming (at least for the male protagonists), and it seems to be everywhere, out in the open and available to (almost) all. Historical authority figures, which were gently mocked in the 1950s, are also tied into the sexualized representation of the past. They are usually seen as tiresome and incompetent, irrelevant and ridiculous, mere obsolete obstacles to pleasure, or, as in *Tom Jones*, revealed to be as 'corrupted', 'sinful' and lustful as everybody else.

The strength of these tendencies is further supported by the fact that they were also the part and parcel of the last group of 1960s period comedies, the genre parodies.

A-Certified Genre Parodies

As in the 1950s, more serious period film cycles and their conventions in the depiction of the past were ridiculed also in the 1960s. Although Universal's *King's Pirate* took on the tropes of the pirate adventure and reworked the story of *Against All Flags* in humorous vein, this group of four films is dominated by the British Carry On team and their box-office-worthy genre parodies. The first of the films, *Carry On, Jack!* ridiculed not only the navy, but the conventions of serious historical nautical dramas, such as *Billy Budd* (Peter Ustinov, 1962) and *Mutiny on the Bounty* (Lewis Milestone, 1962). The credit sequence presents a confusing montage of maritime paintings and a medley of Empire-related music. A *tableau vivant* of Nelson's death creates a joke around Hardy's final kiss to the admiral. The solemnity

and grace of the officers is sent up by Kenneth Williams' totally inefficient and effeminate upper-class silly-ass of a captain, while the flogging scene is staged for laughs and ends in a preposterous mess for everyone concerned. Cross-dressing, slapstick, sexual innuendo and constant parody of the stock characters of sea adventure films fill out the rest of this episodic film, in which the heroic efforts of the lower-class crew and their pretence to glory are repeatedly defeated by the cowardly, inept officer-class of the Carry On splinter group and their seemingly random actions (see: Cull 2002: 92–106; Jordan 1983: 316–318).

The same recipe was used in *Don't Lose Your Head*, which targeted the French revolution, the Scarlet Pimpernel novels and their previous adaptations, and in *Carry On … Up the Khyber*, a farcical version of the empire adventures. Both featured heavily caricatured aristocrats (Williams), lecherous heroes (played by Sidney James), frustrated, yet lustful wives (Joan Sims) and several young beauties engaging in the battles of flirtatious wit with the male characters. The fact that the antics in the harem scene involving several nearly naked women deserved only an A certificate reflects the growing casualness and candour with which the British past was represented in the late 1960s.

Epilogue

In the preceding sections I have presented some evidence on the basis of which one can argue that there was a notable change in the comic representation of British past after the four-year interim period in the late 1950s. To present an analysis that would explain these changes in a comprehensive manner would require another essay, which is why I will offer here only some brief, initial suggestions as to the causes of the changes investigated above.

First, the long-term trends affecting the cinema audience continued on the course set in the late 1950s: the overall decline continued while the remaining regular audiences were getting younger. The inclusive, all-family audiences could now be lured to the cinema only with exceptional fares, such as roadshows, which in due course became the flagship of international Hollywood in the 1960s (Krämer 2005: 21–23; Hall 1999: 2–12). In period comedy, this trend is represented by *My Fair Lady* and its like, hugely successful films that carried on some of the ideological baggage of the 1950s.

Second, for the younger patrons, the groundwork laid in the late 1950s with New Wave films, Hammer horrors and other X-rated fares, proved crucial. As A and X certificates gained in respectability and as the late 1950s cycles started to lose their momentum, period comedy, aided and abetted by the phenomenal success of *Tom Jones*, picked up the trend and re-introduced cheeky bawdiness, lewdness and comic disrespect to the portrayal of the British past in a forceful cycle of period sex comedies. As in the 1950s, the period comedy of the 1960s benefited from the simultaneous enhanced visibility and popularity of other kinds of historical films, some of which formed the biggest roadshow attractions of the decade and which the comedies could reference and satirize, as exemplified by the genre parodies. Although U-rated roadshows might have included the biggest singular hits of the period

comedy in the 1960s, the emergence, breadth and sustained success of the carnevalistic, sexualized past constitutes a clear shift in the comic representation of the British past.

Third, several cultural explanations could be suggested for this shift. The thaw in the attitudes towards censorship evidenced in the trials of controversial books and plays, the relaxation in the policy of the BBFC introduced by John Trevelyan, and more open and liberal discourse on sex and sexuality gaining ground in society at large could be mentioned as some of the immediate frameworks that could have affected the popularity of the period sex comedies. On a larger scale, the growing availability of goods, services, leisure and general affluence, and the coming-of-age of the babyboomers born in the late 1940s might have played a role in alienating the audiences from the austerity of the New Wave films on the one hand. Yet, on the other hand, the same trends might have boosted the young segment of the audiences and their lifestyle options, and guided their choice of filmed entertainment towards more spectacular, hedonistic and fantastic fares, thereby contributing to the success of the period sex comedies.

Bibliography

Altman, Rick, *Film/Genre*, London: BFI, 1999.

Babington, Bruce, 'Song, Narrative and the Mother's Voice: A Deepish Reading of Julie Andrews' in Bruce Babington (ed.) *British Stars and Stardom from Alma Taylor to Sean Connery*, Manchester: Manchester University Press, 2001, pp. 192–204.

Battestin, Martin C., 'Adapting *Tom Jones* for Film and Television' in Robert Mayer (ed.) *Eighteenth-Century Fiction on Screen*, Cambridge: Cambridge University Press, 2002, pp. 88–97.

Bordwell, David, *Making Meaning: Inference and Rhetoric in the Interpretation of Cinema*, Cambridge: Harvard University Press, 1988.

Cook, Pam, 'Neither Here nor There: National Identity in Gainsborough Costume Drama' in Andrew Higson (ed.) *Dissolving Views: Key Writings on British Cinema*, London: Cassell, 1996, pp. 51–65.

Cull, Nicholas J., 'Camping on the Borders: History, Identity and Britishness in the Carry On Costume Parodies 1963–74' in Claire Monk and Amy Sargeant (eds) *British Historical Cinema*, London: Routledge, 2002, pp. 92–106.

Dacre, Richard, 'Traditions of British Comedy' in Robert Murphy (ed.), *British Cinema Book*, 3rd edn, London: BFI, 2009, pp. 106–117.

Finler, Joel W., *The Hollywood Story*, London: Wallflower Press, 2003.

Gifford, Denis, *British Film Catalogue*, London: David & Charles, 1986.

Hall, Sheldon, *Hard Ticket Giants: Hollywood Blockbuster in the Widescreen Era*, Norwich: University of East Anglia, Unpublished PhD Thesis, 1999.

Harper, Sue and Porter, Vincent, *British Cinema of the 1950s: The Decline of Deference*, Oxford: Oxford University Press, 2003.

Hill, John, *Sex, Class and Realism: British Cinema 1956–63*, London: BFI, 1997.

Hummings, N., 'The Silence of Fanny Hill', *Sight and Sound*, 35:3 (Summer 1966), p. 137.

Hutchings, Peter, 'Beyond the New Wave: Realism in British Cinema, 1959–63' in Robert Murphy (ed.) *British Cinema Book*, 3rd edn, London: BFI, 2009, pp. 304–312.

Johnson, Ian, 'Have the British a Sense of Humour?', *Films and Filming* 10:3 (March 1963), pp. 48–53.

Jordan, Marion, 'Carry On … Follow That Stereotype' in James Curran and Vincent Porter (eds) *British Cinema History*, London: Weidenfeld and Nicolson, 1983, pp. 312–327.

Kilpi, Harri, *The Representation of the British Past: Class and Change in the Period Film in Britain from 1950 to 1965*, Norwich: University of East Anglia, Unpublished PhD Thesis, 2006.

Kinematograph Weekly, 1950–1970.

Krämer, Peter, *The New Hollywood: From Bonnie and Clyde to Star Wars*, London: Wallflower, 2005.

Lacey, Stephen, 'Too Theatrical by Half? *The Admirable Crichton* and *Look Back in Anger*' in Ian Duncan Mackillop and Neil Sinyard (eds) *British Cinema of the 1950s: A Celebration*, Manchester: Manchester University Press, 2003, pp. 157–167.

Landy, Marcia, *British Genres: Cinema and Society 1930–60*, Oxford: Princeton University Press, 1991.

Landy, Marcia, *Cinematic Uses of the Past*, Minneapolis: University of Minnesota Press, 1996.

Medhurst, Andy, *A National Joke: Popular Comedy and English Cultural Identities*, London: Routledge, 2007.

Meikle, Denis, *A History of Horrors: The Rise and Fall of the House of Hammer*, London: The Scarecrow Press, 1996.

Monk, Claire and Sargeant, Amy, 'Introduction: The Past in British Cinema' in Claire Monk and Amy Sargeant (eds) *British Historical Cinema*, London: Routledge, 2002, pp. 1–14.

Monthly Film Bulletin, 1950–1970.

Murphy, Robert, *Sixties British Cinema*, London: BFI, 1992.

Neale, Steve, *Genre and Hollywood*, London: Routledge, 2000.

O'Sullivan, Tim, '"If the World Does Not Please You, You Can Change It": *The History of Mr. Polly* (1949) and *The Card* (1952)' in Claire Monk and Amy Sargeant (eds) *British Historical Cinema*, London: Routledge, 2002, pp. 66–81.

Porter, Vincent, 'Methodism versus the Marketplace: The Rank Organisation and British Cinema' in Robert Murphy (ed.) *British Cinema Book*, 3rd edn, London: BFI, 2009, pp. 267–275.

Richards, Jeffrey, 'New Waves and Old Myths: British Cinema in the 1960s' in Bart Moore-Gilbert and John Seed (eds) *Cultural Revolution? The Challenge of the Arts in the 1960s*, London: Routledge, 1992, pp. 219–236.

Walker, Alexander, *Hollywood, England: The British Film Industry in the 1960s*, London: Michael Joseph Ltd, 1974.

Note

1. For more details on this and other period comedies, please see Tables 1 and 2.

Chapter 5

Forms of History in Woody Allen

Maurice Yacowar, University of Calgary

'History will dissolve me', Woody Allen declares in *Bananas* (1971), reprising Fidel Castro's revolution. It still well may, but not before Woody gets in his own licks against the past time that refuses to stand still, to stay buried or to stop fattening itself by gobbling down the future. On the contrary, he has managed to harness history. In the 43 very personal films he directed in 43 years his art draws both on his life and his earlier films.

In some ways *Bananas* is typical of the current history implicit in all Allen's films. As he explores always current obsessions, hypocrisies and neuroses an Allen film provides a time capsule of the culture of its day. *Bananas* conveys the sexual insecurities, the student activism, the (pre-Bush) banana republic politics, the New York parking space shortage even for Christian martyrs, those rumours about J. Edgar Hoover, the politics of Miss America, Jewish neuroses, the dearly departed authority of Howard Cosell and his *Wide World of Sports*, etc. Every Allen film records its cultural moment for posterity.

To his further credit, though the surface is period-specific his themes continue to resonate. All those typewriters in *Manhattan* (1979) suggest a pre-computer world as remote as Mars, but Isaac Stern's (Allen) moral lesson and questionable conduct challenge us still.

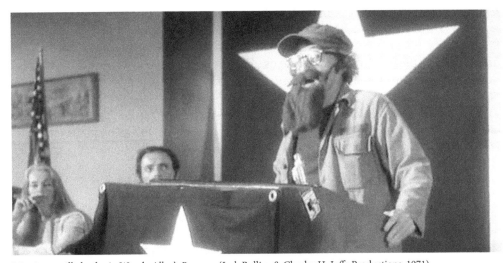

Marxist guerilla leader in Woody Allen's *Bananas* (Jack Rollins & Charles H. Joffe Productions, 1971).

As well as writing history Allen quotes it, especially the past of his medium. Sometimes this takes the form of allusions. The mechanical tasting job in *Bananas* parodys Chaplin's *Modern Times* (1936). In *Love and Death* (1975) his coitally collapsing lions reverse the arousal of Eisenstein's in *Battleship Potemkin* (1925). Allen ratchets up the brow for a dialogue based on Russian classic literature:

Boris: He must have been *Possessed*.
Father: Well, he was *A Raw Youth*.
Boris: *Raw Youth*! He was an *Idiot* ... I hear he was a *Gambler*.
Father: You know, he could be your *Double*.
Boris: Really. How novel.

In *Crimes and Misdemeanors* (1989) he engaged Dostoevsky's *Crime and Punishment* on a more serious level, exploring the same themes of murder, guilt and retribution in a godless order.

In fact, Allen learned to make films by parodying popular genres, from *What's up, Tiger Lily* (1966) and *Take the Money and Run* (1969) through his anthology, *Everything You Wanted to Know about Sex* (1972). He became a filmmaker by engaging with the films of the past. In his maturity he embraced the spirits of his major models, Ingmar Bergman – in *Interiors* (1978), *A Midsummer Night's Sex Comedy* (1982), *Hannah and Her Sisters* (1986) – and Federico Fellini – in *Zelig* (1983), *The Purple Rose of Cairo* (1985), *Radio Days* (1987) – with their dialectical synthesis in *Stardust Memories* (1980). Both in his experiments with the language of film and in his more ambitious later works Allen drew upon the film tradition, its history and its masterworks. This is rather more than the individual talent ransacking tradition. His continuing penchant for black and white and for classical jazz scoring confirms his classicism in form and in values.

When he made a period (historical) film, whether looking back – as in *Love and Death*, *Radio Days* and *Zelig* – or ahead – as in *Sleeper* (1973) – comedic anachronisms root the films in Allen's present. 'If God is testing us, why doesn't He give us a written?' A 200-year sleep is 'like spending a weekend in Beverly Hills'. That is to say, the past – or the future – is not some other country or some other time but an organic part of our present. That concept validates the magical technology (aka gimmick) by which in *Zelig* Allen puts himself into a black jazz band of the 1920s, in the batting order behind Babe Ruth and on platform parties with Pope Pius XI (who swats him with a sacred text) and with Hitler (who oddly does not). History is not where we were but where we are. If we don't understand that we can't know ourselves or how we should live.

The sense of history becomes a persistent self-referentiality in Allen's later films. For all the seriousness of *Crimes and Misdemeanors* – his monumental meditation upon faith, guilt, responsibility, moral blindness and our slippery slide from casual misdemeanour into a crime as serious as murder – Allen leavens his ostensibly comic subplot with self-references. His character, Cliff Stern, apparently a descendant of his Isaac Stern of *Manhattan*, is a

Woody Allen's period comedies: *The Purple Rose of Cairo* (Orion Pictures Corporation, 1985) and *Radio Days* (Orion Pictures Corporation, 1987).

pretentious Lefty documentary filmmaker who loathes his brother-in-law Lester (Alan Alda), a brilliant but amoral TV producer. Stern is appalled when Lester wins and weds the kindred spirit Halley Reed (Mia Farrow), for whom Stern planned to leave his wife.

As his name confirms, Stern is the familiar Allen nebbish/idealist. But he hardly comes near the saintly Rabbi Ben (Sam Waterson) as the film's moral centre. Stern's moral blindness registers in his harshness toward his sister's suffering, his insensitivity to his wife's needs and his increasingly irresponsible instruction of his young teen niece. Encouraging her to play hooky to see old films may be bad enough, but worse is when he unloads his plan for an adulterous affair with Halley. His animosity towards Lester proves both unfair to the generous and accomplished man and destructive of his own career.

Allen studs this storyline with allusions to his earlier films. The collapse of the wedding *kasatzky* repeats a gag in *Love and Death*. He dresses his niece as a miniature Annie Hall. Halley departs for England with the same two-shot, dynamic and even reassuring phrasing as Mariel Hemingway's in *Manhattan*. Allen's ironic injection of film clips – like his Stern's newsreel Mussolini footage in his biopic of Lester – recalls his characters living through films from *What's up Tiger Lily* (1966) and *Play It Again, Sam* (1972) to *Zelig* and *Hollywood Ending* (2002).

So why does Allen resurrect his old gags? The answer lies in the film's central scene, Judah Rosenthal's (Martin Landau) memory of a childhood family seder. There the debate between rational scepticism and faith concludes that whatever our belief in a god we are defined by all the choices we make through our life. This explains Judah's guilt over the murder of his mistress Dolores (Anjelica Huston).

In that light, Allen's recycled jokes (aka self-referential allusions) are how the auteur defines *himself* by the specific choices he has made all his life/career. However heroic or ignoble our pretences or our self-conception, we are only what we have *done*. We are our history. Allen tempers his most sombre exercise in philosophy with these reminders of his comic past. This modesty plays against his Stern's unearned superiority and Judah's massive hypocrisy. It coheres with the blind rabbi's humility and even the gangster Jack's (Jerry Orbach) saving grace: Unlike successful brother Judah, Jack does not forget his obligations. As well, the reminders of Allen the film director encourage us to detach the director from the character actor Allen plays.

Of course, Allen's film career was seriously disrupted by the scandal involving his private life with Mia Farrow and her allegations about his relationship with their children, especially her then twenty-one-year-old stepdaughter, Soon-Yi Previn, with whom he was having an affair. The famed moralist's scandalous behaviour was as disillusioning and career-threatening as the notorious Fatty Arbuckle's had been. It is difficult to read any Allen film of this period – from *Husbands and Wives* (1992) through *Hollywood Ending* (2002) – without taking that scandal into account, whether his statement seems a form of address – *Deconstructing Harry* (1997), *Celebrity* (1998) – or of avoidance – *Manhattan Murder Mystery* (1993), *Small Time Crooks* (2000).

Indeed, when his personal scandal undercut the moral ambition of his films Allen turned to exercise the innocence of classic genre entertainments, as in *Manhattan Murder Mystery*, the superior *Bullets over Broadway* (1994) and the antique musical *Everyone Says I Love You* (1996), and the lesser *Small Time Crooks* and *Curse of the Jade Scorpion* (2001). By turning to the film history he could set aside his own. His retreat included two zipless revivals for television, his own *Don't Drink the Water* (1994) and Neil Simon's *The Sunshine Boys* (1995).

In his nostalgic genre plots Allen dramatized the revival of a waning relationship – or converting an instinctive antagonism into love. In these simpler entertainments Allen considers the values required to regenerate a relationship. A character's/artist's fidelity to an old cultural form reflects a personal honour. This theme is reversed in his best film of this period, *Sweet and Lowdown* (1999), where the mechanics of the musical biopic anatomize a disintegrating psyche. Still, the public structure of a genre provides an apparently innocent, impersonal form for a fiction.

The Innocent Genre series ended with *Hollywood Ending,* where Allen mercifully reverted to his more acidic/Hasidic view of Lotus Land. The film still conveys Allen's love for Old Hollywood movies and his loathing for the current Hollywood culture (an oxymoron, like 'agent ethics'). The failed film director Val Waxman (Allen, striving against his waning career) directs a film despite mysteriously going blind. His terrible film proves a huge success in France – as *Ending* did at Cannes – and wins back Val's ex-wife, Ellie (Tea Leoni). By sweeping her out of Hollywood to their 'unfulfilled life dream', Paris, Val effects the rescue Alvy Singer couldn't in *Annie Hall*. In a satiric version of Allen reworking old themes, a Hollywood hack remakes a 'stupid potboiler'.

Unlike *Purple Rose of Cairo* and *Zelig* films-within-films, we don't see any footage from Val's *The City That Never Sleeps*. But we hear symptomatic crashes. We don't know how it's bad or how it might be taken to be good. But auteurism – like other religions – requires faith

Between fiction and documentary: *Zelig* (Orion Pictures Corporation, 1983).

in the maker. The blind Val may well have made 'the best American film in 50 years' (as the French critics claim), and Val may indeed be a genius who thrives on chaos, like Fellini.

Two acrid satires marked an ambitious recess from Allen's sequence of genre entertainments and a return to his own history. In the first, *Deconstructing Harry* (1997), Harry Block (Allen) is a successful novelist who controversially mined his life for his fiction – like Philip Roth, who at the time was Mia Farrow's love interest. Block's representation in his novel is played by Richard Benjamin, who starred in the film of Roth's *Goodbye Columbus* (1969). About to be honoured by the university that expelled him ('I tried to give the dean's wife an enema'), Harry is arrested for kidnapping his own son. He violated his visitation conditions so his son could share the experience. In Block Allen admits a view of himself as a goof more sinned against sinning. Something of his sense of injustice comes through a rejected mistress's rage at 'retarded talkshow hosts' and even artists who take 'everyone's suffering and turn it into gold'.

The second recess is *Celebrity* (1998) which draws its meaning by its scene-by-scene parallels to and divergence from Fellini's *La Dolce Vita* (1960). In this replay of a jaded celebrity journalist's tour of the culture's sordid glitz, several jokes involve the idea of history and film. One young actor is making 'an adaptation of a sequel of a remake'. The new film leeches on the past, but *sans* discrimination. The Mastroianni figure Lee (Kenneth Branagh) has imagined one temptress as 'the obscure object of desire', a Buñuel film title (1977). The film producer plans to remake '*Birth of a Nation* – an all-black version'. As the original D.W. Griffith film is a classic of racism, valorizing the Ku Klux Klan, the improbable project exposes the producer's ignorance of the very film he presumes to revive. Indeed, *Celebrity* itself mobilizes history. The theme of seductive celebrity is expressed in the classic song over the opening credits – 'You Oughta Be in Pictures'. In context, that love song shrinks to an exhortation to join the shallow world of the Image. In the closing song Billie Holiday alludes to history: 'Did I Remember?' Like its characters, this film does not exist isolated in the present but is defined by its awareness of and response to its past.

Not having recovered his pre-scandal status, Allen left not just his haunting New York but America for three films set and shot in England – *Match Point* (2005), *Scoop* (2006) and *Cassandra's Dream* (2007) – and one in Gaudi's wild Spain, *Vicky Cristina Barcelona* (2008). The films replayed Allen's familiar themes of romantic quest, guilt and betrayal, in other cultural landscapes.

The entire weight of Allen's troubled personal history comes to rest upon even the title of his *Whatever Works* (2009). In casting Larry David as the central nebbish/loser Allen engages the most prominent current figure in the vein of Jewish-American self-satirists that Allen effectively founded.

Boris Yelnikoff (David) is Allen's most outrageous misanthrope. He leaves his perfect wife Jessica (Carolyn McCormick) because 'On paper we're ideal. But life isn't on paper'. His consequent suicide leap leaves him limping. Having abandoned his physics professorship he ekes out a living 'teaching chess to incompetent zombies'. His story insists 'You've got to take what little pleasures you can find in this chamber of horrors'. History has taught Boris that people are essentially terrible. When he marries the very young vagrant Melodie St Ann

Celestine (Evan Rachel Wood), they are 'two runaways from the vast, black, unspeakably violent and indifferent universe'. The theme song of Boris's first two marriages is 'If I Could Be with You (one hour tonight)', an explicit gesture against the abyss of eternity.

At seventy-three Allen seems prompted to spell out as clearly and explicitly as he can his one most compelling theme and lesson. The song over the opening credits sets the valedictory tone: Groucho Marx's 'Hello I Must Be Going'. Not just the film but his whole career is boiled down to the title. In his world of accident, brutality, callousness, moral chaos and social conventions that however idealistic can strangle the individual spirit, people must do 'whatever works'.

The misanthrope's moral slogan catches on. Against Boris's predictions for these 'family values morons', the whole Celestine family from the bathetic, post-lapsarian Eden, Mississippi, find fulfilment in New York. Melodie finds her true love – outside her marriage to Boris. Her mother Marietta (Patricia Clarkson) discovers her own creative powers – in photography, recalling Annie Hall – and finds fulfilment in an arty ménage-a-trois. Marietta's wayward NRA husband John (Ed Begley Jr) frees his natural homosexuality and settles into an antique business with Howard Cummings nee Kaminsky (Christopher Evan Welch). Even Boris finds fulfilment in Helena (Jessica Hecht), the psychic on whom he fell on his second post-marital suicide leap. This takes him out of his neurotic insularity, as emblematized by his singing 'Happy Birthday' to himself when he washes his hands, to avoid germs.

The Purple Rose of Cairo (Orion Pictures Corporation, 1985).

In the first scene Boris criticizes religion for having become corporate and for assuming people are essentially good. 'People make life so much worse than it has to be.' Against social conventions, the film justifies affairs December–June, adulterous, homosexual. Allen reiterates the overriding lesson of the Isaac-Tracy romance in *Manhattan* and the universal moral requirement of love in *Crimes and Misdemeanors*: Whatever works.

One joke fugitively alludes to Allen's notorious affair with Soon-Yi Previn. Trying to persuade Melodie to return home to Mississippi, Boris warns 'You'll wind up a prostitute like those Asian girls who come here full of high hopes and wind up prostitutes, turning tricks to keep alive. And many of them are actually good looking' – unlike Melodie, 'a three'. But Melodie wins her shelter: 'If you throw me out and I wind up an Asian prostitute, that's gonna be on your conscience.' While Allen's scandal has been left in the dust by the success of that relationship, the reference confirms the confluence of Allen's life and his art.

Like the film character's address to the movie audience in *Annie Hall* and throughout *Purple Rose of Cairo*, Boris from the first scene on addresses the film audience that he sees and that the other characters don't. To Boris this proves he alone has 'the big picture'. He alone knows he is living a fiction. His film-awareness redoubles Boris's dismissal of moral absolutes as but fictional constructs. Hence his disdain for social convention – 'Charm has never been a priority with me' – as for religions and social restrictions upon relationships.

Allen's history both on screen and off culminate in the bleak heartiness of this film's resolution. In a heartless universe we can find meaning and love only in each other, so whatever the laws and conventions, go for … whatever works. Otherwise history will dissolve us before our time has come.

PART II

No Laughing Matter

Chapter 6

No Laughing Matter? Comedy and the Spanish Civil War in Cinema

David Archibald, University of Glasgow

W ar, it might be said, is no laughing matter; certainly it seems a far from appropriate response to the brutal, bloody conflict that engulfed Spain in the 1930s. The Spanish Civil War began in July 1936, when a group of Spanish generals led a rebellion against a left-leaning, democratically elected, republican government, and ended, in March 1939, with the establishment of a right-wing military dictatorship headed by General Franco. Following their victory, Franco's nationalist forces continued on a systematic campaign of terror against their opponents; Gabriel Jackson calculates that between 1936 and 1944, they killed 150,000 to 200,000 people in either formal executions or reprisals (Richards, 1996: 209).[1] In this article I analyse the use of comic elements in four Spanish films which are set during, or in the years preceding, this traumatic period: *La vaquilla* (Luis García Berlanga, 1985), *¡Ay, Carmela!* (Carlos Saura, 1990), *Belle époque* (Fernando Trueba, 1992) and *Libertarias* (Vicente Aranda, 1996).[2] My interest here lies in engaging with debates over whether the past contains discernible patterns and whether representations of the past, written or cinematic, are determined by the intrinsic nature of the events that they deem to represent; or, on the contrary, whether representations of the past are determined by the emplotment and narrativization choices of those operating in the present. Hayden White, whose work has gained prominence in the study of cinematic representations of the past, has been a key proponent of the latter position. White (1987: 44) argues that

> (s)ince no given set or sequence of real events is intrinsically tragic, comic, farcical and so on, but can be constructed as such only by the imposition of the structure of a given story type on the events, it is the choice of the story type and its imposition upon the events that endow them with meaning.

In highlighting the constructed nature of historical representations, White challenges the notion that the past contains inherent patterns, a widely held philosophical position; of Hegel's assertion that history repeats itself, Marx (1980: 96) famously writes, 'Hegel remarks somewhere that all facts and personages of great importance in world history occur, as it were, twice. He forgot to add: the first time as tragedy, the second as farce.' Marx (1992: 247–248) developed his analysis from his earlier writings on Germany in the 1840s in which he argues that, in contrast to the *tragic* demise of its French counterpart, the German *ancien régime* was, as he puts it, 'merely the clown of a world order whose *real heroes* are dead'. Marx proceeds to make connections between the past and its literary representations:

History is thorough and passes through many stages while bearing an ancient form to its grave. The last phase of a world-historical form is its comedy. The Greek gods, who already died once of their wounds in Aeschylus's tragedy Prometheus Bound, were forced to die a second death – this time a comic one – in Lucian's Dialogues. Why does history take this course? So that mankind may part happily with its past.

Marx, then, contra White, appears to suggest that the past does indeed have discernible patterns; moreover, he argues that patterns emerge in artistic representations of the past which are ultimately represented in comic form. Terry Eagleton (1981: 161) draws on more contemporary events to problematize the assertion that the past, or its artistic representations, are as malleable as either White or Marx suggest:

it is not of course true that all tragic concerns are changeable, just as carnival is wrong to believe that anything can be converted into humour. There is nothing comic about gang rape, or Auschwitz. There are always blasphemies, words that must on no account be uttered because they defile the tongue. Those who believe that the sacred and the profane belong to a benighted past need only to consider whether they would be prepared to pronounce certain words about Auschwitz even as a joke.

For Eagleton, there are clear moral or political imperatives which impose limits on representations of the past, or certainly of traumatic events in the past.

What, then, might be the relationship between comedy and the Spanish Civil War? It might be worthwhile here to draw a distinction between *the comic* and *comedy*: in their work on comedy and film, Steve Neale and Frank Krutnik (1990: 1) argue that, whereas the former is what makes us laugh, the latter is specific to certain narrative forms. Laughter alone, they argue, is insufficient to make something a comedy; indeed, they note that some comedies can make audiences laugh as much as they can make them cry. Neale and Krutnik cite the Concise Oxford Dictionary definition: 'Comedy n. Stage-play of light, amusing and often satirical character, chiefly representing everyday life, and with a happy ending' (11). They suggest, therefore, that a comedy is characterized not simply by its 'light' or 'amusing' elements, but also by its concern with the representation of everyday life and its conclusion, which is usually a happy one (1). A further feature of the comic form is its political, even subversive, potential: Walter Benjamin (2003: 101) points to its cerebral qualities when he asserts that 'there is no better starting point for thought than laughter; speaking more precisely, spasms of the diaphragm generally offer better chances of thought than spasms of the soul'. Similarly, in contrasting Aristotelian approaches to drama with the Epic Theatre of Bertolt Brecht, Eagleton (1981: 157) highlights the potentially political side of the comic when he states that '(c)omic estrangement allows the audience to "think above the action" [...] thought is freer than pity or fear: it is a matter of thinking around, across and above the dramatic action'. The subversive nature of humour during Franco's reign is evident in a strand of satirical cartoons, exemplified by Juan M. Molina's *Noche sobre España*, which was published in the underground by the

anarchist trade union, Confederación Nacional del Trabajo, or in the work of the cartoonist, José María Pérez González (Peridis). In the world of cinema, which was subject to strict censorship, humour was also utilized to critique life under the dictatorship with ¡Bienvenido, Mister Marshall! (Welcome Mr Marshall, Luis García Berlanga, 1952) and Calle Mayor (Juan Antonio Bardem, 1956) the most notable examples.[3] It is important to note, however, that for oppositional filmmakers living in Franco's Spain, the Spanish Civil War remained largely unrepresented; when it did surface, for instance in the work of Carlos Saura, the conflict was generally referred to obliquely.[4] It was only following Franco's death in 1975 and the scrapping of censorship in 1977 that filmmakers were able to turn their attention to the conflict freely and it is far from accidental that all four films discussed here emerged decades after the conclusion of the conflict. The films all reflect a broadly anti-Franco perspective, contain comic elements and deal with everyday life, albeit in a civil war setting. The chapter analyses the means by which they allow audiences to laugh about aspects of the civil war and, moreover, explores whether they should be classified as comedies, in the sense outlined by Neale and Krutnik. I will deal with each of the films in turn.

Belle époque

Belle époque is a conventional comedy in that it opens with a misfortune – the comic death of two members of the Guardia Civil – and concludes with a happy ending as a young, newly married couple prepare to depart Spain. Set in 1931, the cinematic world created in Belle époque is a million miles removed from the harsh experience of rural life in early 1930s Spain.[5] The central characters inhabit a world free from worry over financial concerns; a world where an abundance of good food is washed down with good wine, and where personal freedom is closely identified with sexual liberation. It is a space where the central characters are breaking free from the repressive strictures of the Catholic Church and joyfully transgressing historically established patriarchal restrictions. Although the strikes and demonstrations sweeping through Spain in this period are referred to, they are located in the urban centres, far removed from this pre-modern idyll on the outskirts of Madrid. It is an idealized sleepy hollow; a world where the patriarchal figurehead, Manolo, says 'we get the papers three days late', but where no one seems the worse for it. This air of libertarian freedom is embodied in Manolo's family, which represents the antithesis of the strict bourgeois model favoured by the church. Manolo's family may be a fractured one – his wife travels the globe with her boyfriend, returning occasionally for sexual trysts with her husband, while her 'cuckolded' lover waits, impatiently, outside the bedroom – but it remains happy, kept together by mutual consent, not legal stipulation.

Belle époque, then, presents a utopian world where the characters revel in elements of the carnivalesque. In his work on the popular folk culture of the Middle Ages, Bakhtin argues that carnival and other marketplace festivals represented a space where it was possible for the lower classes to live, albeit temporarily, relatively free from the strictures of the day. Carnival

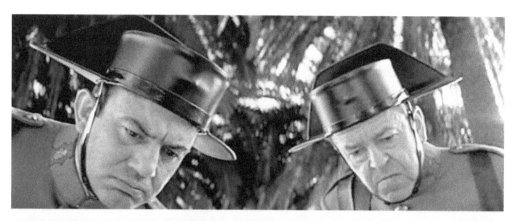

Belle époque (Fernando Trueba Producciones Cinematográficas, 1992).

represented a space where traditional hierarchies and restrictions could be overturned, where all that was fixed and established was open to change and transformation. As Bakhtin (1984: 10) suggests,

> carnival celebrated temporary liberation from the prevailing truth and from the established order; it marked the suspension of all hierarchical rank, privileges, norms, and prohibitions. Carnival was the true feast of time, the feast of becoming, change, and renewal. It was hostile to all that was immortalized and completed.

During the period of carnival, Bakhtin continues,

> (p)eople were, so to speak, reborn for new, purely human relations. These truly human relations were not only a fruit of imagination or abstract thought; they were experienced. The utopian ideal and the realistic merged in this carnival experience, unique of its kind. (10)

This is evident in the world of sexual relations in *Belle époque*; there exists a utopian world of gender reversal where, with the exception of the youngest, Luz, none of Manolo's daughters fulfil traditional female roles. The four sisters are neither dull nor domesticated, but confident, independent young women whose culinary shortcomings are contrasted sharply with the cooking skills of Fernando, the young army deserter who arrives in the village. This reversal of conventional gender roles is apparent when, following Fernando's sexual frolics with all four daughters, it is he who fulfils the traditional female role of actively pursuing marriage, while the sisters, with the exception of Luz, pursue only the transient joys of carnal pleasure. The potential fluidity of gender identities is illustrated in the sequence that occurs, appropriately enough, on the night of the village carnival. Bedecked in Fernando's army uniform and sporting a thin, black, pencilled moustache, Manolo's lesbian daughter, Violeta, leads the young soldier, who is dressed in a maid's uniform, to a quiet barn, throws him to the straw covered floor, straddles him as he lies on his back, and has sex with the bemused but delighted young man. As the couple's copulation reaches its orgasmic heights, Fernando shows Violeta how to blow his army regulation horn, thus restoring patriarchal climactic control; however, rather than simply reversing the natural order of things, in highlighting the fluidity of Violeta's sexuality, the scene breaks down binaries between homo- and heterosexuality. Indeed, Jacky Collins and Chris Perriam (2000: 218) argue that, while the film is conformist in many ways, this particular scene 'contains some of the most advanced representations of lesbianism in Spanish cinema'. It is noteworthy that Violeta's lesbianism is socially acceptable both within the family structure and within the world of the film, thereby creating a link between the fictionalized on-screen utopia and the more liberated sexual politics of post-Franco Spain. Marsha Kinder (1997: 5) highlights this connection when she states that through the film 'the so-called new liberated mentality of Socialist Spain is shown to have historic roots in the pre-Civil War era'. *Belle époque* certainly creates a comic and romantic account of the pre-civil war period, one that elides the harsh experience of the 1930s; nevertheless, its attention to social and sexual dynamics invites a socio-historical comparison with its moment of production. Paul Julian Smith (1994: 38) suggests the film's attitude to the past is one of 'aesthetic amnesia' and, moreover, that 'its sunny good humour conjures away the real conflicts of Spanish history'. *Belle époque* may only contain passing references to the political events of its time; however, it is far from incidental that the action takes place on the cusp of the abdication of the monarchy and the establishment of the Second Republic in April 1931. In the film's conclusion, Fernando and Luz depart from Spain (and the looming turbulence of the pre-civil war period) leaving Don Manolo to drive his horse and trap back to his tranquil, pastoral home, thereby satisfying one of the key traditional conventions of comedy, that of a happy ending. It is noteworthy however that the action takes place in 1931, at a moment of historical potential, and studiously avoids the traumatic years of the civil war itself.

¡Ay, Carmela!

While *Belle époque* creates a romanticized, rural idyll in the years preceding the conflict, *¡Ay Carmela!*, partially shot on the remnants of the battered town of Belchite,[6] focuses on life at the Aragon Front in 1938. Carlos Saura had previously directed a number of films touching on the civil war from a perspective sympathetic to the republican side and highly critical of the dictatorship, notably *La caza* (The Hunt, 1965), *El Jardín de las delicias* (The Garden of Delights, 1970), *La prima Angélica* (Cousin Angelica, 1973) and *Dulces horas* (Sweet Hours, 1982). His previous films, however, are considerably more serious in tone. Saura points out that

> (t)he Spanish civil war appears in many of my earlier films, but in a different way. But it has never been spoken of in the same way as I do in *¡Ay, Carmela!* It was only after Franco was dead that you could make *¡Ay, Carmela!*[7]

In the film, Carmela, Paulino and Gustavete are members of the Tip-Top Variety show, a travelling theatre troupe who perform cabaret acts for Republican soldiers, who, while attempting to flee life at the front, are captured by Nationalist troops. Pérez González (2000: 18) points out that Spain has a long literary tradition of protagonists who 'repeatedly find themselves in an impecunious situation, or simply end up penniless and hungry, and devote all their waking hours and best efforts in trying to avoid its awful consequences'. It is a description that fits perfectly with Paulino who is characterized by aspects of 'grotesque realism' referred to by Bakhtin. For Bakhtin, grotesque realism was opposed to all that was regarded as high or abstract culture. It was culture transferred to a base material level, one

Opening scene of Carlos Saura's *¡Ay, Carmela!* (Ellepi Films, 1990).

120

often associated with the body, particularly the lower part, including the genital organs, the stomach and the buttocks. Whereas the body, and bodily functions, are systematically written out of official culture, in folk culture the body is not to be hidden from, but highlighted and celebrated. Bakhtin suggests that the bodily element is a deeply positive component of life, something universal, affecting all of the people. Paulino's constant hunger for food, which leads to his inadvertent consumption of a cat, corresponds with his insatiable desire to take Carmela, his lover, on frequent trips to 'Uruguay', his euphemism for sexual intercourse. Paulino's desire for sex and gastronomic gratification is only matched by his ability to fart at will, and in key, a skill employed in one of his comic routines, 'The Farts', which further connects his character with Bahktin's 'base' organs. Bakhtin (1984: 20) argues

> To degrade is to bury, to sow, and to kill simultaneously, in order to bring forth something more and better. To degrade also means to concern oneself with the lower stratum of the body, the life of the belly and the reproductive organs; it therefore relates to acts of defecation and copulation, conception, pregnancy, and birth. Degradation digs a bodily grave for a new birth; it has not only a destructive, negative aspect, but also a regenerating one. To degrade an object does not imply merely hurling it into the void of nonexistence, into absolute destruction, but to hurl it down to the reproductive lower stratum, the zone in which conception and a new birth take place. Grotesque realism knows no other level; it is the fruitful earth and the womb. It is always conceiving.

Issues of death and re-birth are raised when the troupe are forced to perform before an audience comprised of an international group of German, Italian, Moroccan and Spanish nationalist soldiers, and a number of republican-supporting members of the International

Carmela's death in ¡Ay, Carmela! (Ellepi Films, 1990).

Brigades who are being held in captivity. The sketch they perform, 'The Republic Goes to the Doctor', involves Carmela removing her militia costume to reveal a republican flag partially covering her body, the sight of the flag provoking a hostile response from the fascist troops.[8] When Carmela falls to the stage floor, the result of a shot to the head fired from the pistol of a nationalist officer, the comic tone, which has grown increasingly dark in the preceding scenes, becomes tragic. Saura credits the original playwright, José Sanchís Sinisterra, with developing this contrast between the tragic and the comic when he comments

> Something very intelligent is done by José Sanchís Sinisterra. If it had come just from myself I would never have been able to do that sort of tragic-comic style. But after watching the play and reading it, I realized the amazing possibilities that working along those lines had. Because there is this double game, you find the humour that you can find everywhere in life, even in the most tragic situations. And sometimes that's exciting. It's what reinforces the most tragic moment because of the contrast.[9]

Carmela's death is also linked to re-birth through the character of Gustavete, a child-like figure who is parented by this unorthodox couple. As Saura states of the impact of Carmela's death on Gustavete, '(w)hen Gustavete speaks he recovers his speech, he lost it with a tragic event and he recovers it with another tragic event and obviously it is the memory of Carmela that remains'.[10] Thus, as Bakhtin suggests a dialectical link between death and birth, the voice of Carmela, of defiance, of opposition to authority and to the regime, will continue in the character of Gustavete. In the closing scene, the tragic conclusion is encapsulated in a shot of Paulino and Gustavete laying flowers at Carmela's graveside before they drive off into a barren Spanish wasteland, but, with Gustavete re-born, the memory of Carmela's struggle against injustice finds life in his newly found voice, with the potential to be re-born for future struggles.

Libertarias

Set in Barcelona at the outbreak of the civil war, as the military revolt is met by a revolutionary response from workers throughout Catalonia, *Libertarias* follows a group of women, including anarchist militiawomen, prostitutes and a nun, who are involved with Spain's anarchist women's movement, *Mujeres Libres* (Free Women). *Libertarias* uncovers, indeed attempts to celebrate, the neglected history of Spanish anarchism, particularly the role anarchist women played in the conflict. Commendable aims perhaps, but despite its intentions, the film's focus on women fails to move beyond the level of caricature. The central characters are all textbook, male fantasy figures, thrown together, incongruously. Comedy is often born from figures being in the wrong place at the wrong time or, as Neale and Krutnik (1990: 3) put it, 'comedy necessarily trades upon the surprising, the improper,

Maria has escaped from the convent in *Libertarias* (LolaFilms, 1996).

the unlikely, and the transgressive in order to make us laugh; it plays on deviations from socio-cultural norms, and from the rules that govern other genres and aesthetic regimes'. *Libertarias* derives much of its comic content from the notion of the civil war being fought by an unlikely assortment of female protagonists. The film, moreover, is awash with incongruous moments, such as when the nun, Maria, forced to flee her convent, accidentally finds herself in a brothel and is forced to hide from the anarchist militia by climbing into bed with a sparsely clad, obese priest who, undertaking a short sabbatical from his clerical duties, is visiting the brothel to sample the sinful pleasures of the flesh. Although *Libertarias* raises serious subject matter, it is introduced in a whimsical, light-hearted fashion, exemplified in the scene where the women are required to undertake a mass urine sample to test for any possible sexually transmitted diseases they may have contracted at the front, or when one of the militiamen shouts to the female soldiers, 'comrades, don't your tits get in the way when you shoot?' Richard Porton (1999: 96) describes *Libertarias* as 'a curious amalgam of historical epic and mildly risqué sex farce [...] The film takes a salacious pleasure in highlighting the comic incongruousness of former nuns and prostitutes fighting alongside Bakunin-spouting women at the front.' Thus, any attempt at an examination of sexual and revolutionary politics, is undermined by its somewhat reactionary representations. Despite the comic tone throughout most of the film, *Libertarias* ends tragically when a group of Moroccan troops attack the militia; one woman is raped and has her throat slit, one has a dagger thrust into her body, and Maria is raped while another Moorish soldier holds a knife against her lips. This displacement of real, historical, Spanish violence into the fictional actions of a savage African 'other' represents an all-too-convenient conclusion, one which adds further to the reactionary politics of *Libertarias*, despite its progressive aspirations.

La vaquilla

On its release in 1985, *La vaquilla* was, one of the best-selling films inside Spain (Deveny 1993: 46). Prior to working on *La vaquilla*, Berlanga had directed a number of films which employed elements of comedy to critique the Franco regime, perhaps most famously *¡Bienvenido, Mister Marshall!* (Welcome Mr Marshall, 1952) but also a trilogy of films made following the dictator's death, *La escopeta nacional* (National Shotgun, 1978), *Patrimonio nacional* (National Patrimony, 1981) and *Nacional III* (National III, 1983). *La vaquilla* was the first film, however, in which he turned his attention to the civil war. Berlanga states that the film is based on a script that had been rejected by the censors in 1956 (Deveny 1993: 46) however, by the mid-1980s, the absence of state censorship created more artistic freedom for filmmakers.

As with *¡Ay, Carmela!*, the film is set on the Aragon front in 1938; however, the focus of *La vaquilla* is on the exploits of a group of republican soldiers who venture surreptitiously into enemy territory in order to steal a bull that the nationalists are planning to use in a bull run during a forthcoming town festival. The film suggests that the civil war is dividing Spain down the middle and a number of scenes point to the absurdity of a nation carved in two. This is exemplified in one early scene where soldiers from both sides exchange supplies because the republican soldiers have tobacco, but no cigarette papers, the nationalists have papers, but no tobacco. Central to the plot is Mariano, an innocent, naive young man who has a girlfriend in the local town, but is worried that he will lose her affections, or that she will be disloyal, sexually, at the impending festival. When the troops hear that the nationalists are planning a special dance on the night, their leader, Sergeant Castro, concerned that his troops will defect, assembles a crew of volunteers who construct a plan to steal the bull in order to wreck the planned festivities, while simultaneously using the adventure to raise his own troops' morale. Thus the civil war forms the backdrop to an absurd, whimsical tale of cattle rustling more reminiscent of a television situation comedy than a serious war film.

Throughout *La vaquilla*, narrative identification is with the republican soldiers, thus inviting sympathy with their position, however, the film steers clear generally of any heavy-handed or overt politicizing. Mariano, we learn, may have voted for the left in the elections, but his main fears flows from concerns over his girlfriend's potential transgressions. His fears are confirmed when he discovers that she is engaged to a nationalist officer and he attempts to kidnap her and scupper any potential wedding. As with *Libertarias*, the audience is invited to laugh at characters caught up in the wrong place at the wrong time. For instance, as the republican soldiers venture further into enemy territory, they find themselves, inadvertently, in a brothel where one of the soldiers, Donato, says, 'Aristotle had it right. You work for two things; to eat and to make it with charming females', to which Sergeant Castro replies, 'you're so right, forget communism and fascism, when it comes to getting it on, we all agree'. Thus, the film suggests that there are universal human desires, which run deeper than ideological divisions, and which can unite all Spaniards.

La vaquilla does not engage with the specific horror of war and, although it is set on the front line, there is not a single shot fired. Indeed the civil war is represented as a calamitous adventure

carried out by politically unaware combatants. But there are moments when the generally apolitical nature of the narrative is punctured, such as when the priest blesses the military aircraft, thus highlighting the church's support for Franco. Moreover, much of the humour is derived from poking fun at the gout-ridden marquis, who is representative of the landowners' support for the nationalists even if, despite his pious rhetoric, he is far from supportive of the nationalists' war effort in practice. *La vaquilla* mocks the church, the oligarchy and Franco, but there is no sense of what the republic is fighting for and, while there is a sympathetic portrayal of the republican soldiers, it is more for their plight than for their politics. As with the character of Paulino in *¡Ay, Carmela!*, the soldiers are caught in a conflict in which they have no real interest. In common with the carnival theme present in *Belle époque*, the bull run is due to coincide with the town's Our Lady of the Assumption festival. The event ends in chaos, however, and the republican soldiers decamp to the home of Mariano's father, who we learn is caretaker to the marquis and has been in hiding since the war broke out. Thomas Deveny points out that the film has been cited as an example of the *esperpento*, a term coined by the Spanish writer, Rámon del Valle-Inclán. Deveny (1993: 47) suggests that the *esperpento* 'represents a systematic distortion of characters and indeed reality that Valle-Inclán created in his dramas and novels'. Deveny notes that, for Valle-Inclán, it was necessary to use 'the grotesque, the absurd, and the ridiculous' in order to get to the reality of Spain. This absurdity is apparent when the soldiers take the marquis hostage, strap him in his wheelchair and push him through a minefield before depositing him in no man's land. As the film draws towards a conclusion, the republicans return to their own lines and a small, black bull and two bullfighters appear on the horizon. A bullfight ensues before the bullfighters depart leaving the bull lying dead on the grass; as vultures sweep down and pick over the carcass, the animal symbolically represents the damage inflicted on war-ravaged Spain.[11] Thus, while the civil war is presented as both divisive and tragic, the film is relatively unproblematic in that it poses few complex or difficult questions about Spain's fractured past. Its significance lies in that it is the first film in which those sympathetic to the republic are presented with the opportunity to begin to laugh about elements of the past, even if it does not end as light-heartedly as it begins.

Conclusion

It is not incidental that three of the films discussed here end in death; Carmela is killed with a single shot from a nationalist officer's pistol in *¡Ay, Carmela!*, anarchist militiawomen are raped and murdered by Moroccan soldiers in *Libertarias* and the dead bull on the Spanish landscape is the closing image in *La vaquilla*. The endings of these films stand in stark contrast to that of *Belle époque*, which ends happily as the young newlyweds depart for the United States. If *Belle époque*'s rose-tinted engagement with Spanish history raises the possibility of what might have been, and what may be possible in the present, then the endings of *¡Ay, Carmela!*, *Libertarias* and *La vaquilla* serve as reminders of the bitter consequences of defeat: the bruising humour only heightening the tragedy and inviting the audience to

'think above the action' as Eagleton suggests. *Belle époque*, by starting with death, but ending happily, is the only film that fulfils the traditional conventions of a comedy; however, it does so by avoiding the specific period of the civil war and it is difficult to imagine how the film could have utilized a similar narrative structure and been set during the civil war. So, does this absence of traditional comedies set during the civil war flow from the subjective narrativization or emplotment choices of filmmakers? Or is it a consequence of the tragic nature of the event itself? The establishment of distance, whether temporal or geographical, allows greater opportunities for the construction of new narratives about the past; however, the contentious nature of the Spanish Civil War in contemporary Spain, combined with its tragic nature, undoubtedly imposes limits on its representation in cinema. Comic elements, at least at significant levels, began to appear in cinematic representations of the civil war in 1985, ten years after the death of the dictator and almost 50 years after the end of the civil war. Twenty-five years further on and there has still been no attempt to represent the Spanish Civil War as a comedy in cinema, at least in the sense outlined by Neale and Krutnik.[12] The Spanish Civil War remains an event which 'mankind' is far from ready to depart from 'happily' and, therefore, thus far at least, films set during the Spanish Civil War employing comic elements may enable audiences to laugh momentarily at the absurdity or incongruity of war situations, but, ultimately, they must end in tears.

Bibliography

Bakhtin, Mikhail, *Rabelais and His World*, trans. Helene Iswolsky, Bloomington: Indiana University Press, 1984.

Benjamin, Walter, *Understanding Brecht*, trans. Anna Bostock, London: Verso, 2003.

Collins, Jacky and Perriam, Chris, 'Representations of Alternative Sexualities in Contemporary Spanish Writing and Film' in Barry Jordan and Rikki Morgan-Tamosunas (eds) *Contemporary Spanish Cultural Studies*, London: Arnold, 2000, pp. 214–222.

Deveny, Thomas G., *Cain on Screen: Contemporary Spanish Cinema*, Metuchen & London: The Scarecrow Press, Inc., 1993.

Eagleton, Terry, *Walter Benjamin or Towards a Revolutionary Criticism*, London: New Left Books, 1981.

Faulkner, Sally, *A Cinema of Contradiction: Spanish Film in the 1960s*, Edinburgh: Edinburgh University Press, 2006.

González, José María Pérez (Peridis), 'Resisting the Dictatorship through Humour' in Monica Threlfall (ed.) *Consensus Politics in Spain: Insider Perspectives*, Bristol: Intellect, 2000, pp. 16–26.

Kinder, Marsha, *Refiguring Spain: Cinema/Media/Representation*, Durham: Duke University Press, 1997.

Marsh, Steven, *Popular Spanish Film under Franco: Comedy and the Weakening of the State*, Basingstoke & New York: Palgrave MacMillan, 2006.

Marx, Karl, 'The Eighteenth Brumaire of Louis Bonaparte' in *Marx/Engels: Selected Works in One Volume*, London: Lawrence and Wishart, 1980, pp. 96–179.

—— 'A Contribution to the Critique of Hegel's Philosophy of Right' in *Early Writings*, Harmondsworth: Penguin, 1992, pp. 243–257.

Molina, Juan, M, *Noche sobre España*, Mexico: Ediciones de la CNT de España, 1958.

Neale, Steve and Krutnik, Frank, *Popular Film and Television Comedy*, London & New York: Routledge, 1990.

Porton, Richard, *Film and the Anarchist Imagination*, London & New York: Verso, 1999.

Richards, Michael, 'Civil War, Violence and the Construction of Francoism' in Paul Preston and Ann L. Mackenzie (eds) *The Republic Besieged: Civil War in Spain 1936–1939*, Edinburgh: Edinburgh University Press, 1996, pp. 197–239.

Roberts, Stephen, 'In Search of a New Republic: Bardem's *Calle Mayor*', in Peter William Evans (ed.) *Spanish Cinema: The Auteurist Tradition*, Oxford: Oxford University Press, 1999, pp. 19–37.

Smith, Paul Julian, '*Belle Epoque*', *Sight and Sound*, 4:4 (1994), p. 38.

White, Hayden, *The Content of the Form*, Baltimore: John Hopkins University Press, 1987.

Notes

1. Following the passing of the Law of Historical Memory, legislation brought in by the Spanish government in 2007, the mass graves containing republicans who were systematically killed, the most notable example being that of the Spanish writer, Federico García Lorca, are being exhumed.

2. Three of the films, *La vaquilla*, *¡Ay, Carmela!* and *Belle Époque* were scripted by Rafael Azcona, the most prolific of screenwriters to cover the civil war.

3. For an analysis of *¡Bienvenido Mr Marshall!* (Welcome Mr Marshall) see Steven Marsh (2006: 97–121); for an analysis of *Calle Mayor* see Stephen Roberts (1999: 19–37).

4. See Sally Faulkner (2006) for an analysis of the ways in which Saura's 1965 film, *La caza* (The Hunt) can be read as a critique of the Franco regime, pp. 145–173.

5. For a sharp contrast see Luis Buñuel's surrealist, ethnographic documentary *Tierra sin pan* (Land Without Bread, 1931) for a rather different take on life in rural Spain at that time.

6. The town of Belchite, located 30–40 kilometres outside Zaragoza, has been left untouched as a monument to the civil war.

7. Interview with author, London, 2002; simultaneously translated by staff at the Instituto Cervantes.

8. With her bare-breasted body wrapped in the republican flag, Carmela brings to mind Eugene Delacroix's painting *Liberty Leading the People* (1830) which features a semi-naked female figure wrapped in the French *tricolore*.

9. Interview with author.

10. Ibid.

11. Steven Marsh (2006: 137) notes that in Berlanga's extensive oeuvre, his films rarely end happily.

12. Pre-production has commenced on a new comedy set during the civil war, *La Mula*, directed by Michael Radford.

Chapter 7

A Killer Joke? World War II in Post-War British Television and Film Comedy

Rami Mähkä, University of Turku

There is a video titled *Saving Private Ryan from the Comedy Channel* at the increasingly popular YouTube internet site. The video consists of some seven minutes of the famous landing scene of the Steven Spielberg blockbuster (1998), but with television comedy style laughter over the soundtrack. The laughter is present from the very start, as a 'reaction' to the un-comical dialogue between the American soldiers. More importantly the laughter, as well as some enthusiastic cheering, is often perfectly timed to the most violent images on screen, e.g. soldiers being shot, catching fire or having their limbs blown off, once the fighting has started. The video poster's ('qqqCYBERLEADERppp') accompanying information to the video is: 'I taped this as it was recently on Fox's the Comedy Channel. I noticed that it contained canned laughter unlike the original version. Funny how many shows nowadays contain canned laughter, even the serious ones. [After clicking the 'more info' button, the following text is revealed:] 'This WASNT from the comedy channel … I made it for u slow ppl :D'. I remember a number of people were not 'slow' to add their comments, and the video was also debated at the discussion forums dedicated to *Saving Private Ryan* at the Internet Movie Database.[1] Most reactions were condemnatory, accusing the maker of being disrespectful against the war veterans, or of being simply 'sick'. The reactions were understandable; the Spielberg film was a representation of the bloodbath and sacrifices of the war, but for me, the video also seems to have a striking 'counter-cinematic' quality to it in adding an alien element – the laughter track is, after all, reserved almost exclusively for television comedy – to the well-established genre of combat film drama. Thus, somehow the idea of the video being disrespectful against actual veterans of the war felt strange, because of the genre hybrid. Why did some people connect the video to World War II as a historical event?

In the midst of ongoing conflicts around the world, World War II once again appears to serve as an important reference point. This seems true especially in the case of the United States, where such nostalgia-tinged accolades as 'the greatest war' and 'the greatest generation' in relation to the war have been widely popularized in media in recent times, not least thanks to the aforementioned Spielberg's now over a decade old *Saving Private Ryan*. The war has also served as an inspiration for topical political rhetoric, e.g. the 'axis of evil' and 'Islamofascism', or as it did as a direct reference in some American reactions to France's decision not to participate in the coalition against Saddam Hussein's Iraq in 2003.[2] Sixty years after its end, World War II continues to occupy a notable presence in television and film. While there have been periods when television programmers and filmmakers have found other topics, and indeed conflicts, more interesting, the last decade or so has seen the

subject become popular again, especially in Hollywood. In television history documentaries, the war is probably the most featured single event or period of the past. A particular matter of interest – if not an obsession (Pugh 2006: 2) – is the Third Reich's twelve-year history, from the rise of Hitler to the fall of Berlin in 1945. The same can be said about the Holocaust.

While the bulk of fiction about the war has been (more or less) serious drama, there are also numerous comedic attempts at covering the subject. This is not, of course, in itself surprising, given the popularity of comedy. Typically television and film comedies ridicule their more serious counterparts, most clearly as straightforward parodies of genre conventions. Comedy can also serve as a tool for alternative interpretations of a subject which are not usually possible for (mainstream) drama, not to mention historical documentaries. A key difference between non-comical and comical is the fact the latter does not have to be truthful, or even in conventional terms to make sense to make a point. A recent example of historical comedy is the German film *Mein Führer – Die wirklich wahrste Wahrheit über Adolf Hitler* (Mein Führer: The Truly Truest Truth about Adolf Hitler, Dani Levy, 2007), which not only through its title claims to reveal the 'truth' about Hitler, but is an obvious reaction to the debate around Oliver Hirschbiegel's 2004 film on the Third Reich's last days, *Der Untergang* (Downfall).

The aim of this article is to look at some major themes in post-war British television and film comedy dealing with conceptions and memories of World War II. The bulk of the works discussed here were produced between the late 1960s and the 1980s, but there are also comedies from the 1990s and the 2000s. The comedic takes on the war vary from feature films to single sketches, and they cover a remarkable spectrum of comedy, including farce, parody and satire. It would be impossible to look into detail in every production, so I have chosen to analyse some comedies in more detail, while others are only referred to. I have also used comedies which were made during the war or outside Britain in addition to non-comedic productions, all of which are used when they appear to support a point. The research on the subject is quite scarce. There have been many excellent studies on films on the war in general, but comedies have been usually only touched upon in these or have appeared only in footnotes. The same is true the other way around: there are of course a great number of studies on comedy, but the question of war in comedy has been studied less.[3] This is understandable, as the vast majority of works about war are serious, therefore non-comical, and that is quite naturally because war is not a laughing matter. Or is it? The number of comedies produced on the subject seems to suggest it can be, at least in retrospect. While I share the belief that while the main purpose of comedy – understood here as Jerry Palmer has defined it, 'comedy-in-intention' (Palmer 1987: 21–22) – is, ultimately, to send things up and make people laugh, at the same time comedy can (and should) make points about the world using means which are often unavailable to non-comical genres.

The article approaches the topic from a number of themes. First, I look at the question of the myth-like post-war notion of wartime national unity, as represented typically in works set on the home front and pre-combat military training in Britain. The comedies discussed here are more often than not military farces, situation comedies and other 'lighter' comical

works, in which the tragedy of war is mostly absent or dealt by means of gallows humour, and subjects such as the horrors of the Blitz are usually only hinted at. In some comedies, the conception of wartime national unity has even nostalgic shades to it, though as we are dealing with comedy, the nostalgia can be considered to contain ironic undertones. It is against this 'myth' that the following themes can be seen working. The second theme is concerned with comic treatments of 'film' Nazis and the problematic British attitudes towards Germans, two issues not always easy to separate from one another. The third theme concerns parodies of various elements of World War II film genre. While there seems to be no out-and-out British feature-length film parody (a subgenre more characteristic of the US film industry), the 'spoofing' of the war film genre is nonetheless apparent in some works, and this arguably arises from comedy writers' willingness to send up clichés which in turn may stem from a degree of boredom with the presence of the war in the various media. From there, the focus shifts to the fourth theme, which is another deconstructive vehicle: how comedy works as a counter-cinematic strategy, and how as such it has challenged conceptions of the war. A special problem is that of making violence and death comic in comedies which are either set in the war or are about the war. Death has not been a subject pushed aside in comedies, and pain has indeed been a common element in comedy ever since the silent film era.

Nostalgia for National Unity

A dozen years after the Second World War we find ourselves in the really quite desperate situation of being, not sick of the war, but hideously in love with it. Not actively fighting, we aren't at peace. The H-bomb looms ahead, and we daren't look at it; so we creep back to the lacerating comfort of 'last time' [...] while we 'adventure' at Suez, in the cinemas we are still thrashing Rommel – and discovering he was a gentleman! – and sweeping the Atlantic of submarines, sending the few to scatter Goering's many. The more we lose face in the world's counsels, the grander, in our excessively modest way, [the more] we swell in this illusionary mirror held up by the screen. It is less a spur to morale than a salve to wounded pride; and as art or entertainment, dreadfully dull. (cit. Hewison 1981: 152)

In this passage from 1958, journalist George Stonier is commenting on contradictions between Britain's current international status and the wave of British films on World War II in the 1950s. Those films very much built on popular conceptions of the war, as well as wartime British cinema, but also further constructed them. The notions of heroic struggle, necessary sacrifices and above all a sense of a national unity led to the idea of the war as Britain's 'finest hour': in a nutshell, after the 'miracle of Dunkirk' and heroism of the RAF during the Battle of Britain, it was, at the end, the British national character (with some help from the Americans) that ensured the victory in 1945 (see for example Dawson and West 1984). With the loss of first-class world power status and the empire, and especially faced with growing social and cultural diversity, such an image of nation turned into a nostalgic

past in the minds of many.[4] Lucy Noakes has argued that the popular memory of World War II, as presented on the public stage, is a synthesis of smaller scale and even private memories. This memory is predominantly that of national unity. It has surfaced again and again, especially during later conflicts Britain has been involved in. Or perhaps it has been reinvented, as the memory of the unity has become a myth, 'a central theme of the popular memory of the war', as Noakes writes (1998: 23). In his book on British national identity, Jeffrey Richards has argued that the long-running television series *Dad's Army* (BBC, 1968–1977), with its popularity is a particularly vivid example of a lasting nostalgic aspect of memories of the war years. Largely based on its characters and down-to-earth humour, the series is about an elderly Home Guard unit, located in a seaside resort, preparing to tackle any German attacks. But as in post-war Ealing comedies, the nostalgia is not, for obvious reasons, for the wartime hardships, death, destruction and austerity, but for the sense of unity, the common effort to survive and, ultimately, to defeat the enemy (Richards 1997: 352–366). The result for *Dad's Army* was '[...] writing which combined to cultivate a set of characterisations that audiences came not only to laugh at but also to live with and love' (McCann 2001: 5).

Two British comedy films set in British Home Front of early World War Two, *Adolf Hitler: My Part in His Downfall* (Norman Cohen, 1972) and *Carry On England* (Gerald Thomas, 1976) belong to the subgenre of military farce, and as such are closely related to the themes of conventional war film, as well as arguably carry the idea of national unity more than most other works discussed in this article. The most apparent feature of the military farce is a 'world turned upside down', as formulated by Mikhail Bakhtin (1984) in his study of the carnival. The army hierarchy, with its chain of command and clearly marked display of rank, has offered a fictional 'false king' a chance to ridicule his or her superiors in many national cinemas. While the first, based on the wartime memoirs of the highly influential post-war British comedian Spike Milligan, also contains moments of tragedy – when the soldiers discover a crash site of a German plane and its dead pilot – and seriousness, it above all displays Milligan (Jim Dale – Milligan himself plays his own father in the film) as the joker that he most likely was, and who makes fools out of army officers. It is definitely worth noting that Milligan's autobiographical book (1971) also documents his traumatic experiences at the front but these are not included in the film. Thus, the film quite firmly remains a conventional military farce.[5]

Carry On England is, in turn, a story about an experimental, 'mixed' anti-aircraft unit of servicemen and women. The film is built on by that time familiar *Carry On* elements, most notably sexual and bodily humour. The recruits, when not engaged in sexual activities, are trying their best *not* to learn any military skills and at the same time humiliate their stereotypically uptight commander by every means possible. In comparison, the earlier *Carry On* military farce set in the modern day, *Carry On Sergeant* (Gerald Thomas, 1958), has the recruits be merely incompetent and their superior, a Sergeant, a likeable authority, and perhaps importantly, an NCO rather than an officer. In *Carry On Sergeant* the recruits learn their Sergeant is retiring from the military and would have wished to train the last

Sexual and bodily humour on the British Home Front in *Carry on England* (Rank Organisation, 1976).

squad trusted to him to the best of the company. A happy ending results as the recruits work hard and rather predictably, pass the inspection as the best squad. Through their efforts, the recruits become good soldiers. *Carry On England* differs from its predecessor in some respects, but not actually in its ending. As a sign of times, the new element is a stronger emphasis on gender and sexual matters, which is in line with the development of the *Carry On* series, but there is another relevant difference, the film's historical setting: unlike its predecessor, *Carry On England* is set in wartime. In the end, this turns out to make little difference because of the (sub)genre: despite having virtually no training, during a sudden air raid the recruits shoot down every visible German plane, thus completely contradicting the tagline of the film, 'The Luftwaffe has never had it so easy'. These contradictions are of course perfectly acceptable in the world of comedy, but the turn of events also leads to the film's curious 'happy end'. The ending, by its very 'happiness', confirms the temporary nature of the carnival. The subordinates have rebelled against the army discipline, but an unexplained display of military prowess and obedience ambivalently reverts them back to their place in the hierarchy, and suddenly as able gunners, too. Simultaneously, social (implicitly national) unity is achieved as everyone works for the same goal, defeating the enemy.[6] In the light of what has been written of the popular conceptions of World War II in Britain this is logical, though as we are dealing with comedy it is also 'the logic of the absurd', as Jerry Palmer (1987) has called it, working for the Britons here.

This nostalgia for the war period is of course not a simple subject. While it seems appropriate to argue that the style and indeed the success of the wartime comedies, especially on television, supports the notion of nostalgia, the subject is without doubt one of ambiguity.[7] Another long-running television situation comedy *Goodnight Sweetheart* (BBC, 1993–1999) approaches the question of a nostalgic past of the war era in a conspicuously articulated fashion. While searching for a backstreet address, television repairman Gary Sparrow (Nicholas Lyndhurst) wanders into what he concludes to be a '1940s theme pub', only to slowly realize he has actually entered wartime London during the Blitz. His suspicious behaviour causes him to be taken as a German spy, but he wins the trust of his compatriots by saving the pub owner's life using his present-day first aid skills. Returning to the present day by walking through the same alley he entered to into the past, a 'time portal' of sorts, he finds it impossible to share the experience with his wife or, for a while, his best mate. The show, in the tradition of time travel fantasies, builds on the juxtapositions of the past and the present, and here also on the comedic theme of living a dual life. However, unlike some other works with similar themes, *Goodnight Sweetheart* makes it clear that Sparrow very much prefers the past over the present. He has serious trouble living up to the expectations of his career-minded wife (Michelle Holmes, later replaced by Emma Amos) and, as his wife says, instead of seriously pursuing a more respectable career, Sparrow 'takes up a healthily obsessed interest in … the Second World War'. Sparrow not only finds it easier to court a woman, Phoebe (Dervla Kirwan) in the 1940s – despite the fact that she is married and her husband is in the service – but also soon realizes that the increasing number of history books he owns give him a chance to influence the fortunes of those close to him in 1940

(e.g. warning them when the next major German air attack will take place) better than lead his own present-day life. Further, even before he finds himself more and more committed to this dual life, Sparrow expresses a kind of sadness that today's men do not have a similar 'initiation rite' to manhood as past generations had through military service.

The series finally concludes with Sparrow finishing his 'initiation rite'. Fittingly, it is on V-E Day that he finally decides to face his present-day wife and tell her he will not be returning to her anymore. What finally seems to inspire his decision is crucial. He listens to MP Clement Attlee's uplifting campaign speech on re-building Britain after the devastations of war at an unpretentious gathering at an East End Workers' Club. His present-day wife is also a member of the Labour party, but the image given of the political culture of today is less than complimentary, and at one point Sparrow has cynically commented on his wife's climb up the party hierarchy. In addition, a series of heroic deeds during the war, including his outwitting of a group of German soldiers behind enemy lines, all serve to underline the conclusion that Sparrow is more a man than he ever was before in the 1990s. Sparrow chooses a life in the past where he will not know about future events beforehand, but it is obvious that here Sparrow is forever free from the pressures he found so hard to cope with in his original present. Thus, *Goodnight Sweetheart* carries a nostalgic idea of the past, in which the hardships of life were evened out by a simpler, more social existence.

While a large portion of the nation was not involved in the actual fighting, most did otherwise work for the war effort and ultimately they all lived through the wartime. The civilian experiences at the home front were dealt with from another angle in the film *Till Death Us Do Part* (Norman Cohen, 1969), based on another long-running BBC situation comedy of the same name (1965–1975). The film makes fun at the expense of exaggerated patriotism through the main character of Alf Garnett (Warren Mitchell), a man of ironic contradictions: a passionate Tory despite his working-class status and a ranting patriot who expects his fellow countrymen to fight heroically but who himself is shocked by orders to enter military service. He manages to keep himself a civilian. As a character, Garnett is firmly rooted in the tradition of dramatic irony: the audience is well aware of the collision between his rants and (in this case historical) events, the latter which preferably occur right after Garnett has said his piece. After the British troops have managed to perform 'the miracle of Dunkirk', Garnett is shown boasting in a pub how the Germans will never be able to attack the Isles, thanks to the superiority of the British navy. This is followed immediately by a cut to a scene of him in a bomb shelter during a German air raid – something the audiences would have expected, had they been given the time. While the play between Garnett's beliefs and the expected is mainly light-hearted comedy, the writers also remind us of what necessarily is involved in war and again, of our historical knowledge: after stock film footage of an atomic bomb exploding, Garnett is seen mocking the Japanese: 'One little bomb and they pack it in!' In Garnett's experience, Hiroshima and Nagasaki are a distant issue, but for him the war has been as well for the most part. The horrors of the Blitz seem to have both reinforced his patriotic attitude but also not have made him more empathetic towards human suffering in general. That he soon finds it hard to participate in victory celebrations

is born out of the sense of guilt of him doing his best not to help in the war effort. It is only in 1966, at the stands at Wembley stadium as England defeats West Germany in the football World Cup final that he really appears to acquire a victory he can feel part of.

The British, the Germans and Nazism

Interestingly, British comedies on World War II are almost exclusively set in the European theatre of war, i.e. the fight against Germany. One reason is probably financial, as shooting a film about the European theatre is much easier and thus less expensive to stage in Britain. Another reason might be that the fighting at the Pacific theatre could be seen just as well as a part of the imperial conflicts, which continued after World War II. This explanation is possible through a consideration of *Privates on Parade* (Michael Blakemore, 1982), which is set in Malaysia in 1947. The film about a highly 'camp' Army entertainment group SADUSEA (Song and Dance Unit South East Asia) features a scene of a lecture on the dangers facing the Empire by the unit's CO, Major Flack (John Cleese). The major's description of events leading to the fall of the British garrison in the region during World War II is highly humoristic in style and content to the point of mocking. The major explains that the attitude of the British command to the Japanese was disparaging ('My dear chap, Britannia rules the waves') and goes on to explain how the Japanese surprised the British by arriving by bicycles, ringing their bells 'ting-a-ling'. The speech makes the major's subordinates laugh, to which the major – true to a military tradition of presenting something serious in a funny way – responds by shouting 'it's not funny!' Here, the major's story about World War II serves merely to remind the men of the dangers of the next enemy, which is of course logical because the film is set in the post-war era. Otherwise, the past war in the Far East is absent from the film, as it is from British comedy on the war in general. It is thus worth noting that yet another long-running BBC television situation comedy set in World War II but, as an exception, in the Pacific theatre, *It Ain't Half Hot Mum* (BBC, 1974–1981), is also about an entertainment unit, the Royal Artillery Concert Party. For the purposes of this article, however, we concentrate on the European theatre and the fight against the Germans.

In the *Monty Python's Flying Circus* (BBC, 1969–1974) sketch *Mr Hilter*, Adolf Hitler (John Cleese) and a few other Nazi leaders have not only survived the war, but have also managed to immigrate to late 1960s Britain. They have set up a party, the National Bocialists, and with Hitler as their candidate are trying to win an election in Minehead, Somerset while planning the recapture of Stalingrad. As the title of the sketch alone suggests, the men have done little to disguise themselves, and are in fact dressed in their uniforms, marching under swastika banners. Despite this, the locals are almost completely nonchalant about the group. The audience for Hitler's campaign speech, delivered in familiar (if nonsensical) tones, consists of three children and a peasant. Public opinions ('vox pops') on the party are also mostly dismissive or make little sense, and while to one character the name 'Ron Vibbentrop' rings familiar, the closest identification Hitler gets is 'Haven't I seen him on

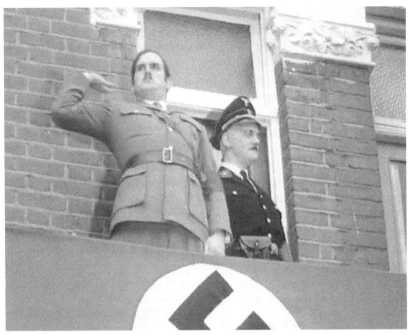

Mr. Hilter (John Cleese) and the National Bocialists in Episode 12 of *Monty Python's Flying Circus* (BBC, 4 January 1970).

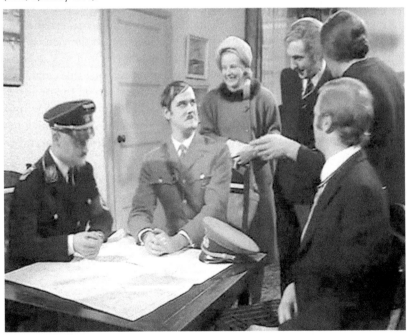

television?'[8] The sketch hardly refers to the fact that Hitler's physical remains were not, from the Western Allies' perspective, unquestionably discovered, and that this would explain his appearance in the 1960s Britain. On the contrary, the fact that Hermann Göring, one of the Nazi leaders accompanying Hitler in the sketch, had committed suicide during the Nürnberg trial in 1946, has not stopped comedians from reviving these historical figures for the sake of comedy. By means available almost exclusively to comedy, the sketch plays on both Britain's relationship to Fascism and on the other hand, Hitler's rise to power in general. After the war, Fascism was easy to see as even more alien to British culture than before it. Even though Sir Oswald Mosley's 'Blackshirts' gained visibility for several years in the 1930s, the movement never became that popular and as the war started, the party lost any hope it had of having a lasting influence in national politics. But there was a widespread belief during the war that considerable parts of the upper classes still in fact supported Fascism, a belief that was already articulated in wartime fiction, as well as later (Richards 1997: 45; Pugh 2006). Also, by portraying Hitler as the raving war-monger he was, the sketch poses the question asked around the world after the war: how was his rise to power possible? The sketch ridicules Hitler himself in the traditions of Chaplin and Allied wartime propaganda, but with all the post-war information on Nazi atrocities, in far a more ambiguous way, which is connected to both World War II and the British attitudes towards Germans in general.

Here it is useful to take a look at a non-comedic but in other ways 'alternative' film for context. *It Happened Here* is an independent 1964 British drama by Kevin Brownlow and Andrew Mollo. The film, set in 1944, writes an imaginary history of Britain under occupation by Nazi Germany. The film's depiction of events and themes relating to World War II was met with an outraged reception despite the fact that the film originally received a very limited release, and that there were other imaginary, 'what-if' histories in the victorious countries, especially in the United Kingdom and in the United States. The film was accused of being pro-fascist and anti-semitic, but it might have been other reasons that finally created the controversy. The film contains scenes of German troops marching on the streets of London, and Nazi rallies at Trafalgar Square. The combination of historical national monuments and symbols of a monstrous, though defeated ideology appeared to be simply too much for many, even some public officials. This leads to the question of why a fictional story of a Nazi-occupied Britain stirred up such a controversy.

In his book on British-German relations, John Ramsden (2006: 378–381) observes that while one of Brownlow's aims was to humanize Germans, in the film there are no Germans shown to resist Fascism. Ramsden is, I believe, correct, but it is important to consider the film's setting: no 'ordinary' Germans are portrayed. Instead, their presence is merely by occupational forces representing the Nazi political system, enforced on the British through the army and the SS. It is the British whose reactions and actions to a Nazi invasion and political propaganda are being speculated upon. The film's title is the key reference point here: *It Happened Here*; the primary historical point of reference in the film is of course that unlike in reality the Germans have managed to invade Britain. But more importantly, the film is about ordinary people's fates and choices under Nazism. The controversial implication

of the film is the idea that the British, or anyone else, could have been equally receptive to Nazi propaganda, and become at least more-or-less willing collaborators, as the Germans once were.[9]

The Holocaust and ordinary Germans' responsibility for it has clearly been seen in retrospect as a key phenomenon of World War II. The vigorous World War II satire *How I Won the War* (Richard Lester, 1967) approaches the Holocaust in a straightforward but multifaceted manner. This happens in a grimly casual discussion between a British soldier and a German officer. The Briton asks the German whether he has killed any Jews, to which the German replies, 'Of course. Hasn't everybody?' The dialogue provocatively addresses the combination of German collective guilt of the event and the avoidance of personal responsibility of the actual killing. It is more difficult to say whether the exchange also refers to the commonness of anti-semitism of the era, and to the fate of Jews through their history, but the notion of the everyday nature of killing appears evident. As Ramsden (2006) has demonstrated, the question of whether Germans were naturally bad or just badly led was again brought up – the question was first asked during World War I, sparked by the reported German atrocities during that conflict – after the news of the sheer volume of the mass killings began to be realized by the public. Germany was again seen in World War II as the sole reason for the war, and what had happened during it made many not bother to make a distinction between a Nazi and a German. According to Ramsden, while political relations between the countries (i.e. Britain and West Germany) became normal as allies,

> from the 1970s onwards, the process went into reverse: although diplomatic relations between the two governments remained as good as those that Britain enjoyed with her other allies, elsewhere resentment apparently increased, as is evident in television programmes, novels, newspapers, comedy routines, the chanting of football crowds and every other manifestation of our popular culture. It became not just acceptable but almost obligatory to refer to the Second World War, when 'we' beat them, when 'we' had right on our side and 'they' sold their souls to the devil in a Faustian pact with Hitler. (Ramsden 2006: ix–x, 121–126, 180, 207–211)

As Tony Barta (1998) has argued, there has been a remarkable fascination in Western popular culture with what he has named 'Film Nazis'. In Britain, this has been shown not only in the number of films and television productions in which you can see them, but indeed a wider spectrum of popular culture. Prince Harry was seen wearing a home-made Nazi uniform prior to his leaving to serve in Iraq, which seems strange given the attributes attached to the war, and not surprisingly, caused a small scandal. Another example of the recurrence of Nazi motifs is late 1970s punk rock, of which popular culture historian Greil Marcus (1989: 116–119) has provocatively said was a sign of Nazism being triumphant in the war! Returning to Barta's argument, he means that the historical Nazis (which in itself is hardly an unproblematic term) 'escaped' from history into the movies – movies (and television shows) ranging from 'conventional' war and adventure films to the most obscure

141

exploitation movies. Nazis became a staple of the entertainment industry, and thus for the generations who did not encounter the historical Nazis, the next worst thing are the 'movie counterparts' (Barta 1998: 127–148). Typically, as we know, Film Nazis are not too clever brutes, who may have conquered continental Europe but make all the wrong decisions when faced with a group (usually remarkably smaller than theirs) of British or American soldiers. It is this image which works as the reference point for many British comedic takes on the subject: the Nazis are indeed similar to their 'dramatic' (i.e. non-comedic) representation. It appears 'serious' filmmakers have done some of the work for the comedians, and what is added is the necessary wink of an eye, even in the shape of a gross exaggeration, providing Film Nazis with their parody counterparts – Comedy Nazis. One reference to this is the British television comedy *That Mitchell and Webb Look* (BBC, 2006–) which includes a sketch in which German Waffen-SS soldiers discuss that are they 'the baddies', because they have 'these little skulls on their hats'. It is with such self-reflection that parody operates.

Comedy as Counter-Cinema

While the likes of Monty Python's *Holy Grail* and *Life of Brian* operate as parodies of historical drama films, there have been no clear-cut British feature-length parodies of World War II fiction films.[10] This is surprising given the multitude of war films produced in Britain, and hence I shall begin with an American example. Probably the best known feature length 'spoof' of the World War II film genre is *Top Secret!* (Jim Abrahams, David Zucker and Jerry Zucker, 1984). Despite the fact that the film is about an American rock 'n' roll singer's visit to East Germany during the Cold War, the film is clearly a parody of the World War II espionage films.[11] In addition to many other obvious references, there is a French resistance movement working underground – in Germany! A key comic idea in the film is based around visual jokes which play on the cinematic aspects of filmmaking, some of which are more general (e.g. usage of reversed film), and many which are genre related. For example, in a scene typical for World War II films, the protagonists are observing how a German garrison is sending out a column of vehicles to pursue the resistance fighters, but as the camera zooms out we learn that there are actually just a few vehicles driving in a circle, something the camera's closer-up shot had hidden. Similarly, when the hero is crawling across a field he bumps into a pair of boots, only to find that what he has encountered is indeed just a pair of boots. The enemy soldier we had expected to see pointing his gun at the hero is nowhere to be seen. Through techniques like this, the film dismantles typical visual clichés of the genre in similar fashion to those that Peter Wollen (1982) has written about in relation to Jean-Luc Godard's avant-garde cinema.

Wollen demonstrates the idea of counter-cinema through a set of cinematic counter-positions. For our purposes here, the central idea is that counter-cinema makes a point of breaking down and revealing the conventions and techniques used by conventional mainstream cinema. Counter-cinema constantly reminds the spectator that they are

watching a film as a constructed entity by means such as revealing the presence of the camera, disrupting the narrative and generally destroying the sense, or illusion, of reality which is usually the objective of mainstream cinema; closure is replaced with aperture. All this leads to the spectators' estrangement as opposed to identification with the characters or the events (Wollen 1982: 79–91). Comedy often works towards the same goal. The examples above from *Top Secret!* parody the conventions of war films in order to mock these conventions, and the spectators, if they are familiar with the war film genre, will recognize the parody approach. The next time the same spectators watch a serious war film they will probably pay attention to the clichés, and can even chuckle when they spot one. However, a more engaging set of works are those which seek to go beyond genre parody in counter-cinematic techniques.

Jeanine Basinger (2003: 110–111) has argued that in the United States, the focus on realism in the 1950s war film was replaced in the 1960s by lavish epic style, which started to become the point of reference to the war as opposed to the real and documented experiences of the war. Many of these films were international productions and featured famous American and British (as well as sometimes German) actors in the cast. These films classified as 'the action adventure epics of the 1960s', such films as *The Guns of Navarone* (J. Lee Thompson, 1961), *Operation Crossbow* (Michael Anderson, 1965), *The Heroes of Telemark* (Anthony Mann, 1965) and *Where Eagles Dare* (Brian G. Hutton, 1968) are, according to Robert Murphy (1992: 7), less rooted in the British culture. They were nonetheless popular, and have served as an inspiration for parody in subsequent comedies. The American film *Top Secret!* includes a scene which highlights one parody element of the film: The Resistance fighters and the Germans are engaged in a fierce hand-to-hand combat. One of the Resistance fighters steps up and fires a long burst with a submachine gun towards the battling group. Against all odds, and indeed any notion of realism, only the Germans fall down dead. This can be seen as a direct reference to numerous films, in which 'the good guys' develop astonishing shooting skills just at the right moment.

On the other hand, this applies not only to such films as *Where Eagles Dare* – see the bus getaway sequence towards the end of the film, with characters mowing down German troops with consummate ease as their vehicle races through the town to the airfield – but also Alberto Cavalcanti's wartime drama *Went the Day Well?* (1942). The final battle scene between the German troops and the civilians has almost a cheerful tone to it. While this can be understood as a morale-lifting cinematic moment for the fighting nation, the same theme is also present, as described above, in *Carry On England*. An important similarity for all the films is the 'otherness' of the enemy. In *Went the Day Well?* the enemy is, even through fictional, a very real one as the war was far from over. In *Where Eagles Dare*, the enemy's nature is two-fold, but at the same time unified: as the film can be indeed classified as a war adventure, in which the enemy are 'baddies' (as in any genre to have a more or less clear-cut side of identification), and as war film is one genre in which violence is the norm of 'settling differences', killing the enemy is considered natural. The Germans in the film are also Film Nazis, which makes them even more appropriate as targets for serial killing. In a

Civilian resistance against German troops in Alberto Cavalcanti's *Went the Day Well?* (Ealing Studios, 1942).

way, the treatment of Nazis in post-war fiction can also be seen as an imaginary revenge for the crimes committed by the Third Reich.[12] It would perhaps be an exaggeration to see *Carry On England*'s comical anti-aircraft battery's superb performance in this light, but at the same time the implication might be there. Besides being an example of a comedic happy ending discussed earlier, it is a lighter example of the more graphic comic violence of the *Top Secret!* scene. All this highlights the ambiguous nature of comedy, and poses questions in defining its subgenres. For example, one can ask where the line should be drawn between parody and satire within an individual production.

The 1950s saw a steady production of British war films more or less celebrating the nation's war efforts, but the late 1960s marked the start of more ambiguous and, at least in one case, even downright hostile interpretations of the 'finest hour': in a way, re-construction was replaced with deconstruction. While much of what could be defined as anti-war fiction commented on the contemporary confrontation of the East and the West, the threat of nuclear war and the Vietnam War, more critical popular works dealing with World War II also surfaced. This was especially the case with *How I Won the War*. The film is probably mostly famous for featuring John Lennon (as Corporal Gripweed) in the cast. But at the same time, it is a most hostile satire about the senselessness of war, and also seeks to highlight and call into question aspects which are considered normal in war films by making them absurd or otherwise unnatural. Set in North Africa, the story is typical for a war film, a secret mission behind enemy lines, but with a twist: the troop's task is to find a suitable location for a cricket field – in fact, many of the comedies cynically refer to the notion of war as a sport, which is in turn related to the idea of military gallantry.[13]

If later conflicts have spurred or reinforced the idea of World War II as a justified, even a 'good' war (most notably in the rightfulness of defeating Nazism/Fascism and stopping

the Holocaust), then the latter has served to further highlight the problems concerning the World War I. This is true to the extent that World War I has become perhaps *the* reference point to the madness of war, with its trench warfare and open-field charges against machine-gun fire. As discussed above, British war films largely also presented the fight against the Axis as perhaps costly, but necessary. However, the more cynical films began making none-too-subtle allusions from each war to the other, and this is exactly the case with *How I Won the War*. In the film, all the soldiers under the command of Lieutenant Goodbody (Michael Crawford) are killed during the war, more often than not because of their leader's incompetence and above all, lust for glory, as noted in the film's title. The comradeship familiar from traditional World War II films is nowhere to be witnessed, and is replaced with a popular idea of indifference to the common ranks' casualties among the officer corps as a natural part of the machinery of war, a mentality shared in the film by officers on both sides.

Violence, death and suffering are at the very heart of any war. It is therefore crucial to ask how the matter is dealt with in comedy; how is death presented in comical terms? Explicit violence has, after all, occupied a notable role in works of comedy, from the slapstick of the silent film era, through the fable cartoons to modern comedy like Monty Python and to the 'horrors' of the splatter films of the 1980s, and beyond. This can be seen in relation to Bakhtinian notion of 'grotesque', in which exaggeration and the human body are key elements.[14] In the television shows and films discussed here, these issues are mostly absent or only alluded to (the bombed houses of London streets in *Till Death Us Do Part*, or German planes being shot down in *Carry On England*). This is because either the events do not take place in battlefields or stem from genre conventions, as in the case of traditional situation comedy (e.g. *'Allo, 'Allo!*, BBC, 1982–1992[15]), but probably also because of sheer tactfulness. In the WW I comedy *Blackadder Goes Forth* (BBC, 1989) the massacre of trench warfare and death in general are repeatedly talked about. While most of the dialogue on the subject is suitably laconic, after receiving the death penalty in an absurd court martial Captain Blackadder (Rowan Atkinson) is forced to face a firing squad. The firing squad is hysterically joyous, making jokes and even pulling a prank on their 'customer'. Evidently the morbid task of executing their own men has led to the squad's reasoning that taking a humorous mode makes the situation easier, as suggested by the leader of the team ('You see, laughter and a smile and all of a sudden the job doesn't seem quite so bad after all, does it, Sir?'). Because of the comic genre, Blackadder of course participates dryly in the squad's joking, and is coincidentally saved from being shot at the last minute. Throughout the whole series, various characters have articulated the almost certain death an attack would mean. At the end of the last episode, Blackadder and his men are faced with the attack order. The spectator once again expects the characters to be saved from the battle, but this time they cannot find an escape from the task of attacking the enemy lines. Ultimately, there seems to be no comical solution to the situation. Instead, the soldiers climb from the trench and charge forward. What follows is film in slow motion, men yelling, explosions and a fade edit to another shot. The studio battlefield set is replaced with an image of a peaceful flowery

meadow, carrying no evidence of the battle. Because *Blackadder Goes Forth* is a situation comedy about war, the makers have not found a comical way to show the characters' fate. According to the genre conventions, most cynical references to death in the battlefield are possible, but the visualization of the men getting killed is not.[16]

Opposing works such as *How I Won the War* or the World War I musical *Oh, What a Lovely War!* (Richard Attenborough, 1969) display explicit violence and death, but with a set of 'alienating' methods used to remind the viewer that they are not watching a war but a film – a notion that is highlighted by mixed footage of feature and documentary film, as well as still photography. For example, in *How I Won the War* the 'dead' soldiers do not 'die', but continue to follow the squadron, albeit as single-coloured 'toy soldiers' (in line with the toy soldier idea, the higher ranking officers collect bubble gum cards of battles they send their men into). Yet at the same time, these methods have implications, as they are watching a film about a historical war. Daniel Pick (1993) has argued how slaughter was rationalized in the nineteenth century and how the idea carried itself over to warfare as well.[17] These darker comedies set on the battlefield 'reverse' the process, which means they irrationalize the slaughter by cinematic means, but also question the reason behind the sacrifices.

Conclusion: A Killer Joke?

The Holocaust is commonly considered to be the most monstrous act of World War II (or indeed any war). The possibilities and the ethical problems of its representation have been a much-debated issue. Nonetheless there have of course been numerous television and film works on the subject. Interestingly, it has been argued that the very failure of dramatic (and indeed tragic) treatment of the Holocaust is behind the recent comedies *La Vita è bella* (Life Is Beautiful, Roberto Benigni, 1997), *Train de vie* (Train of Life, Radu Mihaileanu, 1998) and *Jakob the Liar* (Peter Kassovitz, 1999) (Hoberman, J. 1999; Žižek 2000; Salmi 2000). The almost complete absence – *How I Won the War* is an important exception – of the Holocaust in British comedy arises from at least two reasons, one international and one national. First, the aforementioned problematic nature of seeking to address the genocide in dramatic, let alone comedic terms. Second, the British comedies on the war stem, above all, from *national* experiences and cinema, to which the Holocaust does not belong. There was no 'The Goons of Buchenwald' on the BBC (See Whitehouse 1971: 75).[18]

Instead, the Monty Python troupe has recalled (Chapman et al. 2003: 283–288) how in 1971 they were invited to West Germany to make a comedy show. With their characteristic readiness to make a joke, they later presented the German television station's request as 'We don't have a sense of humour, but we understand you do' (see also *Monty Python Live at Aspen*, 1998). They then went on to claim that the first thing their German hosts did was to take them to see the Dachau concentration camp. There was a problem, however, as the museum was closing and they were not allowing any further visitors that day. Graham

Chapman suggested they should claim to be Jewish; they did, and they were allowed in. Whether it was a case, as the Pythons suggested, of their German hosts wanting to 'get over it' (i.e. the issues of the Holocaust and the last war in general) or not, it is clear that the former enmities cannot be consciously forgotten, and despite the countries being now allies in NATO, political or military alliances will not wipe away what in this case are difficult memories. A sense of humour can help though, as suggested by an episode of the situation comedy *Fawlty Towers* (BBC, 1975; 1979): set in present-day (mid-1970s) Britain, the hotel receives German guests. Basil Fawlty (John Cleese), who is suffering from concussion (a very typical comedy injury of course), cannot relate the Germans to anything but the war and keeps reminding his staff 'not to mention the war'. And no one else but he does. Trying to take the Germans' lunch order, he repeatedly refers to the Nazis and the war, which visibly upsets the Germans. After reminding them that Germany started the war and then trying amuse them by doing a Hitler impression which is not favourably received, he yells, 'You people don't have a sense of humour', before adding, 'Who won the bloody war anyway!' The combination of these lines is interesting.

In their mid-1930s book *Foreigners*, Theodora Benson and Betty Askwith offer comical descriptions of other nations for English readers. After sending up many stereotypical conceptions of the Germans, the authors comment on the state of the Third Reich:

> We have so far got through this article without reference to that somewhat comical trio Hitler, Göring and Goebbels. So many dreary things are known about them all that it is difficult to select the objects of universal knowledge. We shall content ourselves however by mentioning Göring's lion-club, Goebbels' Jewish grandmother and Hitler's Face. A nation which could put a face like that at the head of affairs has naturally no sense of humour. (1936: 59)

This idea was still popular after the war. In the *Flying Circus* sketch 'The Funniest Joke in the World' Ernest Scribbler (Michael Palin), 'a writer of jokes', comes up with a joke that is so funny that everyone who reads or hears it dies. Soon the military become interested in the joke. The 'Killer Joke', as it is dubbed, proves to be a great success, and '60,000 times as powerful as Britain's great pre-war joke [a cut to stock footage of Chamberlain brandishing the Munich pact] … and one which Hitler just couldn't match'. After translating it into German, the British Army uses it as a weapon against the enemy: instead of using conventional arms, British soldiers charge forward reading the joke, and German soldiers die left and right, rolling from laughter. So perhaps in line with the 'killer joke' that the Germans just could not match, comedies for their part suggest that the British won the war thanks to their superior sense of humour?

Despite total victory by the Allies, and the types of images and rhetoric mentioned at the start of this article, World War II also remains a subject with controversies. Most of these are of course debated within historiography. Even given the time that has passed, matters such as the Munich Pact, mass bombings of German cities or the Allies' knowledge of the

Holocaust during the war remain delicate and even heated issues. The histories of many of these subjects will probably be rewritten as new information is uncovered from previously unavailable archives (Keegan 1995). How that would, or will, effect popular conceptions or interpretations remains to be seen. That British film and television comedies on the war started to emerge in larger quantities in the latter half of the 1960s can probably be explained by the temporal distance to the end of the conflict. Even if the people and the nation as a whole were facing new challenges, the war was still very much present in various ways, across the spectrum from everyday lives to products of popular culture – the fact that these comedies were made serves as evidence of this. Perhaps the younger generations who produced most of these works were tired of war and the national myths built around it. War in general had become all the more unpopular because of the Vietnam War and the youth movements opposing it. As suggested in the case of military farce, some comedies set in the war were actually not that preoccupied with the war itself. Nonetheless, even they were set in a wartime context and have to be considered as part of the fictions the memory and conceptions of the era produced. The references to the darker side of the war years were often ambiguous, as demonstrated by, for example, the 'Mr Hilter' sketch. *How I Won the War* is an opposing example, and as described while dealing with some issues – and in a way, the whole war – with outright hostility, the film used alienating, counter-cinematic means to portray the very key element of war, death. It is easy to imagine the wide range of reactions, from light-hearted laughter to anger, that this variety of comedies inspired in their audiences. This is largely due to the ever-present critical potential of comedy, which has at least two features. First, it does not have to be serious or non-comical about anything. Second, in relation to the first aspect, comedy is practically free from being truthful. Interpreting any piece of comedy is always difficult, thus we are prone to do this in terms of subgenre. But this is not unproblematic. For example, according to Linda Hutcheon (1985), there is a critical distance between a parody and the object of the parody. I agree with Hutcheon, but at the same time I think this applies to all comedy. As Michael Palin of the Monty Python troupe has stated (quoted in Landy 2005: 32), 'Comedy's job is to be against things, not for them'. War is such a thing.

Bibliography

Aldgate, Anthony and Richards, Jeffrey, *Britain Can Take It: The British Cinema in the Second World War*, Oxford: Basil Blackwell, 1986.

Bakhtin, Mikhail, *Rabelais and His World*, Bloomington: Indiana University Press, 1984.

Barta, Tony, 'Film Nazis: The Great Escape' in Tony Barta (ed.) *Screening the Past: Film and the Representation of History*, Westport: Praeger, 1998, pp. 127–148.

Basinger, Jeanine, *The World War II Combat Film: Anatomy of a Genre*, New York: Columbia University Press, 2003.

Benson, Theodora and Askwith, Betty, *Foreigners or, The World in a Nutshell*, London: Victor Gollancz Ltd, 1936.

Boyd-Bowman, Susan, 'War and Comedy' in Geoff Hurd (ed.) *National Fictions: World War Two in British Films and Television*, London: British Film Institute, 1984, pp. 39–42.

Brownlow, Kevin, *How It Happened Here: The Making of a Film*, first published in 1968, Ware: UKA Press, 2007.

Chapman, Graham et al., *The Pythons: Autobiography by the Pythons*, London: Orion, 2003.

Dawson, Graham and West, Bob, 'Our Finest Our? The Popular Memory of World War II and the Struggle over National Identity' in Geoff Hurd (ed.) *National Fictions: World War Two in British Films and Television*, London: British Film Institute, 1984, pp. 9–11.

Hewison, Robert, *In Anger: British Culture in the Cold War 1945–60*, Oxford: Oxford University Press, 1981.

Hoberman, J., 'Dreaming the Unthinkable', *Sight and Sound*, 9:2 (February 1999), pp. 20–23.

Hurd, Geoff (ed.), *National Fictions: World War Two in British Films and Television*, London: British Film Institute, 1984.

Jordan, Marion, 'Carry On … Follow That Stereotype' in James Curran and Vincent Porter (eds) *British Cinema History*, London: Weidenfeld and Nicolson, 1983, pp. 312–327.

Keegan, John, *The Battle for History: Re-Fighting World War Two*, London: Pimlico, 1995.

Laine, Kimmo, *Murheenkryyneistä miehiä? Suomalainen sotilasfarssi 1930-luvulta 1950-luvulle* ('Finnish Military Farce from the 1930s to the 1950s'), Turku: Finnish Society for Cinema Studies, 1994.

Landy, Marcia, British Genres: Cinema and Society, 1930–1960, Oxford: Princeton University Press, 1991.

——, *Monty Python's Flying Circus*, Detroit: Wayne State University Press, 2005.

Marcus, Greil, *Lipstick Traces: A Secret History of the Twentieth Century*, Cambridge, MA: Harvard University Press, 1989.

Mäkelä, Janne, *Images in the Works: A Cultural History of John Lennon's Rock Stardom*, Turku: University of Turku, Cultural History, 2002.

McCann, Graham, *Dad's Army: The Story of a Classic Television Show*, London: Fourth Estate, 2001.

McFarlane, Brian, 'Losing the Peace: Some British Films on Postwar Adjustment' in Tony Barta (ed.) *Screening the Past: Film and the Representation of History*, Westport: Praeger, 1998, pp. 93–108.

Milligan, Spike, *Adolf Hitler: My Part in His Downfall*, Harmondsworth: Penguin Books, 1971.

Morris, David B., *The Culture of Pain*, Los Angeles: University of California Press, 1991.

Murphy, Robert, *Sixties British Cinema*, London: British Film Institute, 1992.

——, *British Cinema and the Second World War*, London: Continuum, 2000.

Noakes, Lucy, *War and the British: Gender and National Identity, 1939–91*, London: I.B. Taurus, 1998.

Palmer, Jerry, *The Logic of the Absurd: On Film and Television Comedy*, London: British Film Institute, 1987.

Pick, Daniel, *War Machine: The Rationalisation of Slaughter in the Modern Age*, New Haven, CT: Yale University Press, 1993.

Pugh, Martin, *'Hurrah for the Blackshirts!': Fascists and Fascism in Britain between the Wars*, London: Pimlico, 2006.

Ramsden, John, *Don't Mention the War: The British and the Germans since 1890*, London: Acabus, 2006.

Richards, Jeffrey, *Films and British National Identity: From Dickens to Dad's Army*, Manchester: Manchester University Press, 1997.

Salmi, Hannu, 'Mieletön maailmanhistoria – Historiallisen komedian nauru menneisyydelle' ('Historical Comedy Laughs at the Past') in Anu Koivunen, Susanna Paasonen and Mari Pajala (eds) *Populaarin lumo – mediat ja arki*, Turku: University of Turku, Media Studies, 2000, pp. 389–406.

Sheffield, G.D., '"Oh! What a Futile War": Representations of the Western Front in Modern British Media and Popular Culture' in Ian Stewart and Susan L. Carruthers (eds) *War, Culture and the Media: Representations of the Military in 20th Century Britain*, Trowbridge: Flicks Books, 1996, pp. 54–74.

Stam, Robert, *Subversive Pleasures: Bakhtin, Cultural Criticism, and Film*, Baltimore: John Hopkins University Press, 1989.

Taylor, Philip M. (ed.), *Britain and the Cinema in the Second World War*, Basingstoke: Macmillan, 1988.

Torgovnick, Marianna, *The War Complex: World War II in Our Time*, Chicago: University of Chicago Press, 2005.

Whitehouse, Mary, *Who Does She Think She Is?*, London: New English Library, 1971.

Wiener, Jon, *Come Together: John Lennon in His Time*, New York: Random House, 1984.

Wollen, Peter, *Readings and Writings: Semiotic Counter-Strategies*, London: Verso, 1982.

Žižek, Slavoj, 'Camp Comedy', *Sight & Sound*, 71:4 (April 2000), pp. 26–29.

Notes

1. http://www.youtube.com/watch?v=VA5lKOYzqAQ. The video was posted 19 February 2008. Unfortunately, I have to trust my memory here. The comment option on YouTube was later disabled by the poster and the comments removed, while at the Internet Movie Database the relevant threads are no longer visible.

2. On American, especially 'post-9/11', references to World War II, see for example Jeanine Basinger, *The World War II Combat Film: Anatomy of a Genre* (2003); Marianna Torgovnick, *The War Complex: World War II in Our Time* (2005).

3. Two notable exceptions concerning studies on comedy and World War II are Susan Boyd-Bowman's article 'War and Comedy' from 1984, and Robert Murphy's chapter dedicated to comedy in his book *British Cinema and the Second World War* (2000). On wartime comedies see Anthony Aldgate and Jeffrey Richards, *Britain Can Take It: The British Cinema in the Second World War* (1986). On British war films made during as well as after, see for example *National Fictions: World War Two in British Films and Television*, edited by Geoff Hurd (1984); *Britain and the Cinema in the Second World War*, edited by Philip M. Taylor (1988); Marcia Landy, *British Genres: Cinema and Society* (1991); Murphy 2000.

4. This is not at all to say all war films of the post-war era represented the war as an unproblematic triumph for every Briton, quite the contrary; but it can be argued that on the national level the image was presented as described. See for example Landy 1991; McFarlane 1998.

5. The film is based on the first part of Milligan's three-part book. See also Boyd-Bowman 1984: 39. In his study on Finnish military farces, Kimmo Laine has emphasized the multifaceted and ambiguous nature of such films. For example, are we laughing at the military in general, or just at uptight officers or at incompetent recruits? What are the 'ideological' implications in each case? (Laine 1994: 90–95).

6. On Carry On films, see for example Jordan 1983.

7. The nostalgia element in *Dad's Army*, for example, has been debated. See McCann 2002: 5, note 7.

8. The 2004 British comedy *Churchill: The Hollywood Years* (Peter Richardson) not only has Winston Churchill as an American action hero (Christian Slater), but has the king (Harry Enfield) confuse Hitler for Chaplin.

9. On *It Happened Here*, see Brownlow 2007; Murphy 1992: 85–87.
10. *Churchill: The Hollywood Years* has many parody elements, but is not a strict parody as such. Of course, this could be said of many works often classified as parodies.
11. It is obvious that the genre variations clearly also suggest East Germany as the successor of the Third Reich. The Eastern and Western Blocs of course argued about which Germany was the inheritor of the Nazi past.
12. Quentin Tarantino's recent film *Inglourious Basterds* (2009) plays this notion to the fullest.
13. See also Wiener 1984: 25–27; Mäkelä 2002: 171–177.
14. On comedy and pain, see Morris 1991: 79–102. On applying Bakhtin in film, see for example Stam 1989.
15. *Allo, 'Allo!* was made as a parody of the BBC drama series *Secret War* (1977–1979), but even more so, is a situation comedy. The Finnish title of Secret Army was (translated into English) 'The Underground Army'. Having seen the series as a youngster, I still remember the preceding joy and then disappointment a few years later when watching the first episode of (again translated into English) 'The Underground Army Strikes Again' – which turned out to be *'Allo, 'Allo!* The Finnish translator must have had a chuckle when coming up with the title to the latter series!
16. On *Blackadder Goes Forth* and World War I see Sheffield 1996: 54–55.
17. See also Sheffield 1996.
18. The Sex Pistols wrote and performed a notorious song 'Belsen Was a Gas', but did not record it (Marcus 1989: 116–119). According to Wikipedia, the reunited band updated the lyrics in 2003. It was now titled 'Baghdad Was a Blast' (http://en.wikipedia.org/wiki/Belsen_Was_a_Gas, accessed 1 June 2010).

Chapter 8

'Holocaust-Nostalgia', Humour and Irony: The Case of *Pizza in Auschwitz*

Hagai Dagan, Sapir College

Nostalgia and Irony

Humour and Holocaust seem to be opposites. Contemplating this grim period with its numerous atrocities what is there to laugh about? But human nature is slightly more complex than this, and apparently humour could and did play a significant role in facing the horror while it unfolded and to a far greater extent afterwards (Fackenheim 1997: 67). This paper deals with a very specific kind of humour, characterized by irony and sarcasm, and combined with a highly unique type of nostalgia, referred to as 'Holocaust-nostalgia'. An examination of this mixture may provide some interesting insights into nostalgia, irony and humour when confronting memories of the Holocaust.

The combination of nostalgia, irony and sarcasm may sound slightly odd, but actually they have much in common. Both irony and sarcasm are about the gap between the literal, explicit meaning and the implicit, non-literal one (Booth 1974: 10; Muecke 1980: 19). This gap exposes the complexity of reality, as well as its treacherous nature and its tendency to fool one. The reaction to that nature may often be suspicion, cynicism, black humour, mockery. Ironic mockery tends to be more subtle, the sarcastic one is blunter and bitter (Muecke 1980: 20). Black humour takes an extreme, sometimes macabre form, a humour that crosses most normative barriers, sometimes in a provocative manner and sometimes in order to undermine conformist perceptions.

Splitting reality into several layers of meaning is common to nostalgia and the expressions above. Nostalgia too does not treat reality as one simple entity. Irony splits reality into no less than three levels: (1) the 'real one' (that is, the one that is supposed to be real, if there is such a thing at all); (2) things as they appear to be; (3) the (ironic) twisting of things as they appear to be. Only the third level is vividly present in the ironic act. The second one is implied through the third one, because the third one refers to it by mocking, ridiculing or twisting it. The first one is only indirectly hinted at, because the mockery of the second one raises the question about an alternative, about the true nature of things.

Irony is a complex performance. The person performing it is probably aware at least of some of that complexity. Nostalgia, on the other hand, has an image linked to innocence and it can indeed be carried out in a rather innocent way. But this does not mean that it cannot be a quite sophisticated psychological and cultural performance; because nostalgia also splits reality – in this case the reality of the past. It alters the past by stressing its positive aspects or by changing it altogether and presenting it as a far more enjoyable experience than it actually was (Hertz 1990: 195). It tends to be manipulative and to prefer our needs

and fantasies over our actual cognitive capacities to reconstruct the past using memory. But by doing so it necessarily posits a split between the past as remembered and the past as presented by the nostalgic gaze. Here, too, one can speak of a third (hidden) level – the past as it really was (because memory itself, prior to undergoing nostalgic manipulation, is not exactly an accurate documentation tool). What allows nostalgia to be simplistic or innocent is the state of unawareness to the nature of this mechanism. Awareness might – but is not bound to – undermine the whole nostalgic process. One can think of instances in which nostalgia was used as a tool to achieve certain cultural or political goals (Allan, Atkinson and Montgomery 1995: 365, 367–368); in those cases, the whole process of its use was very sober, sometimes even cynical. This creates a distinctive gap regarding nostalgia: by nature it has a complex quality, and its appearance has an innocent, simple quality. This innocent quality might be taken seriously by the individuals or groups acting it; that is, by nostalgic people. Irony, on the other hand, is not innocent in any way or aspect. This is why irony can get in the way of nostalgia. But I intend to discuss one case where irony did not get in the way, but rather paved the way for nostalgia, for a complex nostalgia, a very non-innocent one, a nostalgia that was not treated innocently by its subjects (who still recognized it as nostalgia) and that served a complex redemptive course.

In this phase of a conceptual discussion I should add that irony, being an expression that assumes both the complex and the treacherous nature of reality, seems to be – unlike most people's assumptions – an ideal way to approach the Holocaust, as well as other atrocities. Broader public opinion might see an ironic-sarcastic treatment of the Holocaust as a treatment that degrades or holds it in contempt, but this kind of criticism misses the real nature of irony. One might also argue that it misses the nature of such atrocities by imposing a simplistic semi-religious meaning on them and by elevating or sanctifying them into something utterly strange to their actual nature. In this sense, ironic interpretations of the Holocaust such as Art Spiegelman's *Maus* or Roberto Benigni's *La Vita è bella* (Life Is Beautiful, 1997) are more to the point than pompous, exalting speeches such as the ones made by Israeli politicians in Auschwitz every year on the occasion of 'The March of the Living'. Recently, the barriers of 'respect and awe' around the memory of the Holocaust, so to speak, are cracking rapidly. More and more humouristic references to it are emerging in Israel. One of the most famous examples is the episode of Hitler in the bunker (taken originally from the film *Der Untergang* (Downfall), Oliver Hirschbiegel, 2004) which was transformed into Hitler complaining about the awful parking arrangements in Tel Aviv.[1] Indeed, the internet enables a radical stretching of the previous boundaries. Another such example is a web sketch showing Jews on their way to the gas chambers. One of them protests to the German in charge, telling him the whole thing is very immoral. The German – probably faced with this point of view for the first time in his life – is baffled. He reports it to his superior, he to his and so on. This goes all the way up the chain of command, up to Hitler. He considers this new idea for a few seconds and then gives orders to stop the whole thing.[2] Of course such a process of ironizing the Holocaust might slide down a slope of utterly trivializing it, but I hardly think it is more problematic than its trivialization through

Dani Hanoch in *Pizza in Auschwitz*
(Trabelsi Productions, 2008).

political and nationalistic clichés, and semi-sanctification and mystification. It was the same Dani Hanoch – the protagonist of the film that will be discussed here – who said, referring to the sketch about Hitler complaining about parking in Tel Aviv, that there's no big harm in it; the harm is rather in the overseriousness of the collective Holocaust memory in Israel.[3]

In this context of Holocaust irony I should mention that Booth (1974: 6) assumes that the inscription *Arbeit macht frei* was probably meant to be ironic. In this case, it is a cruel irony of the perpetrators. Another such example is the speech that Heinrich Himmler made in Poznan, in October 1943.[4] Addressing SS officers, Himmler said there, among others:

> It is one of those things that is easily said, 'The Jewish people is being exterminated,' every Party member will tell you, 'perfectly clear, it is part of our plans, we're eliminating the Jews, exterminating them, ha! a small matter.' And then along they all come, all the 80 million upright Germans, and each one has his decent Jew. They say: 'all the others are swine, but here is a first-class Jew.'

Here, the irony is interwoven in the complex of slavery and extermination. In this light, one could see the irony of the survivors and victims of this complex as a defensive irony, an anti-irony that defends itself against the murderous irony of the aggressors.

It is worth mentioning one previous attempt to discuss nostalgia and irony. I am referring to the most thought-provoking article of Linda Hutcheon (2000), in which she maintains that irony and nostalgia do not necessarily contradict each other. She deals mainly with cultural nostalgia and offers examples like the series *All in the Family* (CBS 1971–1979) that

drew on old conservative patterns but dealt with them ironically. Her main argument is that irony and nostalgia are not entities, but rather characteristics of human response. Therefore one can think of a complex response that will include both of them at the same instance. According to this argument, any simultaneous combination of human responses is possible. If this is true, it makes the particular combination of nostalgia and irony as trivial as any other. (Although I do not think it is true. Can one genuinely express anxiety and serenity at the same time?) Still, Hutcheon acknowledges a certain gap between irony and nostalgia. When irony is attached to nostalgia, it restrains it, she maintains. I want to show here how it can also enable it: how nostalgia may be in need of irony.

The combination of nostalgia and irony seems odd because we are accustomed to thinking about nostalgia as positive feelings towards the past.[5] This view implies that in order to be able to create and preserve a nostalgic state of mind, one has to have a positive attitude towards the past. But there is another possibility: we need to be nostalgic, and therefore we create the past so that it will serve this need. Nostalgia does not respond to the past, but rather dictates it. Naturally, this dictated past has much more to do with our situation in the present than with the past as it was experienced before it became a past. Nevertheless, it may be assumed that it would be easier to cast a positive light on a past that was positive in the first place (Smith 2000: 508), for there is a limit to the ability to reinvent the past. Nostalgia is not a total delusion; it maintains a complex link to the past, a creative link in which concrete memory is not put aside. If this is true, the creative room of nostalgia will become very limited when facing a traumatic past, one that evokes hardly any positive memories or even none at all.

Nostalgia is often related to childhood memories. In this context it has innocent connotations and brings about something I would call positive hermeticity. Childhood, positive as it might have been, gains a further flair of sweet innocence and delight as it emerges from within the nostalgic state of mind as an idyllic cluster. Irony (let alone sarcasm) does not seem to fit in such a mental environment. Irony creates a suspicious, distanced, half-hearted gaze, a gaze hostile to the momentum of nostalgic embracing of the past.[6]

In light of the above, it could be argued that (1) nostalgia cannot be applied to a traumatic past; (2) irony contradicts nostalgia. However, in the documentary *Pizza in Auschwitz* (Trabelsi Productions, 2008) directed by Moshe Zimerman, nostalgia takes place in a modus that contradicts both those statements: it is implemented on a traumatic past and is mixed with humour. This humour is redolent with heavy irony and sarcasm. Looking into this case could shed new light on the concept of nostalgia vis-à-vis the Holocaust, and on the status of irony and humour in that context.

Nostalgic Gaze and the Traumatic Past

During the twentieth century, nostalgia became widely seen as a normal way of treating the private or collective past. The new, rehabilitated nostalgia was perceived not as morbid or

destructive, but as a means of charging life with a sense of significance and mental richness, stemming from a positive integration of past and future. Others described it as a bittersweet, mixed experience, since the gap between the perfect past and imperfect present cannot be bridged.

Some noted that nostalgia functions as an emotional reaction to a radical event, one that interrupts the normal flow of life. What might have been perceived as an escape to the past is described rather as an amending of the harsh present by harnessing the picture of the idealized past (Wildschut, Sedikides and Arndt 2006: 975, 982, 985, 988–989). In this light, nostalgia appears as an identity-building and stability-constituting state of mind. Beyond personal stability, it also enables the creation of solidarity and partnership with other people around us, who share a similar nostalgia with similar content. Such nostalgia strengthens identity by creating a sense of significance, by calming the fear of death and temporariness and enabling one to cope with the loss of self-value. The perfect past fixes the lame present. In this sense nostalgia can be therapeutic. It helps to deal with loneliness and alienation; it creates a sense of belonging to the past, to past social, religious and ritual frameworks.[7]

An alienated attitude to the past would mean in this view an alienated attitude towards the progressive self. A furnished past serves a positive and productive identity very well. Therefore, while in middle age nostalgia could function mainly as a lamentation for lost youth, in old age it functions as a peacemaking mechanism; a reconciliation with the past and a way to depart peacefully from the world. Such a description might explain the need for a nostalgic gaze – mostly during old age – even if the object of this gaze is a traumatic past. In old age, nostalgia can have the function of adjusting and accommodating the present by acceptance of the past (Hertz 1990: 195; Erikson 1968: 139). This could explain the need to apply a nostalgic gaze to a traumatic past as well.

Indeed, during the nineteenth century, the nostalgic type was described as melancholic, introverted and depressed, but later nostalgia was diagnosed as being rather an antidote (in the long run) against depression and melancholy. Now, both trauma and nostalgia refer to the past. The post-traumatic person is being attacked by a negative past that erupts into the present and cracks it.[8] The post-traumatic person runs from his past to his fragile present whereas the nostalgic person runs from his present to his half-invented past. But when the nostalgic past can be imposed on the traumatic one, therein could lay a certain remedy.

The greater the need to cling to the past or to childhood, the more crucial becomes the question what can be done with a traumatic and shattered childhood. One option is to try and 'redo' it. The need to decorate the past applies not only to childhood, but also to the near past. That sort of repair is called the Pollyanna Principle. Naturally the flexibility of the Pollyanna Principle is limited. It is much easier to apply it to a bad holiday than to a long imprisonment in a gulag. And still, apparently it is not impossible to do that too. In an interview given in 2008[9] Natan Sharansky talked about his gulag years. The interview showed it was possible for him to recall that horrible period in a positive way by emphasizing the very few positive events – or events that had gained a positive meaning over the years – rather than the long depressive, wearing routine. In this case, the events Sharansky clung to

were the celebrating of Jewish holidays with his neighbouring prisoner by way of shouting ritual texts (from memory) into the emptied toilet.

Nevertheless, this attempt to decorate the past might run into an intuition that the past is sealed, that it would not allow an active intervention.[10] In such a case, the attempt to intervene – guided by the nostalgic need – is accompanied by a sense of self-deception and can evoke feelings of frustration and bitterness. Therefore it was maintained that nostalgia is ultimately a negative experience, because it is tied up with the certain, painful awareness that the past is forever lost, that it is doomed to remain unchanged in memory. We are condemned to live with it – as is – in our ongoing present. This combination of (1) striving to cast a positive gaze at the past and (2) realizing how difficult it is – especially when the past is traumatic – might attach an ironic edge to the nostalgic look.

Such irony would be a sort of self-criticism. One might still cling to the nostalgic effort and, at the same moment, see this effort as futile or ridiculous. Irony in this case is an extra awareness that does not allow the partial blindness typical of many nostalgic stands. But this does not mean that it must disrupt the whole nostalgic stand. One can be nostalgic and laugh at one's own nostalgia or be critical about it.[11]

So there seems to be a struggle here between the stubbornness and firmness of a bad past and the strong need to be able to accommodate the past by means of a nostalgic gaze. One way of coping with such a past is to combine nostalgia with irony. The question is to how traumatic a past this gaze can be applied.

Unique Model of Nostalgia

One major characteristic of nostalgia that blocks irony, let alone sarcasm, is its close linkage to childhood (Hertz 1990: 192–193). Even when childhood is traumatic, memory might preserve vivid pictures attached to it, as if disconnected from the traumatic content and connected, on the other hand, to the life of the child as such: to curiosity, wonder, excitement and to the freshness and virginity of the world. This set of qualities could perhaps have its own life, a life that even when affected by a traumatic content is not necessarily destroyed by it. An example of such a phenomenon can be found in the Holocaust memories of Imre Kertész (2004), in which his first memories from the concentration camps still retain the character of youthful adventures. Then they gradually fade, giving way to a faceless apathy. But before that, for as long as he can preserve the child in him, it gives him a fragile defence against the reality around him. One of the characteristics of this childish perspective is the lack of irony. Kids have humour, but it is not ironic. Irony requires a more complex, sober, slightly bitter perspective. Some people do not acquire it, even when they mature. The question is, whether a nostalgic gaze that observes a past in which we were children becomes childish itself. If so, it can hardly be ironic. But it does not appear to be the case. The gaze might 'catch' something of the childish quality, but only to a certain extent. It brings us back to that time and allows us to relive it, but not entirely. We still stay the adults

that we are and we live that child of the past through the eyes of the adult. This is very clear in the film I am about to discuss. As the adult maintains his present, he can also watch the child he was from an ironic perspective.

Pizza in Auschwitz accompanies Dani Hanoch, a Holocaust survivor from Lithuania, during a kind of roots journey, starting from his childhood places in Lithuania and ending back at home in Israel. The visit to Auschwitz is the journey's peak. Dani Hanoch, accompanied by his adult children Miri Hanoch and Shagi Hanoch, is the protagonist of the movie. The whole journey is made according to his will and is constructed to fulfil a vision he has. It is something of a reconstruction journey, a journey meant to revive experiences and to be nostalgic about them, and something of a farewell journey. It is also an educational trip, meant to transmit some critical messages from the father to his children, by means of restoration and semi-symbolical re-enactment of key moments. During the whole trip, Dani Hanoch acts and reacts with a mix of nostalgia, irony and sarcasm. He rejects the common sentimental state of mind that is typical to such trips.

Dani Hanoch is a well-known figure in certain circles in Israel. He is what one could refer to as a professional witness. He was born in Kaunas, Lithuania, in 1933. As the Germans entered Lithuania in 1941 he was sent to the Kaunas Ghetto with his family. In 1944 the family was deported to the Stuthof concentration camp (in Poland), where the men and the boys were separated from the women and the girls. From there he was sent with his father to the Landsberg concentration camp (in Germany), where he was separated from his father and sent with a group of young Jewish boys to the nearby Dachau concentration camp.

Dani and Shagi Hanoch in Auschwitz in *Pizza in Auschwitz* (Trabelsi Productions, 2008).

161

From Dachau he was sent to Auschwitz-Birkenau (Poland) where he managed to survive six months. In 1945, as the war was at its end, he was sent to Mauthausen (Austria) on a 'death march'. He was liberated by the Americans in May 1945.

Dani Hanoch gives lectures on his experiences of the Holocaust, attends panels, visits schools and so on. In the film it is quite obvious that he is accustomed to the presence of the camera. He utilizes this presence and makes use of the camera to stress messages that are important for him. Sometimes it feels as if he's 'taking over' the whole film. He dictates the details and tells the director what he should shoot. For instance, he tells the driver of the van to stop in a certain place and says: 'We're filming this site.' In another place he stands beside the commemoration site in Gunzkirchen, salutes theatrically and says: 'We honour the 71st division of the US Army.' But does all this mean that Dani Hanoch is merely putting on an act? That he is being dishonest about the whole thing? That his nostalgia and irony are also part of a professional, well-orchestrated show?

The complex position of the Holocaust witness in general, and of the professional Holocaust witness in particular has already been discussed (Felman and Laub 2008; Givoni 2008; Oliver 2001). In a way, almost every testimony is a public one because the witness speaks to other people, to the public. Nevertheless testimony documented in front of the camera is more distinctly public, and necessarily has a political dimension. Even so, I do not think that the political dimension excludes any chance of personal sincerity. More so: the quality of 'acting out' may appear as a part of a sincere coping process. In the case of Dani Hanoch, one can see how the extreme situations into which he brings himself and his family (situations that could well be intended to serve some acting-out agenda) interfere with his acting-out habits and modus, and put him in a conflictual phase. In certain situations, for instance when he describes his childhood neighbourhood in Kaunas, or while organizing the collective singing of the Israeli national anthem in the Kaunas synagogue, he indeed appears like a formal representative of the state of Israel and the Zionist movement. In other situations, though, he seems much more 'personal'. As the trip continues, he even loses control of events and of the journey's entire strategy and rationale. Sometimes he is very excited, and hyper-energetic. This could be caused by the presence of the camera and by the unique position of representation, but it does not seem to be the only explanation.

The strongest argument one can make against the depiction of Dani Hanoch as a typical professional witness is his frequent use of sarcasm and black humour. It is completely antithetical to the manner in which the Holocaust is customarily dealt with in Israel's public and official sphere. In the hands of Dani Hanoch, the Holocaust – the strictest taboo, the holy of holies in official Israel – becomes the object of jokes, ridiculous songs and infantile word-games. In this sense, even if his testimony has qualities of a professional one, it surely is not representative in terms of the normative Holocaust discourse in Israel. More so: it challenges this discourse and opposes it. One can only imagine the scandal that would break out if Dani Hanoch's jokes were told by teachers in one of the school trips (partly financed by the Israeli Education Ministry) to the concentration camps. The Hanoch family's sarcasm

is not public, but rather private, although they choose to make it public and to challenge the public Holocaust memory with it.

This family sarcasm gains a very unique character during the film. Miri Hanoch opposes her father's sarcasm with her own sarcasm. It is simultaneously an aspect of the family's shared behaviour, and a weapon aimed at ridiculing the father's nostalgic quest of reliving his childhood and the Holocaust period: 'Dad escapes into his childhood legend.'

During the journey Miri Hanoch appears very gloomy, sentimental, offensive, but also very sarcastic. Her sarcasm is a sort of a family tradition (Holocaust black jokes) but also her way of coping with the loaded situation, with which she is conflicted from the start. The journey brings about many frustrations that she carries with her about her upbringing. She blames her father for placing her whole childhood under the shadow of the Holocaust, but even those accusations are mixed with an ironic humour: 'In our case, the stories about Dad walking barefoot in the snow replaced the stories of Hansel and Gretel and Snow White.'[12] In fact throughout the film she blames her father for denying her a normal childhood, just as his childhood was denied him (this slightly bothering symmetry is woven through the entire film). This could mean that a nostalgic state of mind would be a difficult one for both of them. It stems from a common motive shared by the second generation (sons and daughters of Holocaust survivors): their own past is sucked into their parents' past – a harsher, more intense and all-consuming past.

Humour and irony is very present in the film, first and foremost in Dani Hanoch's remarks, such as 'I have a BA – *Boger* Auschwitz' (Hebrew: Auschwitz graduate); 'In Auschwitz there are orthopedic benches'; 'Poland won Auschwitz in an international contest' (Miri Hanoch responds: 'it was a start-up'); but also in the common manner of the father and his son and daughter, like a sarcastic variation on a children's song: A – Auschwitz, B – Birkenau; G – Gas; D – Dachau.

As noted, irony usually seems to contradict the nostalgic gaze, because it disrupts the sentimental harmony and smoothness it seeks. But here it seems to be paving the way for the nostalgic gaze, since it softens the harshness of the (at least potentially) traumatic content of the past.

The film starts with a visit to some key childhood sites, supposed to be linked to pre-Holocaust memories. But it proves to be a difficult task. As Dani Hanoch stands in the Lithuanian town Zasliai (he pronounces it 'Zusla'), he recalls his childhood there with an almost natural joy, but Miri Hanoch insists on tying it to what followed, saying that 'Zusla looks like a place forsaken by God, a place no one wants to remember except my father.' By that she asserts, at least for herself, that she cannot separate anything from the all-consuming memory of the Holocaust events, even if it occurred before them. The magnitude of those events projects itself in memory forwards and backwards and blocks the way for a simple, natural, nostalgic gaze on childhood. Nevertheless, while for Miri Hanoch the isolation of anything from the context of the Holocaust seems impossible, it would appear that Dani Hanoch is at least partially capable of producing a nostalgic gaze. He is glad to find Yiddish writing on walls, hugs his parents' old neighbours with

excitement, etc. During the whole trip he really seems to try and create a complicated, unusual nostalgic gaze, while confronting both the traumatic content of his memories and the aggressive opposition to this gaze displayed by his daughter. She represents here a sort of common sense, probably shared by most people, that Holocaust memories must be traumatic and therefore allows no nostalgia whatsoever. But for her (unlike most people) this stand means confronting her own, highly distinctive, upbringing, a mix of Holocaust stories, black humour and another very crucial ingredient, which she herself refers to (with mixed seriousness and irony) as 'father's Holocaust-nostalgia'. Her own conflict, it seems, blinds her to his complex conflict throughout the journey. She confronts her father for trying to drag her into his (seemingly) unnatural way of treating the Holocaust. While doing so, she turns his own sarcasm against him, calling the whole event 'a Holocaust reality show'. Some of her remarks are bitter-funny, and others sound like typical Israeli clichés (that evoke Jewish paranoia): 'In every turnoff from the main road, it feels as if we're going to be murdered in the woods'; 'Jews are always welcome in Auschwitz. They never turned a Jew away there'. This kind of sarcasm very effectively illustrates the emotional complexity in which all the participants are trapped.

With all her antagonism, Miri Hanoch does recognize her father's almost desperate need for nostalgia (though she does not necessarily approve of it). Referring to a previous journey of her father and her uncle to their town, she says: 'They came to look for proofs for the existence of childhood'. This is a very keen sentence, because the problem is not only the distancing of childhood as a result of aging, but also memories of a good childhood (as described by Dani Hanoch) becoming almost impossible to imagine in contrast to the later memories of the Holocaust.

From what Dani Hanoch says, it becomes clear that for him the journey has a function of an amendment. Visiting his primary school, he says he returned in order to reconstruct the feeling he had there before the Germans came 'and deprived me of the joy of learning in a nice school beside a river and a green mountain'. So he is caught between the motivation to isolate the childhood and 'defend' it from later memories, the contradicting motivation to remember everything to do with the Germans and what they did to him, and the third motivation – not to put away the Holocaust memories, but rather to be able to turn them into nostalgic materials.

But with all the difficulty, it seems that Dani Hanoch is really able to reconstruct his childhood as something to be happy about, and not (only) as something to mourn over. This mission faces harsh opposition from Miri Hanoch and at a certain point also from the director Moshe Zimerman, a son of Holocaust survivors himself, about whom Miri Hanoch says that he had a tremendous interest in the project, because 'he felt that my father's Holocaust is also his Holocaust'. Zimerman asks Dani Hanoch critically why he does not cry (meaning: how come you rejoice about your childhood instead of mourning it; instead of seeing it in the all-consuming shade of the Holocaust). Dani Hanoch replies aggressively, criticizing Zimerman for not allowing him to live his childhood memories his own way. This is important, because it really seems that both the director and Miri

Hanoch, in spite of accompanying the whole process, surprisingly miss what I find to be the main happening of the whole film: Dani Hanoch's struggle to construct a very unique attitude to Holocaust memories; a state of mind that will not erase them on the one hand, and will not only painfully relive them on the other hand, but will allow – as remarkable as it may sound – an accepting gaze upon them; a gaze that contains them as a human complexity, very dark, but not entirely dark. Of course Dani Hanoch was a young boy at the time, and a child's perspective is perhaps more lenient to such a state of affairs.[13] But here the child's perspective becomes mixed with the perspective of the adult. The adult knows how horrible things were (and the child probably knew it as well) and he 'solves' the gap between wanting to preserve a good childhood and the realization of the magnitude of atrocities that occurred by calling on irony and dark humour. Irony and sarcasm dissolve the magnitude of horror and in so doing enable him to preserve some of the 'innocent' childhood.

Therefore Dani Hanoch refuses Zimerman's attempt to drag him down the familiar, more 'understandable' trail of attitude to the Holocaust – namely the sentimental, mourning attitude. He says: 'I despise the ones who cry.' And: 'Whoever cries, dies.' He says that no one cried in Auschwitz.[14] This I find interesting, because it might tie a sort of accumulated survivor harshness (quite common among survivors) to the rejection of the mournful attitude and a turning to the half-positive, humouristic and nostalgic state of mind. This harshness is, by the way, something that (ironically) links survivors with perpetrators. In the above-mentioned speech, Himmler exalts the ideal – what he considers to be a unique form of heroism – built on hardness and the 'Nietzschean' ability not to submit to feelings:

> And none of them has seen it, has endured it. Most of you will know what it means when 100 bodies lie together, when there are 500, or when there are 1000. And to have seen this through, and – with the exception of human weaknesses – to have remained decent, has made us hard, and is a page of glory never mentioned and never to be mentioned.

So both the ones who caused it, and the ones who – so to speak – were in that pile of bodies, will not cry about it. Crying became irrelevant.[15]

Instead, Dani Hanoch prefers to bring up memories from the numerous concentration camps in which he was interned in an enthusiastic, almost cheerful way. He does that while they wait at the border between Lithuania and Poland. Miri Hanoch replies with an ironic contrast, saying that his 'Holocaust-nostalgia' floats in the van without any rational order. But this 'Holocaust-nostalgia' itself is related by him with a strange mixture of excitement, a re-animation of the past, sarcasm and dark humour. Inside the van, he throws out sentences like: 'At Mengele's I was a model for the Red Cross.' Apparently he has no difficulty talking of those things, and his enthusiasm seems authentic. But it also seems to require the sarcasm that goes along with it.

Auschwitz as Home

If Dani Hanoch's nostalgic effort had stopped at the childhood period, and he would have mostly tried to separate it from the traumatic events that came afterwards; that is, to 'save' the childhood memory from the burden of Holocaust memory, his quest would have been easier to understand. But the visit to Auschwitz – the peak of the journey – reveals that things are not that simple.

Upon entering the site Dani Hanoch argues with the Polish people in charge, as a result of a misunderstanding concerning the details of the visit. While arguing, he shouts at them a few times that they cannot tell him what to do in this place, because, he says, 'it is my home'. That is, not only the childhood home in Lithuania is portrayed as home, as the place that channels nostalgic feeling, but also Auschwitz. This motive is repeated several times: Auschwitz is home.

I should add here that Auschwitz has been depicted by several writers (among them Wieslaw Kielar and Primo Levi) as *anus mundi* – the anus of the world. In sharp contrast to that view, in Israeli popular and political discourse of the last ten years or so Auschwitz has gained a quasi-theological status and acquired certain holiness. Hence it is 'sanctified' with rituals like 'The March of the Living'. As much as one can gather from the film, Dani Hanoch's perception of Auschwitz as home does not abolish its meaning as *anus mundi*. It is both. In other words: *anus mundi* can also serve as a home. As for its alleged holiness, this is certainly not the approach taken by the film. Even Shagi Hanoch, Dani Hanoch's religious and quiet son, does not really create this impression, in spite of some prayers, Kaddish and such that he finds suitable to say there. There is a sort of consensus among the participants that Auschwitz was and remains an accursed place. And still – for Dani Hanoch – a home. On this aspect there is no consensus of course. None of the participants share this view. They all seem to oppose this nostalgic effort and to maintain that the real and only home is the one they left in Israel.

The sarcastic approach matches the view of the place as *anus mundi*, but when Dani Hanoch refers to it as home he abandons the ironic tone and replaces it with an impatient, excited, dramatic one. It would seem that as the journey reaches its core, nostalgia remains but it stays naked, without its irony defence. And indeed, in this last phase Dani Hanoch is much more vulnerable. He is excited, angry, hurt and has lost his fragile humouristic armour. It is in this state of mind that he takes his family to an Auschwitz barrack and treats it as his own. He explains the sleeping arrangements and repeats the orders that were shouted in German before sleeping time. He is enthusiastic and his enthusiasm does not appear to contain a traumatic residue. At a certain point he talks by mobile phone with his grand-daughter, telling her that 'we are here in the barrack, talking, in the barrack now in the best of moods'. Miri Hanoch reproaches him, telling him: 'You're enjoying yourself, you're wallowing in it.' But he says: 'Why? It feels good here.'

Obviously it is most reasonable to treat any such act or saying in this context as split, charged and bearing multiple meanings. The context refutes any possibility for taking such

phrases to mean just what their semantics would mean in more normal circumstances. And still, I think it would be wrong to think that it does not mean anything of that semantics at all. I think Dani Hanoch made an effort in that barrack to create a loaded and complicated modus of nostalgia that would apply to his Holocaust memories. He also seems to have planned to orchestrate the session in the barrack so it would enable him to tie together the different – apparently remote and contrasting – periods of his life into one cluster, to present it as one life and to extract from it some lesson for his family.

But Miri Hanoch would not allow it. Just as the night in the barrack is the peak of the journey for Dani Hanoch, it is the same for her but it is also the peak of her antagonism to the whole concept. She just cannot stand it anymore. She, too, hardly clings to the black humour that partially defended her until that last session. It feels as if the humour has exhausted itself. The night in the barrack is too intensive or harsh for all participants. In the face of it, Dani Hanoch adopts an almost ecstatic enthusiasm, whereas Miri Hanoch falls into despair and depression combined with an extreme impatience that soon changes into a firm resoluteness. She confronts her father and interrupts his reconstruction by ordering a takeaway pizza to the barrack. As the pizza arrives she still clings to a shred of irony, saying 'have a slice of pizza, pizza from Auschwitz' thus casting an ironic-bizarre light on the whole scene, but then she becomes very irritated and edgy and she does not let him go on with his speech. Obviously she reaches a dark climax of her own as the scene fills her with the accumulating traumas of her childhood as the 'second generation'. She attacks the whole rationale of the journey, arguing that the Auschwitz reality cannot be reconstructed and

Miri and Shagi Hanoch in the Auschwitz barrack in *Pizza in Auschwitz* (Trabelsi Productions, 2008).

simulated. To the few words that Dani Hanoch manages to say – mainly that he does not understand his children's worries (implying that they are nothing compared to the suffering that he knew) she responds with bitter sarcasm: 'Maybe we are an inferior breed and should all be shot.'

The result of this confrontation is an anti-climax, reflected in the bitter disappointment that Dani Hanoch expresses the following day. He argues that the journey has failed, its goal was unfulfilled and that his children also failed to gain anything from it, because the circle could not be closed. By circle he probably means the closure of the (partly) reconstructed experience and the lesson that should have been drawn from it. But there is another circle that Dani Hanoch fights throughout the film: the circle of a whole and coherent life that, illusionary as it may be (even in less difficult circumstances) seems to be crucial to many people's peace of mind. This circle gains a tremendous support from the nostalgic gaze. To achieve that effect, Dani Hanoch tried to apply the nostalgic gaze to an extremely traumatic and intense content. Whether or not he succeeded is a question that, according to the film, is almost impossible to answer. I would say that here and there he may have had at least partial success. But the motivation itself is important. It embodies a charge of the nostalgic gaze on a stronghold that seems impossible to be taken, a bold charge, in spite of all assessments and calculations.

It should be stressed that for Dani Hanoch to achieve a sense of integrity and a certain harmony with the past, he had to leave his life in Israel, make his children leave their own lives there and go to Auschwitz. The circle should have been closed in Auschwitz. The others do not only reject this attitude (or fail to grasp it), but also obstruct the whole process, and the director Zimerman implements this rejection by producing another closure to the film, the trivial, common closure of all such films: everyone returns home and we see Dani Hanoch dancing with his wife back in Israel. It draws the film back to the familiar sticky soil of the 'roots-journey' and destroys the uniqueness of Dani Hanoch's quest.

One thing is clear. In spite of bringing his children up on this remarkable 'Holocaust-nostalgia', he could not really get it through to them. They are the ones who live it primarily as a traumatic layer, mixed with dark humour. They fail to see how one can be nostalgic about a trauma. They do not want to be nostalgic about it, but they still (well, at least Miri Hanoch) cooperate in the dynamics of joking about it. In both cases – the father's and the daughter's – humour seems to have the function of a defence system. But in the daughter's case it serves as defence against mere trauma, whereas in the father's case it has a far more complex role – a defence against trauma, and a tool that enables the preservation of nostalgia: Holocaust-nostalgia.

Embracing the Traumatic Past

There are no traces of melancholy in Dani Hanoch's nostalgia in *Pizza in Auschwitz*. It is full of life, almost cheerful. It seems to absorb harsh content by generating a radical change in

it, allowing it to lose much of its initial horrific quality and become a part of the nostalgic, almost merry cluster. Perhaps at that moment, that content is gaining the quality of a child's perspective. As Dani Hanoch is reliving the commands shouted in German in the barrack, one can sense the enthusiasm and vividness typical of a teenager's look. It is highly possible that to some extent he experienced that reality, terrible as it was, as a thrilling adventure.

The next moment the nostalgic observer himself (Dani Hanoch) might recognize and realize the horror of this same content, but he is able – it seems – to preserve both perspectives of the same data constantly, without letting them disrupt one another. The disruption in the film is caused by Miri Hanoch, but he himself – when not disturbed – seems to manage to maintain both ways of looking at the same past. At least until the last part of the film, he manages it through humour, irony and sarcasm that function here as a sort of filter of trauma. Trauma (or potential trauma) is 'dealt' with by irony and sarcasm and thus loses much of its traumatic magnitude. Nostalgia can hardly exist in a traumatic environment. If each time the longing gaze is turned toward the past it comes across a painful memory, it will not be able to preserve the sense of longing. But irony makes it less painful. It follows that nostalgia and irony do not necessarily contradict each other, and irony may even assist nostalgia.

Nostalgia can therefore be applied to a traumatic past, given that the nostalgic effort (in this case it is most certainly an effort) is assisted with filters. In the case of *Pizza in Auschwitz* the filters are irony and, presumably, a reconstructed child's perspective. The child provides the vividness and the excitement, while the adult defends this limited gaze with sarcasm. This particular pattern is partly found in Spiegelman's *Maus*, where the author 'wraps' the Holocaust with a sort of bitter, gloomy irony (stemming also from the character of the protagonist – the author's father) in which a sort of fragile childish innocence (related to the very nature of the chosen medium – comics) exists.[16]

This combination proves quite effective. It is not sentimental at all – Dani Hanoch refuses to cry and there is something very belligerent about him. Nostalgia tends quite often to be sentimental, saccharine and kitschy, but here we find a nostalgia that is not like that at all. Moreover, it is revolted by such sentimentality. Further: Dani Hanoch's nostalgia might be slightly selective but it does not categorically ignore the horror; it does not require repression or silence. This special mixture of humour and nostalgia apparently allows its subject to bear a past that is usually referred to as too terrible to bear.

A few years ago Shira Stav wrote[17] of Holocaust survivors as an

enclave […] who could never assimilate in the state [of Israel] and remained in it angry, alienated, shut in their sorrow and mourning their dead. Here, in Israel, they slowly developed a mentality of a persecuted minority, an extinct species whose sole replacement for an identity is nostalgia.

Shira Stav does not explain what she means by the term 'nostalgia'. I assume she means a nostalgia that refers to the period before the Holocaust, not to the period of the Holocaust

itself. Be that as it may, Dani Hanoch does not come out of the film as a person who is angry, alienated or shut in his private sorrow. And still, he is shut; shut in his personal nostalgia, a nostalgia that applies to the Holocaust itself, one that is hardly (or not at all) understood by the people surrounding him. Even when his son and daughter do understand it partially, they resent it; they think it went too far, that it borders on insanity. Hence they try to make Dani Hanoch adopt more familiar formulas of coping with Holocaust memories. But he resents those formulas and even despises them. This motive of a growing gap between the state of mind of survivors themselves and common formulas of memory and commemoration can also be seen in other documentations. Thus in Yair Lev's film *Hugo 2* (2008) the two survivors, Hugo and Fani, are quite indifferent to the question whether someone will still remember the Holocaust and preserve its memory after they die. Fani remarks that she is far more bothered by the fact that her old age prevents her from going down to the street and seeing people.

The strong will expressed by Dani Hanoch to sleep with his family in the Auschwitz barrack is the bluntest expression of his motivation to integrate the past, to gather together his (non-traumatic) childhood and his (traumatic) youth into one cluster with his adult life. The (aware or just sensed) insight behind this move might be that if only the childhood would have been brought into this cluster, and the youth would have been 'skipped', it would have still lurked there, one would not be able to ignore it (being such an important time of life in general and involving such extreme memories in this case) and eventually it would undermine the whole structure.

As mentioned above, the need for a 'good closure' becomes more acute in old age. The nostalgic gaze does this job, as it assembles all life-components into one harmonic unity. If it encounters very painful components, of the kind that cannot be smoothed out with some overall sentimental rationale, or with a late, retrospective justification, the sense of an impassable obstacle might emerge, followed by a sense of frustration and the bitter understanding that the life at hand must remain dissembled, painful without any sense of justice or comfort. This feeling is very dominant in Primo Levi's *The Drowned and the Saved* (1988). Another author who was a Holocaust survivor – Yehiel De-Nur (known as Ka-Tzetnik) – turned away at a late period of his life from writing the perspective of Auschwitz as 'a different planet' and – following LSD therapy – he wrote *Shivitti: A Vision* (1989). This book can be seen as an attempt by De-Nur to accommodate the Holocaust into his own life by declaring Auschwitz as something human, not something utterly strange, different and remote. This late stand of De-Nur was Primo Levi's stand from the beginning and, still, the insight emerging from Levi's above-mentioned book is that this field of human experience was so harsh that any attempt to integrate it is bound to fail.

Nevertheless it seems that Dani Hanoch does not yield to this feeling and that his integration effort has met with considerable success. It might have succeeded even more in *Pizza in Auschwitz*, had it not been blocked by his daughter who insists on preserving the Holocaust memory as an indigested trauma.

It is important to clarify that Dani Hanoch's effort does not rely on autosuggestion. The child's perspective mentioned above does not mean that he turns a completely blind eye

Miri and Dani Hanoch in *Pizza in Auschwitz* (Trabelsi Productions, 2008).

to the traumatic meaning of the events. No – he comes across as a sober realist. He is well aware of the horrible quality of the events, both when he mentions his personal loss and when he expresses hatred (mixed with dark humour) of the Germans. Therefore what we discuss here is not the case of irony obstructing a harsh horror and creating a false reality, as in Benigni's *La Vita è bella*. Here irony does not block the harsh memory, but certainly allows us to confront it, because by nature irony creates a distancing effect.

The great need to integrate the past can hardly be explained in this case as resulting from unease concerning the present. Dani Hanoch appears to be a healthy, invigorated person, full of life, surrounded by a loving family. This becomes even clearer as his daughter criticizes him for dragging them to his Holocaust sites instead of finding comfort in the love they all offer him. It seems, though, that a satisfying present might not do, when not integrated with a matching past. There seems to be an inherent human discomfort about a fragmental life. Sometimes we hear people declare they will put their past behind them. But then they are left with the sense of a fragile present, and this 'put behind' past might still haunt them. The troubling feeling of a much too fragile present might still grow acuter as the sense of drawing near to death intensifies. Maybe nostalgia serves also in this sense, namely that it supplies us with a sense of a more solid, fuller life, as a sort of contra to the threatening void of death. This could clarify Dani Hanoch's heroic solution, in his old age, to go back to this traumatic past, confront it and even try to embrace it.

Conclusion

Dani Hanoch's most characteristic and surprising expression is his reference to Auschwitz as his real home. Here, the nostalgic attitude defeats most known formulas for dealing with the memory of the Holocaust. Most survivors would say that Auschwitz is the opposite of home, that it is an accursed place, contradicted (and even defeated) by the real home, the one they established after the war. The post-war home allegedly compensates for the lost pre-war one, and the new established family is a certain compensation for the loss of the previous family. This means the constructive look should turn away from the void of the past and concentrate on the present or the newer, post-war past. But, in *Pizza in Auschwitz*, Dani Hanoch seeks a different way of amendment: he aims to take his new family, that is his present and post-war past, to his 'real home' – the forsaken barrack in Auschwitz. He aims at unifying the post-war past and present with the pre-war past (Lithuania) and with the Holocaust past itself, to generate a complete integration through the symbolic-nostalgic deed of a return home. It is not mere nostalgia; it is an assertive, activist nostalgia, a dramatic act of unifying homes and times.

I could not identify any touch of irony in Dani Hanoch's tone when he referred to Auschwitz as home, but this is one of those things that can be seen as bearing a certain ironic quality, even if not intended as such. Because when we come to think about it, it sounds rather ironic that a place like Auschwitz, probably the worst place in human history, will be defined as home. It is a further dimension of irony in the movie, an irony that the participants did not intend, but rather was imposed on them by the nature of their act.

To sum up, the documentary film *Pizza in Auschwitz* presents a unique model of nostalgia, a model contradicting the usual and accepted understandings of the term, both in common discourse and in research. It is a nostalgia applied to exceptionally traumatic events and memories; a nostalgia mixed with irony and dark humour, serving to reduce the traumatic magnitude of events and clear the way for the nostalgic gaze. It is a stubborn and resolute nostalgia, an activist one. It serves to accommodate and integrate the wounded past with the present and to create an image of a harmonic life.

Even if this integration partially fails in the film, the failure is not necessarily a result of this unique model, but rather a result of the specific dynamics of the Hanoch family. Moreover, even if this model is too pretentious to succeed, it still presents a most unexpected motivation, namely to combine nostalgia with irony and apply it to traumatic content. This non-conformist 'Holocaust-nostalgia' challenges our routine conceptions of nostalgia, as well as of Holocaust remembrance.

Bibliography

Allan, Stuart, Atkinson, Karen and Montgomery, Martin, 'Time and the Politics of Nostalgia: An Analysis of the Conservative Party Election Broadcast "The Journey"', *Time and Society*, 4:3 (1995), pp. 365–395.

Booth, Wayne C., *A Rhetoric of Irony*, Chicago: University of Chicago Press, 1974.

Boym, Svetlana, 'Nostalgia and its Discontents', *The Hedgehog Review* 9:2 (Summer 2007), pp. 7–18.

Erikson, Erik H., *Identity: Youth and Crisis*, New York: Norton, 1968.

Fackenheim, Emil L., *God's Presence in History*, Northvale: Jason Aronson, 1997.

Felman, S. and Laub, D., *The Crisis of Testimony in Literature, Psychoanalyses and History*, Tel Aviv: Resling, 2008 (Hebrew).

Givoni, Michal, *Testimony in Action* (Dissertation), Tel Aviv: Tel Aviv University, Cohn Institute for the History and Philosophy of Science and Ideas, 2008.

Hertz, D.G., 'Trauma and Nostalgia: New Aspects on the Coping of Aging Holocaust Survivors', *Israel Journal of Psychiatry and Related Sciences*, 27:4 (1990), pp. 189–198.

Hezroni, A., *Conception of the Past, Public Nostalgia, Representation of the Past and Nostalgia in Publicity* (Hebrew), Jerusalem: Hebrew University, Unpublished PhD thesis, 1999.

Hutcheon, Linda, 'Irony, Nostalgia, and the Postmodern', *Studies in Comparative Literature*, 30 (2000), pp. 189–207.

Ka-Tzetnik, *Shivitti: A Vision*, trans. E.N. De-Nur and L. Herman, San Francisco: Harper & Row, 1989.

Kertész, Imre, *Fatelessness*, trans. T. Wilkinson, New York: Vintage Books, 2004.

Levi, Primo, *The Drowned and the Saved*, trans. R. Rosenthal, London: Abacus, 1988.

Lyons, John D., 'The Ancients' Ironic Nostalgia', *Paragraph*, 29:1 (2006), pp. 94–107.

Morgenstern, N.E., '"Love is Home-Sickness": Nostalgia and Lesbian Desire in "Sapphira and the Slave Girl"', *Novel*, 29:2 (1996), pp. 184–205.

Muecke, Douglas Colin, *The Compass of Irony*, London: Methuen, 1980.

Oliver, Kelly, *Witnessing: Beyond Recognition*, Minnesota: University of Minnesota Press, 2001.

Smith, Kimberly K., 'Mere Nostalgia: Notes on a Progressive Paratheory', *Rhetoric and Public Affairs*, 3:4 (2000), pp. 505–527.

Wildschut, T., Sedikides, C. and Arndt, J., 'Nostalgia: Content, Triggers, Functions', *Journal of Personality and Social Psychology*, 91:5 (2006), pp. 975–993.

Notes

1. http://www.youtube.com/watch?v=WQqlyJ2x5yA. The Hebrew text about the parking is in subtitles, accessed 30 August 2010.
2. The speech can be heard at http://www.matarproductions.tv/content_in.asp?id=171&title=The%20Saddest%20Sketch%20show%20In%20The%20World&cat=comedy# , accessed 1 June 2010.
3. *Haaretz*, 8 April 2010.
4. http://www.holocaust-history.org/himmler-poznan/speech-text.shtml, accessed 30 August 2010.
5. The *New Oxford Dictionary* defines nostalgia as a sentimental yearning for the past, attached to positive associations; a somewhat more radical phrasing is the one suggested by Naomi E. Morgenstern (1996: 186): nostalgia is 'the pleasurable reproduction of the past'.
6. A good example of that process can be found in Milan Kundera's *The Unbearable Lightness of Being*, trans. M.H. Heim, London: Faber and Faber, 1984, pp. 244–257, as he handles kitsch and nostalgia with irony.
7. Another possible therapeutic trail of nostalgia can be found in John D. Lyons (2006: 103). Lyons maintains that since nostalgia occurs completely in the imagination, it can be controlled and manipulated, and can therefore be channeled to therapeutic uses. This is a somewhat simplistic view, because nostalgia does rely upon memory and is not entirely a fantasy.

8. A very figurative example is the beginning of Ari Folman's animation film *Waltz with Bashir* (Israel, 2008). This film is all about trauma, and 'war nostalgia' plays a crucial role in it. Its beginning features the eruption of trauma into life, through the image of a pack of black dogs running wild through the streets of Tel Aviv and gathering under the window of one of the protagonists.

9. In the Israeli newspaper *Haaretz*, Sukkoth holiday edition 13 October 2008.

10. Amir Hezroni (1999: 93) calls it 'bitter nostalgia'.

11. See Boym 2007. Boym's main argument is that there are two types of nostalgia: a restorative one, truly aimed at reconstructing the past and returning home; and a reflexive one – that understands the futileness of the restorative attempt and therefore tends to dwell on the longing itself. This is a more creative, sadder, but also ironic nostalgia. But the nostalgia that I'm going to discuss here is rather ironic, in spite of being restorative up to a certain point.

12. All citations from the film are translated from the Hebrew by me.

13. This was partially shown in Roberto Benigni's controversial film *La Vita è bella* (1997).

14. This rationale is cited by more than a few survivors. See Yair Lev's film *Hugo 2* (2008).

15. This is thoroughly discussed in J. Little, *The Kindly Ones*, Paris: Gallimard, 2006.

16. In a way *Maus* is also a documentary, because it documents the true story of the author's father by means of comics.

17. *Haaretz*, Sfarim (Book Supplement), 9 August 2006. Stav's review refers to a book by Gil Iltovitch (*Tmunot Hatuna* (Wedding Pictures), Tel Aviv: Am Oved, 2006) (Hebrew).

Chapter 9

Comedy and Counter-History

Marcia Landy, University of Pittsburgh

Prologue

arx's *Eighteenth Brumaire of Louis Bonaparte* provides a drama in the service of counter-history to detail the rise to absolute power of a dictator. Marx's claim that the counter-revolutionary events of the 1850s are farce not tragedy is a critical strategy to characterize, caricature, invert and puncture the abuses of power. More than a rhetorical flourish, the 'farce' stages a theatrical scenario involving the various social classes, the monarch himself and the uses of costume and stage setting for events to dramatize how the 'tradition of all the dead generations weighs like a nightmare on the brain of the living', causing them to 'anxiously conjure up the spirits of the past to their service and borrow from the names, battle cries and costumes in order to present the new scene of world history in this time-honored disguise' (Marx 1990: 15). Marx's linking of history to farce is an opportunity to rethink how comedy can be regarded as a form of historicizing, as more than mere occasion to produce laughter at human foibles but an opportunity for critical reflections on the uses and abuses of the past.

In his observations on 'The Uses and Disadvantages of History for Life', Nietzsche too explored 'the tradition of all the dead generations' as a dark and invisible burden'. His essay underscores 'the necessity of being able to forget at the right time, when it is necessary to feel historically and when unhistorically' (Nietzsche 1991: 63). Elaborating further on Nietzsche's essay, Michel Foucault described what he termed 'effective history' as differentiated from 'traditional history'. Foucault distinguished three types of historicizing: (1) the parodic and farcical that exposes its disguises and masquerades (Foucault 1977: 160) in relation to reigning forms of monumental, antiquarian and critical history; (2) the dissociation of identity 'which we attempt to support and unify under a mask' (161) and (3) the 'sacrifice of the subject of knowledge' (162) that replaces mastery of nature and absolute truth through a rejection of traditional attitudes of reverence' (164).

These descriptions of historicizing are critical for an understanding of how comedy has functioned as counter-history to undermine official narratives of the past, as they are manifest through the visual media. Once upon a time, professional historians denigrated films that purported to dramatize history regarding them at best as mere entertainment or at worst as escapism, distortions, inaccuracies and harmful fictions. Today, popular film and television through the lens of parody, farce and satire are instrumental in offering a view of the past that run counter to official historicizing. I have selected for discussion film texts that dramatize different historical moments and adopt different styles to produce their forms of

counter-history. Three films, *Monty Python and the Holy Grail* (1975), *L'armata Brancaleone* (Brancaleone's Army, 1966) and *Brancaleone alle crociate* (Brancaleone at the Crusades, 1970), are set in the Middle Ages, *Carry On Up the Khyber* (1968) during the British Raj and *Paths of Glory* (1957) during World War I.

In delineating the nature of history as farce, Marx's *Eighteenth Brumaire* focuses on one of the key features of comedy, its reliance on theatricality involving performance (diegetic and intra-diegetic) for others through the adoption of masks, impersonation, costumes, disguises, doubling and mimicry and validate Nietzsche and Foucault's observations on the historical process that link historicizing to considerations of comic theatre and to humour. Their language in the service of effective history relies on such terms as 'masquerade', 'buffoonery', 'disguise' and 'carnival' (Foucault 1977: 161). These uses of the language of comic theatre, exemplified particularly through parody, farce and satire entail the unmasking not merely of individual characters but of their social performances and of the histrionic situations in which they appear. Comic theatricality has relied on the trope of the world as a stage in the service of exposing how 'everyone is "role-playing" in the interests of questioning and challenging the basis of common sense, of 'the very basis of commonplace actuality' (Levin 1987: 120).

What's in a Joke: *Carry On...Up the Khyber*

The British 'Carry On' films (28 in number from 1958–1980) are exemplary for their stereotyping and specializing in bawdy sexual situations and 'lower' physical functions set in various social institutions (Jordan 1983: 316–317). One of the most popular films of a popular series, *Carry On... Up the Khyber* announces itself in a subtitle as addressing 'The British Position in India'. The film is a parody of British Empire novels such as *Kim* and *Passage to India* and Zoltan Korda's films *The Drum* (1938) and *Four Feathers* (1939) among numerous others, adopting the rituals, language, behaviour and landscape of these works. Beyond its parodic dimensions, the film is an instance of farce which relies on impropriety and vulgarity (involving the body) and on 'joking turned theatrical' (Bentley 1965: 279, 282). Providing a farcical treatment of British imperialism, *Carry On...Up the Khyber* extends beyond its mimicry of the familiar cinematic genre of the empire film to unmask representations of the Raj by subverting social and cultural practices that underpin British imperial power as well as oppositions to that power.

Carry On...Up the Khyber is founded on a familiar joke; namely, what do the Scots wear, if anything, under their kilts? The narrative is deceptively simple relying in its single-minded focus on a joke and challenges the viewer to think about the means and ends of this form of humour in relation to the film's historicizing. Set in 1895 in the Northwest Province of India under the 'control' of Sir Sidney Ruff-Diamond with the military support of the 'third Foot and Mouth Regiment', also known as the 'Devils in Kilts', the narrative is set in motion by the 'discovery' that Private Jimmy Widdle, one of the recruits ordered to guard the Khyber Pass

178

is found to be wearing underpants. Widdle is reported by Sergeant-Major MacNutt to Major Shorthouse who in turn reports the 'offence' to the Governor Sir Sidney Ruff-Diamond. This 'infraction' sets in motion a rebellion led by Randi Lal, the Khasi of Kalabar in league with Bundit Gin, the leader of the Burpa tribesmen that is, unsurprisingly, 'resolved' in favour of the British. The film's farcical character relies on its ridicule of the assumed 'fearsome' bodies of the imperial 'masters'. Even the names of the characters suggest the sexual traits of the 'actors' in this imperial spectacle. From the outset of the film in the introduction of Lord and Lady Ruff-Diamond riding in a procession on an elephant, the elephant's fart undercuts the solemnity of the occasion and prefigures the enigma of the unseen lower parts as they finally become attached to sexuality and further to imperial power, raising complicated questions about how far to go in extrapolating on connections between the sexual body and politics. The visual, verbal and aural language implicates relations between the governor and his wife, the Khasi and Lady Ruff-Diamond, and finally the presumed terror of the Burpa warriors at the sight of the lifted kilts of the Scots regiment.

The film provides numerous distinctions between the easily recognized imperial spectacle and discordant encounters that involve sexual interactions. The betrayal of Lady Ruff-Diamond involves a photo taken by her surreptitiously of the regiment on review revealing their underpants to their superior officer. She uses this photo to blackmail the Khasi into sex. Subsequently, a group composed of Captain Keene, Private Widdle and Mr Belcher, the sexually active missionary who preaches publicly against sins of the flesh, gain access to a harem where they disport themselves but then are forced to cross-dress in order to escape.

One of the scenes that ridicule British superiority in the face of danger takes place during a dinner in the governor's palace. While the Khasi and his men are bombing the compound, the governor, his wife, Mr Belcher, Princess Jheli and Captain Keene are served their meal as mayhem and disorder rage outside the governor's palace. Learning that the British are at dinner, the Khasi describes this behaviour 'as typical exhibition of British flim ... starched uniforms and stiff upper lip'. As exemplification of this 'flim' the dinner party proceeds

Underpants found in Gerald Thomas' *Carry On...Up the Khyber* (Peter Rogers Productions & Rank Organisation, 1968).

179

indifferent to the attack. As the musicians play a Viennese waltz and the group engages in small talk, windows are blown out, plaster falls from the ceiling onto the guests and a chandelier falls onto the dinner table. However, the guests describe the falling plaster as merely 'a strong wind' and the loud noise as 'a spot of thunder'. The film climaxes with a display of the troops lifting their kilts and with the hasty disappearance in terror of the Khasi and the Burpa warriors, returning to the enigma of the body of imperialism.

How then does the film qualify in a more serious vein as a form of counter-history? The question that animates the film is articulated by Princess Jheli who asks her father the regal Khasi, 'What is there to fear from a warrior who wears nothing beneath his skirt?' and he responds, 'Oh, my child, think how frightening it would be to have such a man flying at you with his skirts in the air.' The numerous allusions to what it is that 'dangles' produces different responses from the governor and his wife Lady Ruff-Diamond who is eager to betray her husband and experience sex with 'Randi Lal' and from Princess Jheli who is attracted to Captain Keene and, hence, willing to betray her father. Their 'betrayals' are tied to opposing conceptions of the sexed body as an instrument of pleasure in the case of women and as diplomacy and control in the case of the men. For the British and the subjugated Indians, the battles that ensue are founded on the power of vision as control and the contrast between 'surface and beneath-the surface' (Bentley 1965: 294). The question of 'surface' has ties to imperial lore. H. Trevor Roper indicates how the wearing of the kilt does not derive from ancient practices but is an invention of eighteenth and nineteenth centuries to bolster the martial prowess of the Scotsman, culminating in the British government's deployment of Highland regiments in India and America (Trevor-Roper 1985: 25). Initially this costume was described derisively as 'worn so very short that in a windy day, going up a hill, or stooping, the indecency of it is plainly discovered' (20). The film, playing with this 'petticoat', earlier associated with effeminacy, wreaks havoc with the sexual potency and primitive virility mythically associated with its wearers and hence with British power.

While the film on the surface adopts the theatrical trappings of imperial literature and film, including the use of a voice-of-God narrator to elevate the British 'position in India', public displays, ceremonial entertainments and forms of ritualized duplicity in relation to diplomacy, it also includes reflexive elements that clue the spectator to the incongruities – names, body parts and actions – that strip away the surface to reveal incongruities, disorder and violence. The farcical character of empire invites audiences to encounter tragedy in the forms of barbarism that mask as civility. The film becomes a form of 'effective history' by virtue of its invitation to regard the puncturing of monumental conceptions of the past and to regard them, not from superior heights but from a shortening of 'vision to those things nearest it – the body, the nervous system, digestion, and energies; it unearths the periods of decadence and if it chances on lofty epochs, it is with the suspicion – not lofty but joyous – of finding a barbarous and dreadful confusion' (Foucault 1977: 155). While Carry On...Up the Khyber might seem a frivolous and vulgar portrait of imperialism in its emphasis on the body and on sexuality, the film invites a rethinking of the mechanisms that underpin (literally as

well as metaphorically) the exercise of political force and power, introducing disorder and confusion into a system of beliefs and practices that had enormous consequences for an assessment of British history.

The Historical Theatre of the Middle Ages

Two comedy films set in the Middle Ages, directed by Mario Monicelli and starring the versatile actor Vittorio Gassman, are a compendium of myths, counter-myths, social practices, literary and cinematic portraits of this historical period in the interests of contemporary beliefs and practices. The films are not tied tightly to a particular historical or literary text on the Middle Ages but are rather a conflation of various and familiar narratives, characters and images drawn from this hard to define moment. Monicelli's films are not comedies of manners or romantic comedies but are satiric, utilizing parody and farce, as a pretext to explore affinities with contemporary cultural and political life. Based on the conventional quest motif of chivalric lore, but presenting a protagonist who inverts heroic patterns of chivalry, the film renders serio-comic a lofty vision of knight errantry. Brancaleone (the lion's talon) is a descendant of Don Quixote and his followers are multiple versions of the Don's squire Sancho Panza. Set during the Crusades, the first film, *L'armata Brancaleone* (Brancaleone's Army, 1966), follows Brancaleone through a landscape fraught with obstacles. The stages of the journey involves him (and the spectator) in an encyclopedic confrontation with different aspects of the medieval world including class, gendered and religious differences, disease, war and economic practice that, in the spirit of parody, are as much indebted to medieval chronicles as to modern life.

The film begins with a marauding band of Hungarians ravaging an Italian village. The rape, pillage and sacking are prologue to the film's gritty images of a medieval world

Vittorio Gassman as Brancaleone da Nordia in Mario Monicelli's *L'armata Brancaleone* (Fair Film, Les Films Marceau, Vertice Film, 1966).

that focuses on the underside of the chivalric ethos, undercutting whenever possible the tendency to glamorize heroism and power. Hardly unique and with a bow to medieval fabliaux, the images call attention to the physical hardships and the mercenary objectives of inhabitants of this world. The journey is set in motion by the brutal killing of the knight Arnolfo Manofiero at the hands of two Italian survivors, Mangoldo and Taccone, who will soon become members of Brancaleone's ragged 'army'. They plunder Manofiero's belongings and sell them to a Jewish merchant Abacuc, who, able to read, discovers among these items a parchment that cedes the knight's property as ruler of the fiefdom Rocco of Aurocastro in Puglia to the 'noble' bearer of this document. Abacuc, Mangoldo and Taccone determine to find a knight who can lead them to this wealth and chance on Brancaleone, an impoverished knight, who at first refuses the offer of future wealth, claiming that he will gain his fortune by winning the hand of a wealthy woman in a tournament.

Brancaleone with his wild hair, tattered garments, rusty armour and his recalcitrant yellow-painted nag Aquilante is hardly the incarnation of a heroic warrior. Losing the tournament by being thrown from his horse that refuses to obey his commands, he has no choice but to join the rogues and undertake the journey to claim Aurocastro. In a mock-epic scene he proclaims himself the men's 'Duce' and commands them to swear fealty. On the road to the refrains of a lyric, 'Branca, Branca, Branca, leone, leone, leone', Brancaleone encounters a knight, Teofilato dei Leonzi, who refuses to let him pass. As expected of knights, the men duel, but in spite of three attempts, neither is able to overcome the other. Three times they declare truce and then return to combat. Each time missing their opponent, the men cut down trees with their axes and completely mow a wheat field with their swords, thus at least rendering practical their ridiculous duelling. Teofilato, now a prisoner, offers them a reward from his father if they take him home, but the men vote to continue to finish their mission.

The men's next encounter looks more promising for the fortune hunters. Coming upon a seemingly deserted fortress and finding food, the men sack the place, and, inspecting the premises further, Brancaleone finds a beautiful woman who offers him sexual delights. The promise of pleasant entertainment is truncated when he discovers that her husband and the other inhabitants of the castle had died from the plague. Fleeing the place, the men are on the road again, this time confronting Christian Crusaders on their way to the Terra Santa (the Holy Land). Anti-Semitism is introduced as Zenone, their fanatical leader, inveighs against the impure Jew insisting that he be purified, and the men 'cleanse' him in a waterfall. In a scene that tests the men's faith, the men are ordered by Zenone to cross a footbridge, but after Brancaleone and his men succeed in crossing the bridge it collapses, causing some of the men to plunge to their deaths. Zenone ascribes this misfortune to God's will. Thus far the film has focused on critical aspects of both medieval and modern history, the plague, the plight of the Jew and the Crusades.

The pitfalls of chivalric honour are further parodied when Brancaleone saves a young woman from the violence of warriors seeing to restore the unwilling Matelda to her fiancé. However, Brancaleone swears to her dying tutor that he will respect her chastity and return her to Duke Guccione. Unfortunately, she does not share his commitment to this oath and,

unknown to Brancaleone, has sex with Teofilato. Upon return to her promised spouse, the Duke discovers that she has been 'abused', and Brancaleone is now imprisoned. Saved by his men, he tries to find Matelda in a monastery, but she now declares that her new spouse is Christ. On the road again to Aurocastro, Abacuc dies and is buried by Brancaleone with the reassurance that the Jew will go to a better life than on earth whether it be Christian paradise or not. Now it looks like the journey is about to end successfully when the men finally arrive at Aurocastro. Unfortunately, the original document had a part torn from it, and Brancaleone now learns that he must fight the Saracens. Almost burned at the stake by the Saracens, then by Christians (since it turns out that Arnolfo Manofiero did not die and has returned to reclaim his patrimony) Brancaleone and his men are saved by Zenone and his Crusaders. Astride Acquilante who has parted from a willing mare, Brancaleone joins the singing Crusaders.

Thus, it transpires that all of Brancaleone and his followers have not succeeded in any of their enterprises, though they have managed to escape from imprisonment and/or death and to provide a different, unromantic, view of the medieval landscape. The episodic style of the narrative has resisted any opportunity to offer either material or spiritual resolution to the hardships encountered on this allegorical journey. The world of the Middle Ages has been portrayed from a bottom up view of historical events, pitting the threadbare rogues against more powerful forces. This history from below has shifted the onus from upper-class characters to a nomadic and vulnerable band whose quest is not for glory but for material gain.

Through comedy, the film has appropriated the narrative of chivalry and exposed its idealist dimensions, focusing on the vulnerable physical body and on failure rather than success. Instead of emphasizing the spiritual rewards for the subjugated, the film has dramatized how history often works to forget, idealize or work against them. Their history is one of survival through their wits and collective endeavours. In the comic world 'all goodness is weakness or hypocrisy and the supreme virtue is quickness of wit' (Nelson 1990: 101) and Brancaleone and his men exemplify this view. In fact, by making them picaresque rogues, they become examples of 'knight-errantry minus the illusions' (93). The film has followed the route of comedy that debunks the mighty and powerful. In its visualization of the unsuccessful quest, it has consistently portrayed a world turned upside down in contrast to the predictable consolation of reward offered for earthly suffering.

Brancaleone alle crociate (Brancaleone at the Crusades, 1970) delves even more deeply into the medieval landscape, focusing on madness, witchcraft, leprosy, dwarfism, papal legitimacy and faith. The film, like the earlier one, opens with animated cartoons drawn in childlike fashion under the credits and also interspersed throughout the film. Brancaleone and the chanting Christian pilgrims under the leadership of the 'prophet' Zenone set out on their journey to the Holy Land, giving thanks to the Lord and praising Pope Gregory. Unfortunately, the pilgrims land in the wrong place and are massacred by supporters of Pope Clement, and Brancaleone who had hidden under a boat is left alone to undertake the crusade. Viewing the bodies of his comrades buried head first in the sand with legs

Brancaleone's army captured in Mario Monicelli's *L'armata Brancaleone* (Fair Film, Les Films Marceau, Vertice Film, 1966).

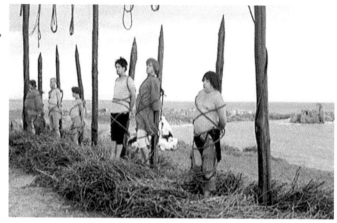

protruding, Brancaleone laments his survival, but as in Ingmar Bergman's *The Seventh Seal* (1957), another film set in the Middle Ages, Brancaleone confronts the gruesome figure of Death. Bargaining with the Grim Reaper, Brancaleone, chooses a short and glorious life, and Death vows to return for him at the end of seven months.

As prophesied by Death, Brancaleone's first adventure on his journey to the Holy Land is the rescue of a baby, the son of Boemondo, King of Sicily, who has been abducted by the German knight Turone. After a decidedly unfair struggle with a follower of Turone, Thorz, who proposes that they fight blindfolded but does not blindfold himself, Brancaleone gains advantage thanks to the assistance of sympathetic observers. He allows the German and the bystanders to join him on the journey to the Holy Land. However, more adventures befall these pilgrims, the first being a man who is inflicting pain on himself, claiming to have committed an unpardonable sin. His madness is treated in comical terms. When asked if he spat in the holy water or violated his mother, the abject man claims to have done far worse, but his pleasure in self-punishment is treated as an amusing aberration, causing the others to regard him as mad rather than pious. Thus another pilgrim joins the group and thus too the film parodies self-punishment.

On their way again, the men encounter another outcast, a woman about to be burned at the stake for witchcraft. Similar to another later comic text set in the Middle Ages, *Monty Python and the Holy Grail* (1975), this episode involves the bizarre and nonsensical 'proofs' of witchcraft. While in the Python film, the presumed witch is left behind to suffer her unjust punishment, in *Brancaleone alle crociate* Tiburzia is 'rescued' by Brancaleone and witchcraft is central to the events that follow. A dwarf who had claimed that she was responsible for his diminutive appearance joins her. Yet another familiar character in narratives of the period, the leper also appears. At first the group tells him to leave. After reconsidering, the group allows him as a 'creature of God' to remain but stay at a respectable distance from the others.

This film is more attentive than *L'armata Brancaleone* to the diseased and deformed body. The Crusaders next encounter with deformed bodies involves a Dante-esque image of human bodies hanging, like birds, from the branches of a tree. The character of Tiburzia serves as a medium to communicate with these suffering sinners. When questioned by Tiburzia, the suffering sinners describe themselves as being punished for adultery, eating meat on a holy day, being a Jew and holding radical religious and political views, thus underscoring the film's satirical treatment of medieval Catholic orthodoxy that resonates with contemporary intolerance.

Brancaleone now encounters and fights with Turone, the brother of King Boemondo, who has come for the baby, but the group saves both the baby and Brancaleone who has been left to hang upside down from a high ledge, thus allowing the journey to proceed. For the second time, the issue of papal legitimacy comes to the fore when Brancaleone confronts a holy man, the stylite Colombino, who will determine the 'real' pope from the anti-pope. As the supporters of each pope face each other, Colombino tells Brancaleone to walk on hot coals and to bring a dove to the rightful pope.

Brancaleone succeeds and gives the dove to Pope Gregory but burns the soles of his feet. As he is assuaging his pain in water, he meets the 'leper' who turns out to be a princess, Berta da Avignone, seeking to regain her kingdom after the death of her husband. She had adopted the garb of a leper to protect herself from being assaulted by men. Returning to the other pilgrims, Brancaleone and Berta join them in a carnivalesque moment where all sing and dance except Tiburzia who is jealous of Brancaleone's attentions to the princess. The moment of gaiety is short-lived. Turone and his men attack the group and mortally wound the dwarf. Before he dies, the dwarf asks if he will go to Paradise and is told by Brancaleone that he will go to a special Paradise for dwarfs, where all men become dwarfs. The dwarf's dissatisfaction with his body serves to highlight the medieval treatment of 'monstrosity' whether of wild, aberrant and anti-social beings, giants, dwarfs, the physically or mentally ill, tying it to Christian beliefs in sin and redemption that were internalized by the victims of social ostracism. Repeatedly, the comedy complicates conceptions of normality through the lens of the medieval landscape, unsettling inherited myths of that time as primitive in relation to enlightened modernity, suggesting rather that what might be deemed as archaic is still present.

The long-awaited arrival in Jerusalem brings with it further complications. King Boemondo is at first delighted with the return of his son, until he finds that the birthmark that he and his son share on their posterior parts is not to be seen, thus he rejects the child, condemning it to death. Tiburzia comes to the rescue claiming that she is a witch and has caused the birthmark to disappear. She is put to the test by being asked to render herself invisible, but when she does, she is sent away, barred from witnessing the battle. Arrayed in ritual formations, Boemondo's supporters are surprised to see the Saracens emerge from their fortress bearing white flags. Their leader Omar Sheik proposes that instead of a pitched battle they conduct a tournament to establish the champions, five knights from Boemondo's men against five from the Saracens – but the men must be of aristocratic lineage. Boemondo can only find four knights, since Brancaleone's lineage is challenged. Alone and rejected, Brancaleone laments his fate, accusing

himself of being a false knight and spitting on his reflection in a pool of water. Tiburzia appears and urges him to flee, but, having learned that all four of Boemondo's knights have been defeated, he rides off determined to confront the king. He tells Boemondo that he can be knighted if the king so wishes, and thus he is made a baron. He now defeats the Saracens and is about to finish off Turone when Tiburzia, having observed the tournament from afar, causes a coconut to fall on his head, thus depriving him of the glory of his victory.

In a desert, Brancaleone attempts to avenge himself on Tiburzia, who keeps disappearing. He accuses her of being jealous, but is interrupted in his vengeance when he hears the voice of Death. His seven months have elapsed. He has had his glory; however, he does not succumb but undertakes combat with Death, who is bodiless. Therefore Brancaleone's sword is useless, but just as Death is about to end Brancaleone's life, Tiburzia intervenes and is herself wounded. Death disappears. Asked why she did this, Tiburzia tells Brancaleone that it was for love of him. He renames her 'Felicilla' (happy one) rather than 'Pazzarella' (crazy one). And she expires. He begins to move through the desert, alone, when a bird that he calls Felicilla joins him. Placing the bird on his shoulder he walks off, while the soundtrack plays the Brancaleone theme song. An aerial shot captures his image with the bird on his shoulder until he recedes from view.

The film's uses of history would hardly be considered a 'factual' account of the Crusades. Yet in its parodic and satirical treatment of aspects of medieval life and culture, the film's counter-history is aligned to various scholarly explorations of the period. Its historicizing can be characterized as discourse that creates a different relation to personages and events, and this discourse is indeed poetic. It is a creation of 'the story of the vanquished, the abject, and the downcast of history' (Rancière 1994: 114). In this context literature (and cinema) are not to be dismissed as mere illusion, fancy or untruth. They are not apart from but related to the problematic of historicizing that entails finding a way to portray actors who seem to have no voice, of transforming the *spoken*, always already spoken, always an effect and a producer of anachronism, into the *visible*. And this visible shows the meaning that speech failed to express' (Rancière 1994: 46).

At the heart of Monicelli's comedy is a historian at work self-consciously drawing from various sources: Cervantes, Dante, folk tales, romances, magic, superstition, theology, church history, chronicles of the period, current history and other films. Furthermore, the eclectic borrowings have their counterpart in the visual images involving cartoons, paintings, drawings, a panoply of bodies, large, small, deformed, living and dead. The verbal language is also eclectic, indicative as the critic Gian Piero Brunetta (2001: 4, 97) suggests, of a mixture of various regional dialects, archaisms, Latinate constructions and foreign phrases. The second Brancaleone film with the introduction of King Boemondo also introduces poetry into the dialogue: the characters begin to speak in rhymed couplets, thus further fracturing the unity of an historical viewpoint, paralleling how the comedy strives to differentiate its personae, the high and the low, as well as expectations of a familiar treatment of the past derived from both scholarly and commonsensical perceptions of social class, romanticism and idealism that pertains to the persistence of values, attitudes and beliefs in the present.

Anarchic and Surreal Comedy in Monty Python

Monty Python and the Holy Grail undertakes a revisionist view of history by means of comedy set in the Middle Ages. The Pythons' perspective on comedy has commonly been labelled as 'anarchic', and 'surreal'. This anarchic dimension involves unsettling conceptions of the past, rendering them strange through inverting, reversing and undermining traditional forms of storytelling. The film punctures heroic gestures, exaggerating commonplace situations to the point of rendering them grotesque. It challenges pious conceptions of morality and of historical interpretation as well as mocking the literary and cinematic forms through which these conceptions are disseminated. A dominant strategy employed by the Pythons involves placing a character in a predictable and normative situation, reversing expectations of the outcome of events. Through the use of hyperbole, impersonation and escalation, the viewer is treated to a bizarre, even nonsensical, vision that produces shock, disorientation in the distance created between received sentimental and canonical views of historical events.

The film begins with the insertion of another film in black and white, entitled 'Dentist on the Job', that is interrupted to introduce *Monty Python and the Holy Grail*. Then titles are embellished with cartoons including an image of clouds, a disgruntled image of a king emerging from the Grail and other grotesque figures accompanied by stately music and with Dutch subtitles, each time winding down and beginning again along with intertitles about all who got sacked. Finally the date 932AD and an image of a rotting body stretched on a wheel set atop a pole appears, and King Arthur and his squire Patsy emerge from the haze, galloping without horses. Knocking two coconuts together Patsy supplies the sound of horses' hooves. Stopping at a castle, the two are greeted by a taunting Frenchman who tells them they do not have horses but are merely using coconuts. Arthur's demands to see the lord of the castle are ignored. Instead a lengthy dialogue ensues replete with insults by the Frenchman about how Arthur was able to get coconuts in this non-temperate climate.

The film self-consciously adopts an elliptical structure, shifting abruptly to a smoky village with a man shouting, 'Bring me your dead'. Several carts loaded with bodies pass through the village, and a man is brought out shouting, 'I'm not dead', but the man in charge says that he will be soon. Resisting them, the man is hit on the head sharply and thrown on the cart. Arthur and Patsy appear and a man comments, 'He must be a king. He hasn't got shit all over him.' Arthur's next encounter involves some peasants' refusal to recognize the 'rightful King of the Britons', and the king gets lessons in Marxism from the 'autonomous collective' about dictatorship, exploitation, repression and violence inherent to the system. When asked by them how he became king, Arthur explains that he was chosen by the Lady of the Lake, 'Her arm clad in purest shimmering samite, held Excalibur aloft from the bosom of the waters to signify that by Divine Providence, I, Arthur, was to carry Excalibur.' Their response is 'Strange women lying on their backs in ponds and handing over swords is no basis for government', thus ridiculing the myth of kingship. A further incongruity arises from the introduction of the language of Marxism against Arthur's poetic recounting of his 'legitimacy'.

The Pythons' comedy relies for its impact on deflating common sense, received truths, sentiment and heroic pretensions that underpin conventional values and behaviour. The devices employed by the film are a veritable encyclopedia of comedy – involving gags, slapstick, the grotesque, word play and banter – toward the ends of invoking a familiar world and rendering it strange through undermining traditional forms of historical narratives. For example, in an episode that punctures conceptions of chivalric combat, Arthur confronts a Black Knight who will not allow him to pass. After Arthur's cutting off all of his limbs with copious blood spurting from each, the limbless knight in a bizarre example of understatement declares, 'just a scratch' and 'just a flesh wound'.

The episode involving witchcraft is a classic instance of Python exposure of irrationality. While bloodthirsty peasants shout gleefully, 'We've got a witch', Sir Bedevere, overseeing this impending auto-da-fe appears to be a voice of reason, asking the peasants how they know she is a witch. And they respond, 'She looks like one.' The accused appears with a carrot covering her nose. After protesting that she is not a witch, the knight retorts, 'but you are dressed as one'. It appears that Sir Bedevere is no more rational than the others, suggesting that there are 'ways of telling whether she is a witch', beginning with the absurd premise that witches burn therefore they must be made of wood and, further, that they can weigh her and if she weighs the same as a duck, she is a witch. She loses out, and Sir Bedevere goes off with Arthur to become a Knight of the Round Table.

The film interrupts the narration by a cartoon image of an illuminated manuscript that describes the knights who join Arthur on this as yet purposeless mission. Not only is the image of a manuscript a familiar self-reflexive device of the Python's to call attention to the manuscript as a fiction but also to serve as a way of disrupting any expectation of seamless narration. Another form of intrusiveness is the cutting between past and present, seriousness and levity. The vision of Camelot famous in legends of the Middle Ages turns out to be a variety show with a chorus line of knights doing a song and dance routine, causing the knights to resume their aimless chivalric travels.

However, the next episode is a parody of medieval dream visions. A cartoon announces the presence of God who chastises the knights for grovelling and then asks Arthur what he is doing. He responds, 'I'm averting my eyes, Lord.' 'Well, don't', says the Lord. 'It's like those miserable psalms. They're so depressing', the Lord complains. But finally the knights have a mission: 'Arthur, King of the Britons. It is your sacred task to seek this Grail.' The cartoon ends with clouds closing like a door. 'Good idea', says Arthur, and his knights set out now on their journey with a purpose. The irreverent treatment of both the Lord and Arthur (as well as the Bible) is sustained. Later in the film, in the episode of the 'Holy Hand Grenade', a monk reads from the Book of Armaments: 'Bless this Thy Hand Grenade that with it "Thou mayest blow Thine enemies to tiny bits, in Thy mercy" and the Lord did grin, and the people did feast upon the lambs and sloths and carp and anchovies and orang-utangs and breakfast cereals and fruit bats.' Thus, not only is the purity of the Crusades debunked but, more generally, warfare in league with religion.

Among the other quests undertaken by the knights that destabilize myth and introduce history are the encounters with the Frenchman who refuses to convey Arthur's request for

a meeting with Sir Guy de Lombard and who tease him by saying that they already have the grail: 'He's already got one, you see.' Frustrated the knights create a large wooden 'rabbit' with a red bow tied to it in imitation of the Trojan horse, however the knights forget to hide in it and fail to enter the castle. This episode is also notable for the bawdiness of exchanged taunts, parodying requisite combat ritual. For example, the Frenchman shouts, after Arthur has threatened an assault on the castle: 'You don't frighten us, you English pig-dog. Go and boil your bottom, you son of a silly person. I blow my nose on you so-called Arthur King, you and your silly English k…niggets … I fart in your general direction' (The Pythons 2002: 26). The knights leave without having gained any satisfaction, and the film returns to the present with an image of an older man identified by a subtitle as 'A Very Famous Historian' who while commenting on Arthur's difficulties is abruptly hacked by a medieval knight who barges into this contemporary setting. Not only is this episode another instance of the film's designs on official history (and academics), but it also becomes the deus ex machina to end the film in the present.

Among the other targets for comedy is the song of Sir Robin, a ditty in the style of medieval music that seems harmless, played by a troupe dressed in courtly costumes, but the lilting music is accompanied by gruesome lyrics with references to the knight's being 'mashed to a pulp', 'eyes gouged out', 'limbs all hacked and mangled', and 'penis split', etc. Galahad's adventure at castle Anthrax evokes medieval tales about a young man caught in a castle (or convent) with young women eager to partake of sex with a man, but he is 'sworn to chastity'. One of the women, Dingo, suggests that Galahad spank another young woman for deceiving him by lighting a lamp cast in the image of the Grail, but the women all beg to be spanked, and 'after the spanking' 'oral sex'. Brave Sir Launcelot saves Galahad, but the episode has done its work of poking fun at the knight and at conceptions of abstinence.

The frequent allusions to bodily functions, to the role of cross-dressing and to grotesque images of violence are, in the spirit of farce, a reminder not only of the desires and needs of the flesh but of the tendency to idealize, hierarchize and spiritualize at the expense of historical and material realities. In the case of the adventure of Sir Launcelot at Swamp Castle, the focus is on violence not sexuality. It takes a familiar situation of a father's insistence that his son marry and be prepared to manage an estate. The father speaks in the language of a modern entrepreneur: 'Listen. Lad, I built this kingdom up from nothing. All I had when I started was a swamp …' The son would rather be a singer, but the father keeps him imprisoned in his room until the marriage. The Prince sends out a note for help with his bow and arrow, and Launcelot, thinking this is from a damsel in distress, arrives hacking most of the guests to pieces. When confronted by the king, Sir Launcelot says in the comic spirit of understatement, 'I'm awfully sorry.' This episode not only pokes fun at chivalric representations but also inverts them to expose their monstrous face.

As the quest for the Grail draws to a close the assembled knights must confront a most horrible creature, a killer rabbit. Scoffing at the possibility that a bunny could be dangerous, the knights do indeed discover its ferocity, and thus realize that they need a powerful weapon to destroy it, the Holy Hand Grenade. This episode, reminiscent of many sketches from *Monty*

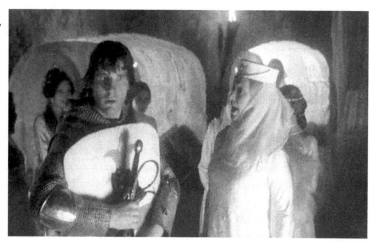

Sir Galahad (Michael Palin) at the castle of Anthrax in *Monty Python and the Holy Grail* (Python Pictures, 1975).

Python's Flying Circus is in keeping with the tendency of comedy to focus on the physical body and particularly on cultural taboos and restraints on language and behaviour. The comic images the Pythons adopt in the forms of the sketches and in the animation rely on magical thinking, focusing on mutations in form. As in Ovid's *Metamorphosis* and all kinds of fantasy and satire, animals are endowed with human attributes. The Python world is saturated with unpredictable transformations from animal to human, from realist style to fantasy, from photography to animation, from sense to nonsense, and from cool delivery to hysterical and inappropriate rant. These metamorphoses are a form of underscoring cultural restraints that are placed on the body and on all forms of language, both gestural and verbal.

Increasingly, the action shifts from the medieval context to the modern as another quest takes over, the search for the killer of the very famous professor. Just as the moment of victory over the inhabitants of the Castle Arrrghhh is about to take place, the police enter with the professor's wife as she points directly at the camera, 'that's the one', and the police arrest Arthur and his knights. The suggestive non-ending ending in the present intrudes on the history of the past, reminding the viewer that this is a modern film, bringing the many intercuts between past and present into crisis, and also linking the quest for the Holy Grail to a modern context by arresting the knights who were, after all, masquerading in the theatre of the Middle Ages. The ending also introduces the ambiguity of the boundaries between madness and sanity. Certainly the film addresses the metamorphosis of high drama or tragedy into farce functioning as satire in the interests of offering views of history that run against the grain of conventional wisdom.

'Something Completely Different (?)': Satire in *Paths of Glory*

Paths of Glory (Stanley Kubrick, 1957) is not an official history of World War I: it is a cinematic counter-history, relying on visual and sound images in relation to characterization and landscape to convey its critical uses of the past. Its satiric portrait of World War I is not an attempt to reconstruct, enshrine or monumentalize that past. Its power lies in its bold dissection of the rules of war as intrinsically connected to traditional social and political structures. This form of satire resides at the limits of comedy in which monumental 'history becomes itself a parody [...] in the form of a concerted carnival' (Foucault 1977: 161). The serio-comic treatment exposes sense as nonsense, challenges common sense and offers a form of cruel and grotesque humour to produce a dismantling of traditional history and of the epic form.

Unlike Kubrick's films *Dr Strangelove* (1964), *A Clockwork Orange* (1971) and *Full Metal Jacket* (1987), *Paths of Glory* presents a different, less overtly exaggerated, less obviously caricatured form of satire, albeit one that disorients the spectator in relation to binary and reductive conceptions of truth and falsity, causality and teleology. Though this film presents a protagonist that promises to embody agency and ethical purpose, his restricted sphere of action becomes increasingly apparent. He (and the spectator) are witness to the arbitrary imposition of the rules of war inimical to the 'reverence' associated with a monumental treatment. The film parodies cinematic war narratives taking place in a milieu that is 'completed, conclusive, and immutable' (Bakhtin 1984: 17). The world viewed in the film is absurd, topsy-turvy, and the actions of the characters a bizarre undermining of heroic action. Tragedy thus becomes farce.

In intricate and painstaking fashion, the film is relentless in exposing the failure of intelligence – a recurrent issue in Kubrick's films – that he identifies with human actions, not with fate or the gods. What makes the film difficult to classify is that the laughter it produces poses a different relation to the tragic and ironic, one that 'gives way to a new value, that of humor' in the 'co-extensiveness of sense and nonsense' (Deleuze 1990: 141). The humour is related to what Bakhtin in his discussion of satire in relation to novelizing, describes as a serio-comic treatment of the 'absolute past [...] brought low, represented on a plane equal with contemporary life, in an everyday environment, and in the low language of contemporaneity' (Bakhtin 1984: 21). Such a treatment invites a critical engagement with the transitoriness and open-ended potential for rethinking the past.

Kubrick undertakes an exposé of social institutions that presents them as rigid, impersonal and arbitrary. His historical theatre is populated by actors, even by ones that might seem attractive and sympathetic, who do not deviate from a prescribed and inflexible scenario, a major element in satire. In adopting a seemingly 'objective' and 'realist' portrayal of characters and situation and then unmasking the realism to expose its artifice, Kubrick destabilizes received styles and conceptions of militarism and patriotism derived from official history, photography and cinema. Eschewing the exaggerated postures, facial contortions and idioms that characterize such later films as *Dr Strangelove* (1964) and *A*

Clockwork Orange (1971), the film, through its elaborately choreographed visual and aural style, does not need to produce a topsy-turvy world but rather offers a familiar world as already inverted. *Paths of Glory* does not generate a festive or hilarious tone but is generative of the scornful laughter associated with satire.

The pervasive irony serves to undermine taken-for-granted assumptions. Enlightenment rests with viewers who might hopefully become critically engaged with the work rather than being passive spectators. *Paths of Glory* is that rare type of Hollywood film that invites its audiences to think about those who create and participate in warfare not by removing militarism from social life and restricting events to action on the battlefield or to the 'home front', but by mocking the celebration of heroic sacrifice for the good of the nation. The film unmasks the forms of behaviour that pertain to nationalism and the rules that govern so-called civilization, both European and American, present and past. In the images of unnecessary death on the battlefield, in the mockery of legal justice at the trial of the three scapegoats and in the barbarity of their execution for cowardice, the spectator is invited to contemplate the rules of both peace and war that imprison all, though with differing and dire consequences.

How does a film that restricts its focus to a brief three days and to a restricted geographic area communicate an expansive vision of a society where war is an inherent feature of social life? To answer this question, it is necessary to understand how Kubrick's cinematic images function to generate complex layers of thought. The forms of cinematic history, whether those of Oliver Stone, Alain Resnais, Bernardo Bertolucci or Stanley Kubrick, are reliant on visual and sound images and not primarily on the written word. The filmmakers are free to embellish events through the use of fictional characters, invented dialogue, and highly selective uses of space and time, but their films are nonetheless forms of effective history. They have the potential for producing meanings contrary to conventional expectations through how they establish associations between the characters and the landscape, architecture and the spaces in which the characters move. In Kubrick's film, space controls the characters rather than their controlling it. They are 'surrounded and impelled by the mechanism of their destruction' (Kolker 2000: 105). The satiric element relies on the cinematic language that serves to destabilize official versions of historical events.

The visual treatment of the film is dependent on an intricate demarcation of spaces. Actions in the film are divided between the chateau and the trenches. On the one hand, the chateau is the clichéd reminder of French civilization and its aristocratic heritage with its imposing edifices, ornate interiors filled with historical artifacts, paintings, furniture and fine foods. In contrast, the narrow trenches and the claustrophobic barracks define the world of the common soldiers. This antithesis is visualized through an 'ironic structure of oppositions and parallels between the chateau and the trenches though which Kubrick will turn a system of clearly defined contrasts into a maze of paradoxical associations' (Nelson 2000: 43).

The chateau and the landscape surrounding it underscore the rigid social class distinctions that separate the upper classes from the common soldiers. The chateau and the world of the

Soldier in the trench in Stanley Kubrick's *Paths of Glory* (Bryna Productions, 1957).

officers are seen not only in terms of extended space, but in terms of verticality that conveys its loftiness and grandeur, its reaching upward to the sky. Moreover, its interior is the stage setting for French history, its national aspirations and its cultural and economic grandeur. The world of the men is seen by contrast in horizontal terms focusing on the earth, its mud, the maze of trenches and the battlefield with its supine and lifeless bodies. The space in which the men move is already a grave. What visually and thematically becomes evident is that there is no escape, no path to transcendence beyond the grave. Furthermore, the film pursues its geometric patterns evident in the chateau in relation to the choreography of marching men, frequently invoked but implicitly contrasted to the disordered confrontations with death on the battlefield and before a firing squad. The orderly formations of marching men contrast painfully with the three dishevelled and immobile men tied to the stakes, one of whom is already half dead, and has to be pinched on the cheek to revive momentarily so that he can be awake for the firing squad.

The characters are isolated from each other and attest to their imprisonment in their different but connected worlds. However, they are not the heroes and malevolent figures of conventional war melodramas, but rather they dramatize individuals or types of behaviour caught up in a rigid and destructive process. The film unmasks the pretensions of all of the characters, revealing them as 'walking down paths that lead into personal ambition and delusion or into the endgame of death' (Nelson 2000: 44–45). The characters are caricatures of the military ethos.

Through General Mireau, the spectator is introduced not to a melodramatic villain but to an opportunist whose behaviour serves as a deconstruction of the meaning of leadership and glory. His lofty and altruistic rhetoric, expressing concern for the welfare of his men is quickly revealed as formulaic and devoid of meaning. Engineer of the futile and losing

attack on the Ant Hill Mireau is responsible for the execution of three men as scapegoats for the failure of the mission. His clichéd responses expose his ineptness in dealing with his soldiers and his cynicism ('Hello, soldier. Ready to kill more Germans?') His puppet-like movements through the trenches are grotesque and reveal his disdain in being among the men, and he is finally exposed as bereft of any concern for their welfare and eager only to cover his own mistakes. But his rhetoric, in contrast to his behaviour, escalates as he justifies his actions in the name of national honour, the glory of the nation and all that it stands for (visualized in the chateau in contrast to his callous sacrifice of the men in the trenches under his command).

His opportunism and careerism are further tied to the necessity to save face at any cost. He has recourse to the familiar rhetoric of a society of entrenched privilege mobilized for war, namely, charging his soldiers with cowardice and treason, of sullying the honour of the nation. His rage is a form of theatrics designed to deflect the recognition of his having ordered the men to undertake what he knew to be a hopeless and suicidal military operation. His behaviour underlines how 'miscalculations' in strategy are paid for by his subordinates, thus undermining any sense that there is a glorious cause that is being fought for other than self-interest aligned with the interests of a privileged class that has power over life and death. In effect, the hierarchy which Mireau dominates is a downward ladder, whereby the men in the lowest rung are the ones to pay for the 'cover up'. The phenomenon of the scapegoat essential to the perpetuation of hierarchy finally implicates Mireau who turns out to be an embarrassment and whose role will be passed on to another officer more capable of keeping the show going.

General Broulard, in contrast, presents an urbane and genial veneer, attuned to political expediency and manipulation, but for both officers duty, nationalism and patriotism are obviously a façade to cover their ambition and to uphold the order of things. Broulard is a servant of the state and of its military organization, the one character best suited to the codes and conventions of the game of statecraft in the hands of the upper class. He is accountable to off-screen forces that do not enter into this world but are present in his adherence to the good life and to professionalism. He is cunning, a cynic attuned to realpolitik, a competent manipulator of men, at home in this world. Morals do not bother him; nor does truth or humanitarianism enter into his assessment of tactics and strategy. His primary commitment is to avoid embarrassment. Human life is superfluous; what matters to Broulard is covering up errors and finding scapegoats from the lower classes to mitigate the possibility of exposure at higher levels. Broulard appears genial, unruffled and distanced from Mireau's clichés. His cynicism is most apparent in his misunderstanding Dax's revelation of Mireau's duplicity. He assumes that Dax's motive is desire for promotion, and when he learns that Dax is seeking justice, he tells him 'I pity you as I would the village idiot'. His feigned misperception parodies a familiar opportunism with its indifference to ethical considerations.

Colonel Dax, played by Kirk Douglas, seems at first to have the qualifications of a tragic hero, but *Paths of Glory* does not move in this direction; in fact, it moves counter to it. He 'seems to be a voice of reason […] but he is not' (Kolker 2000: 112). Dax is, after all, a part

of an unrelenting machinic system that offers no exit. All of the officers, like the regular troops, are portrayed as part of a larger structure, namely, a military organization that acts in the name of the nation/state. Individualism, sentiment and benevolence must be set aside (except where it serves sovereign interests). Dax becomes the film's instrument for highlighting the inexorable nature of militarism and the naivety of those who think that it has a human or moral side. In his actions, he may seem like the humane aspect of the military, but the film progressively reveals that he is a necessary part of a machine of war and politics. He too is a creature dedicated to survival – of course, with good conscience. In fact the film is relentless in emphasizing the role that the struggle to survive at all costs plays both physically and socially. The commitment to survival traps the men in their various roles and, as in the case of the perfidious Roget, can turn them into liars and manipulators to save their own skins. Even worse, this clinging to survival can lead them, as it does Lieutenant Roget, to cynically destroy their own men, an aspect of war omitted in many cinematic portrayals of war.

In the case of Dax, he is not a rebel but an officer compliant with the orders of his superiors similar to the other officers including Mireau, thus acquiescing to the impossible suicidal manoeuvre of taking the Ant Hill. However, he does what is expected of a professional soldier, to follow orders despite the lunacy of the operation. When the military operation fails, as predicted by Dax that it would, the officer in command decides to create a scapegoat. After a grotesque bargaining session over how many are to be killed, three are chosen, one by of his immediate officer, Lieutenant Roget, to eliminate the possibility of the lieutenant's cowardice bring exposed. Dax, a lawyer in civilian life, undertakes their 'defence'. In any conventional war film, his noble efforts on behalf of the men would have been successful, but not in this film. The court martial is a farce. For all the emphasis on rules and procedures, the trial is a game of naked power. Dax is repeatedly silenced. No testimony on behalf of the men is allowed. Dax's rejected plea for compassion, 'the noblest impulse in man', dramatizes that sentiment and morality has no place in a political game where the stakes involve sovereign power over life and death. The wide-angle photography, the framing and the point-of view shots along with the floor tiling (suggesting a chess game) contribute to underlining 'the lunatic, distorted values of the trial' (Falsetto 2001: 39).

The law is revealed ironically as a travesty through an officer who should know the rules of the game of power. Thus, *Paths of Glory* indicts the state along with the military. In fact, through Dax as spokesperson for justice, the film suggests that only an idealist would mis-recognize significant connections to be made between civil and military justice though they are usually regarded as completely separate. The court martial is a dark satire that challenges those who think that an appeal to law or justice can mitigate the brutality of war. Ironically too, further scapegoats are selected though with less mortal consequences. General Broulard, learning from Dax of Mireau's bungling of the whole affair and fearful that the news of it will become public, sacrifices his colleague to a court of inquiry and offers Dax the job, assuming erroneously that the colonel had been angling for it. Dax returns to fighting, having rejected the offer of the promotion, but his decision is not

presented as a heroic act of self-sacrifice but as another instance of Dax's unswerving commitment to his role as an officer.

Another unconventional characteristic of this film treatment of history is how it excludes portraits of the 'enemy', focusing rather on antagonisms among the French. German voices are only heard on the soundtrack. The only representative of the Germans is the young captive woman forced to sing to the French soldiers at the ending of the film. Thus the film refuses a classical dichotomy between the brave French and a dastardly German enemy. As for the three scapegoats, Arnaud, Ferol and Paris, they are not exalted in predictable fashion. The refusal of binary thinking in relation to the characters extends to refusing a view of them as self-sacrificing volunteers to the cause of war: they are the pawns in this game. In the eyes of their superiors they are 'scum', 'cowards', insects and herded like animals. But the film does not present them as stoic. Rather they appear as struggling vainly to preserve their lives, trapped like the men who have condemned them to their arbitrary fate.

Their last refuge is, like the animals that they are considered to be, a barn. Yet they are little more heroic than the officers who have sentenced them to death. They share with these officers the same entrapment in a dehumanized world and the same struggle to survive, albeit in their case to survive physically. The ignominious form of their deaths, including the last cruel pinch on the cheek to bring the dying Arnaud to consciousness, painfully enacts their fear, their vain rebelliousness, and exposes the thin veneer of 'civilization' in the name of national honour, and patriotism. They are a grotesque testimony to the price of 'glory'. Even the moment that presents the German woman forced to sing to the troops in an inn before they return to the war (with Dax listening from outside) is a further extension of the film's unrelenting dismantling of effects. Rather than being 'a bit of sentimentality that runs against the grain of the film' (Kolker 2000: 113), this scene captures (as did Dax's character) a disjunction between the sentiments attributed to the men and the inexorability of their condition. In portraying the woman held captive and forced to entertain, the film is consistent in its exposure of sentiment (and forms of sentimental art?) as reinforcing resignation rather than insight.

In unsentimental fashion, *Paths of Glory* situates warfare in the context of a society where this aristocratic world as exemplified by the chateau is characterized by arrogance, ambition, deceit and by theatricality displays like the trial and the execution. And the actors in this drama are the instruments to portray a counter view of history that parodies idealistic and high-flown sentiments, reducing them to deadly clichés. The history of World War I is thus presented without nostalgia but in highly ironic fashion, undermining honour, glory and patriotism, robbing spectators of their illusions about history as ultimately benevolent. The film reduces the characters to puppets that are manipulated in an 'endlessly repeated play of dominations' (Foucault 1977: 150).

In its transformation of tragedy into parody and farce, *Paths of Glory* overturns a belief in the sanctity of the state and therefore in the idea that there can be a just war. Furthermore, the film calls into question the belief in the immutability of historical truths that are neither

just nor equitable. Through a chain of events, the impossible assault on the Ant Hill, the attempts to disguise this error, the masquerade of the court martial and the execution of the men, the film has been unrelenting in inverting, making incongruous, received values and beliefs. If there is laughter in this satiric treatment of World War I, it is the scornful and grim laughter of recognition in tearing away the masks of those that have historically wielded power.

Epilogue

The evolution of cinema studies has produced theoretical studies and practical readings studies that have enabled a serious encounter with cinema as a purveyor of cinematic uses of the past. As indicated by the examples described above, it is necessary to examine texts that treat history through the lens of popular cinema to challenge long-held positions that regarded historical films at best as mere entertainment or at worst as escapism, distortions, inaccuracies and harmful fictions. In particular, the role of comedy has been long neglected in this examination, but it is evident that comedy is a creative source for rethinking visual history. Comedy has much to reveal about counter-history in the terms advanced by Michel Foucault as a mode of effective history. While such film historians as Hayden White, Robert A. Rosenstone, Philip Rosen, Vivien Sobchack and Robert Burgoyne, among others, have traced theories of cinema and offered readings of historical films that counter the prejudice against popular cinema, they have yet to include popular comedy in their rethinking of history on film. Moreover, not only have academic critics proffered complex theoretical examinations of cinematic time and the role of the archive, but film and television through the lens of parody, farce and satire are instrumental in offering portrayals of the past that challenge official historicizing, and certain filmmakers have created films that can and should be considered as theoretical work, as essays on forms of counter-official historicizing.

Bibliography

Bakhtin, Mikhail, *Rabelais and His World*, trans. Helene Iswolsky, Bloomington: Indiana University Press, 1984.

Bentley, Eric, *The Life of the Drama*, London: Methuen & Co., 1965.

Bildhauer, Bettina and Robert Mills (eds), *The Monstrous Middle Ages*, Toronto: University of Toronto Press, 2003.

Brunetta, Gian Piero, *Storia del cinema italiano: Dal miracolo economica agli anni novanta*, Rome: Riuniti, 2001.

Caldiron, Orio, *Mario Monicelli*, Rome: National Association of Motion Pictures and Affiliated Industries, 1998.

Charney, Maurice, *Comedy High and Low: An Introduction to the Experience of Comedy*, New York: Peter Lang, 1991.

—— (ed.), *Comedy: New Perspectives*, New York: New York Literary Forum, 1978.

Corrigan, Robert W. (ed.), *Comedy: Meaning and Form*, San Francisco: Chandler Publishing Company, 1965.

Deleuze, Gilles, *The Logic of Sense*, trans. Mark Lester, New York: Columbia University Press, 1990.

Falsetto, Mario, *Stanley Kubrick: A Narrative and Stylistic Analysis*, Westport: Praeger, 2001.

Foucault, Michel, *Language, Counter-Memory, Practice: Selected Essays and Interviews*, ed. Donald F. Bouchard, trans. Donald F. Bouchard and Sherry Simon, Ithaca: Cornell University Press, 1977.

Jordan, Marion, 'Carry On – Follow that Stereotype' in James Curran and Vincent Porter (eds) *British Cinema History*, London: Weidenfield and Nicholson, 1983, pp. 312–327.

Kolker, Robert, *A Cinema of Loneliness: Penn, Stone, Kubrick. Scorsese, Spielberg, Altman*, New York: Oxford University Press, 2000.

Landy, Marcia, *Cinematic Uses of the Past*, Minneapolis: University of Minnesota Press, 1996.

Levin, Harry, *Playboys and Killjoys: An Essay on the Theory and Practice of Comedy*, New York: Oxford University Press, 1987.

Levy, Brian and Coote, Lesley, 'The Subversion of Medievalism in *Launcelot du Lac* and *Monty Python's Holy Grail*' in Richard Utz and Jesse G. Swan (eds) *Postmodern Medievalisms*, Cambridge: D.S. Brewer, 2005, pp. 99–127.

Marx, Karl, *The Eighteenth Brumaire of Louis Bonaparte*, New York: International Publishers, 1990.

Nelson, Thomas Allen, *Kubrick: Inside a Film Artist's Maze*, Bloomington: Indiana University Press, 2000.

Nelson, T.G.A., *Comedy: An Introduction to Literature, Drama, and Cinema*, Oxford: Oxford University Press, 1990.

Nietzsche, Friedrich, 'On the Uses and Disadvantages of History for Life', trans. J.F. Stern in Introduction, R.J. Hollingdale (ed.) *Untimely Meditations*, Cambridge: Cambridge University Press, 1991, pp. 57–124.

Pythons, The, *Monty Python and the Holy Grail*, Screenplay, London: Methuen, 2002.

Rancière, Jacques, *The Names of History: On the Poetics of Knowledge*, trans. Hassan Melehy, Minneapolis: University of Minnesota Press, 1994.

Sigal, Pierre André, '*Brancaleone s'en va-t-aux-crois*; Satire d'un moyen-âge conventionnel', *Le moyen age au cinema*, special issue of *Les cahiers de la cinémathèque*, 42/43 (1985), pp. 152–154.

Sypher, Wylie (ed.), *Comedy*, Baltimore: Johns Hopkins University Press, 1983.

Trevor-Roper, Hugh, 'The Invention of Tradition: The Highland Tradition of Scotland' in Eric Hobsbawm and Terence Ranger (eds) *The Invention of Tradition*, Cambridge: Cambridge University Press, 1985, pp. 15–43.

Utz, Richard and Swan, Jesse G. (eds), *Postmodern Medievalisms*, Cambridge: D.S. Brewer, 2005.

Index

Page numbers in italics refer to illustrations.

2001, 37

A-certified comedies, *84*(table), *91*(table), 94–7
Åberg, Lasse, 59, 60
Abrahams, Jim, 142
Admirable Crichton, The, 86
Adolf Hitler: My Part in His Downfall, 134
Aeschylus, 9
Against All Flags, 96
Alda, Alan, 106
All in the Family, 157–8
All the President's Men, 14
Allen, Woody, 10, 16, 17, 23–4, 103–10
'Allo, 'Allo, 21, 145
American Civil War settings, 43
Amorous Adventures of Moll Flanders, The, 81, 95
Amos, Emma, 136
anachronisms, in historical comedies, 13–19
Anderson, Lindsay, 90
Anderson, Michael, 143
Andrews, Julie, 92
Annie Hall, 110
Anouilh, Jean, 92, 95
Aranda, Vicente, 115
Arbuckle, Roscoe 'Fatty', 37, 106
Arehn, Mats, 59
Aristophanes, 9
Aristotle, 9, 23, 25, 116
armata Brancaleone, L', 10, 181, *181*, 184
Askwith, Betty, 147
Assassination Bureau, 94
Astérix comics, 16
Atkinson, Rowan, 56, 145

Attenborough, Richard, 146
Auschwitz, writing about, 166
! Ay, Carmela!, 11, 115, *120*, 120–2, *121*, 125

Bakhtin, Mikhail, 20, 29, 117–18, 120–2, 134, 145, 191
Bananas, 103, 103–4
Barabbas, 21
Bardem, Juan Antonio, 117
Barker, Reginald, 44
Barrie, J.M., 85
Barta, Tony, 141–2
Basinger, Jeanine, 143
Battleship Potemkin, 104
Beggar's Opera, The, 89
Begley, Ed, Jr, 109
Belle époque, 115, 117–19, 125–6
Ben-Hur, 13, 19, 21
Bendix, William, *87*
Benigni, Roberto, 28, 29, 146, 156
Benjamin, Richard, 108
Benjamin, Walter, 116
Benson, Theodora, 147
Bergman, Ingmar, 55, 104
Bergson, Henri, 11, 19, 37
Berlanga, Luis García, 115, 117, 124
Besson, Luc, 9
Best House in London, The, 96
! Bienvenido Mister Marshall!, 117, 124
Billy Budd, 96
Bilton, Alan, 35, 46, 47
Birth of a Nation, The, 35, 108
black humour, 155
Blackadder series, 21, 56
　　Blackadder Goes Forth, 145–6

Blakemore, Michael, 138
Blazing Saddles, 21
Bonnie and Clyde, 14
Booth, Wayne C., 157
Bordwell, David, 41, 86
Börjlind, Rolf, 59
Brady, Mathew, 43
Branagh, Kenneth, 108
Brancaleone alle crociate, 178, 183–6
Brännström, Brasse, 60
Breakfast at Tiffany's, 93
Brecht, Bertolt, 116
Brighouse, Harold, 85, 88
British Film Catalogue, 82
British New Wave, 90
Broken Blossoms, 49
Brooks, Mel, 16, 17, 19, 21, 22
Brownlow, Kevin, 140
Brunetta, Gian Piero, 186
Bullets over Broadway, 107
Buñuel, Luis, 108
Burgoyne, Robert, 197
Butler, David, 15

Cavalcanti, Alberto, 143
Calle Majoy, 117
Card, The, 88
Cardboard Cavalier, 87
'Carry On' films, 178
 Carry On England, 134, *135*, 143, 144, 145
 Carry On, Jack!, 96–7
 Carry On Sergeant, 134–6
 Carry On … Up the Khyber, 91, 97, 178–81,
 179
cartoons, satirical, 116–17
Cassandra's Dream, 108
Caza, La, 120
Celebrity, 106, 108
certification categories of films, 83, *84*(table),
 89–92, *91*(table), 94–7
Chaplin, Charlie, 56, 104
Chapman, Graham, 16, 20
chivalric ideal, 181–2
Cicero, 23
Cilento, Diane, 86
Clarkson, Patricia, 109
Clayton, Jack, 90

Cleese, John, 138, 147
Cleland, John, 92, 95
Clockwork Orange, A, 191, 193
Coe, Peter, 96
Cohen, Norman, 134, 137
Collins, Jacky, 119
comedy
 classic theory of, 23
 comedian comedy, 56
 comedy of manners, 83, 85–8
 critical potential of, 148
 definitions and characteristics, 116
 and grand narrative history, 61–6, 73
 episodic comedy, 83, 88
 period comedy, 81–2
 purpose of, 132
 romance comedy, 56–7, 72
 situation comedy, 20–1, 134, 136–8, 145–6,
 147
 slapstick comedy, 88
 traditions, 56
 see also humour
Confederación Nacional del Trabajo, 116–17
Cops, 41
Cornelius, Henry, 93
counter-cinema, 142–6
counter-history, 177–8
Court Jester, The, 87, 88
Coward, The, 44
Crawford, Michael, 145
Crichton, Charles, 93
Crime and Punishment, 104
Crimes and Misdemeanors, 104, 110
Crosby, Bing, *87*, 88
Curse of the Jade Scorpion, 107
Curtiz, Michael, 25

Dad's Army, 134
Dale, Jim, 134
Dardis, Tom, 44
David, Larry, 108
De-Nur, Yehiel (Ka-Tzetnik), 170
Deconstructing Harry, 106, *108*
Defoe, Daniel, 95
Descartes, René, 23
Deux heures moins le quart avant Jésus-Christ,
 10–11, *18*

Deveny, Thomas, 125
Dickens, Charles, 85
Dirks, Tom, 46
Don Juan, 23
Don't Drink the Water, 107
Don't Lose Your Head, 97
Dostoevsky, Fyodor, 104
Double Crossbones, 87
Douglas, Kirk, 193
Dr Strangelove, 191
Dracula, 90
Drowned and the Saved, The, 170
Drum, The, 178
Duck Soup, 15
Dulces horas, 120
Dyke, Dick van, 92

Eagleton, Terry, 116
Egyptian, The, 25
Eighteenth Brumaire of Louise Bonaparte, 177, 178
Eisenstein, Sergei, 104
Ekman, Gösta (the elder), 58
Ekman, Gösta (the younger), 60
El Cid, 21
Electric House, The, 43
Emmerich, Roland, 9
Engels, Friedrich, 9
Escopeta nacional, La, 124
esperpento, 125
Euripides, 9
Europa Film, 55, 60
Everyone Says I Love You, 107
Everything You Wanted to Know about Sex, 104

Fanny and Alexander, 55
Fanny Hill – Memoirs of a Woman of Pleasure, 92, 95
Farrow, Mia, 106, 108
Fascism, 138
Fawlty Towers, 147
Feyder, Jacques, 15
fiction, historical, 25–6
Field, Sid, 87
Fielding, Henry, 95
'Film Nazis', 141–2, 143

Finland, historical films, 12
Finney, Albert, 95
Fischer, Lucy, 41
Fisher, Terence, 90
Foreigners, 147
Foucault, Michel, 197
Four Feathers, The, 178
Franco, General, 115, 117, 124
Frängsmyr, Tore, 59
Freud, Sigmund, 37–8
Frye, Northrop, 25
Full Metal Jacket, 191
'Funniest Joke in the World' sketch (*Monty Python's Flying Circus*), 147

Gassman, Vittorio, 181, *181*
Gay, John, 85
General, The, 10, 35, 43–9, *45*, *48*, 56
Genevieve, 93
Genghis Khan, 21
Germans and Nazism, 138–42
Ghosts of Berkeley Square, The, 88
Gifford, Dennis, 82
Girl on the Boat, The, 90, 92
Gish, Lilian, 49
Gladiator, The, 9, 17
Go-Between, The, 27
Go West, 49
Godard, Jean-Luc, 142
Goodbye Columbus, 108
Goodnight Sweetheart, 136–7
Goscinny, René, 16
Gotell, Walter, 60
Great Locomotive Chase, The, 43
Greece, ancient, 9
Griffith, D.W., 35, 108
Grindon, Leger, 14
grotesque realism, 120–1
Guitry, Sacha, 10
Gunning, Tom, 46
Guns of Navarone, The, 143

Hammer Films, 90, 97
Hannah and Her Sisters, 104
Hanoch, Dani, 157, *157*, *161*, 161–2, 163, 165, 168, *171*
Hanoch, Miri, 161, 163, 164, *167*, *171*

Hanoch, Shagi, 161, *161, 167*
Harrison, Rex, 92
Hartley, L.P., 27
Harvey, Laurence, 86
Haunted House, The, 43
Hecht, Jessica, 109
Hegel, 115
Helen of Troy, 23
Hepburn, Audrey, 92, 93
Heroes of Telemark, The, 143
High Anxiety, 21
Himmler, Heinrich, 157
Hirschbiegel, Oliver, 9, 156
historians, professional, and historical films, 177
historical awareness, of spectators, 19, 56, 73
historical fiction, 25–6
History by Hollywood, 14
History of the World: Part I, The, 16–17, 19, 21, 25
Hitler, Adolf, 138–40
 'Mr Hilter' sketch (*Monty Python's Flying Circus*), 138–40, *139*, 148
Hobson's Choice, 88, 89
Holiday, Billie, 108
Holloway, Stanley, 92
Hollywood Ending, 106, 107–8
Holmes, Michelle, 136
Holocaust, 27–9, 132, 141, 146–8, 155–72
Hope, Bob, 15–16
How I Won the War, 141, 144–6, 148
humour
 black, 155
 'otherness' and, 25–9, 143–4
 subversive, 116–17
 see also comedy
Husbands and Wives, 106
Huston, Anjelica, 106
Huston, John, 95
Hutcheon, Linda, 148, 157–8
Hutton, Brian G., 143

Ideal Husband, An, 81
Ihonen, Markku, 26
Ince, Thomas, 44
Interiors, 104
Intolerance, 50
irony, 22–3, 155–60, 163

Isn't Life Wonderful!, 86
It Ain't Half Hot Mum, 138
It Happened Here, 140–1

Jackson, Gabriel, 115
Jakob the Liar, 146
James, Sidney, 97
Jardín de las delicias, El, 120
JFK, 14
John of the Fair, 89
Jones, Terry, 16, 19
Jonsson, Bosse, 55, 59
Jules Verne's Rocket to the Moon, 94

Ka-Tzetnik (Yehiel De-Nur), 170
Kalabaliken i Bender (*Kalabalik*), 10, 12, 19, 55, 57–74, *65, 70*
Kalela, Jorma, 13–14
Karl XII, 57–9, 73
Karl XII, 58
Karlyn, Kathleen Rowe, 37
Kassovitz, Peter, 146
Kaye, Danny, 87
Keaton, Buster, 9–10, 12, 35–6, 38, 39, 43–4, *45*
Kermesse héroïque, La, *15*, 15, 25
Kertész, Imre, 160
Kielar, Wieslaw, 166
Kind Hearts and Coronets, 86
Kinder, Marsha, 119
King's Pirate, 96
Kipling, Rudyard, 85
Kirwan, Dervla, 136
Korda, Alexander, 10, 23, 81
Korda, Zoltan, 178
Krutnik, Frank, 116, 122, 126
Kubrick, Stanley, 10, 191
Kuray, Ayse Emel Mesci, 60

La Dolce Vita, 108
Lanchester, Elsa, *24*
Landau, Martin, 106
Landy, Marcia, 82
Lansbury, Angela, 87
Laughter, 11, 37
laughter, nature of, 11–12
Laughton, Charles, *24*, 88, *89*
Lennon, John, 144

Leoni, Tea, 107
LeRoy, Mervyn, 13
Lev, Yair, 170
Levi, Primo, 166, 170
Levy, Dani, 132
Libertarias, 115, 122–3, *123*, 125
Life of Brian, The, 12, 16, 19–22, *21*, 26–7, *27*, 142
Lipps, Theodor, 19
Lloyd, Harold, 56
Lock up Your Daughters!, 96
Lockwood, Margaret, 87
Looking Back, 104
Love and Death, 16, *17*, *18*, 104, 106
Lyndhurst, Nicholas, 136

Magyar Film, 60
Man Who Loved Redheads, The, 86
Manhattan, 103, 104–6, 110
Manhattan Murder Mystery, 106, 107
Mann, Anthony, 143
Marcus, Greil, 141–2
Marx Brothers, 15
Marx, Karl, 115–16, 177, 178
Mary Poppins, 92
Match Point, 108
Maus, 27–9, 156
Mayo, Virginia, 16
McCormick, Carolyn, 108
Medhurst, Andy, 82
Mein Führer – Die wirklich wahrste Wahrheit über Adolf Hitler, 132
melodrama, silent, 35, 38, 49
Messenger: The Story of Joan of Arc, The, 9
Metahistory, 22
Metamorphosis (Ovid), 190
Meyer, Russ, 95
Midsummer Night's Sex Comedy, A, 104
Mihaileanu, Radu, 28, 146
Milligan, Spike, 134
Million Pound Note, The, 86
Mitchell, Warren, 137
Modern Times, 104
Molinas, Juan M., 116
Moll Flanders, 81, 95
Monicelli, Mario, 10
Monty Python group, 12, 13, 16, 19, 22, 146, 187–8

Life of Brian, The, 12, 16, 19–22, *21*, 26–7, *27*, 142
Monty Python and the Holy Grail, 13, 16, *18*, 20–1, 22, 26, 74, 142, 178, 187–90, *190*
Monty Python's Flying Circus, 138–40, *139*, 147, 148, 190
 'Funniest Joke in the World' sketch, 147
 'Mr Hilter' sketch, 138–40, *139*, 148
Mr Bean series, 56
Mujeres Libres, 122
Mummy, The, 90
Murphy, Robert 143
Mutiny on the Bounty, 96
My Fair Lady, 92–3, 97

Nacional III, 124
Navigator, The, 36, 41
Nazism
 'Film Nazis', 141–2, 143
 see also Hitler, Adolf
Neale, Steve, 116, 122, 126
Nell Gwyn, 81
Nietzsche, Friedrich, 177
Noakes, Lucy, 134
Noche sobre España, 116
Noin seitsemän veljestä, 12
nostalgia
 and childhood, 160
 'Holocaust-nostalgia', 155
 and irony, 155–60
 and World War II films, 133–8

Oh, What a Lovely War!, 146
One Week, 41, 43
Operation Crossbow, 143
Orbach, Jerry, 106
'otherness' and humour, 25–9, 143–4
Our Hospitality, 10, 35, 39–43, *42*, 44, 45, 49
Ovid, 190

Pale Face, The, 50
Palin, Michael, 148, *190*
Palmer, Jerry, 136
Parker, Cecil, 87
parody, 10, 19–21, 26, 83, 86
Paths of Glory, 178, 191–7, *193*
Patrimonio nacional, 124

Patriot, The, 9
Patton, 14
Pelham, David, 95
Pérez González, José Maria, 117, 120
Perriam, Chris, 119
Pick, Daniel, 146
Pickwick Papers, The, 88
Pittenger, William, 43
Pizza in Auschwitz, 10, 11, 29, *157,* 157–8, *161,*
 161–72, *167, 171*
Play It Again, Sam, 106
Poetics (Aristotle), 9
Poiré, Jean-Marie, 11
Pollyanna Principle, 159–60
Porton, Richard, *123*
Previn, Soon-Yi, 106, 110
prima Angélica, La, 120
Princess and the Pirate, The, 15–16
Private Life of Henry VIII, The, 10, 23, *24,* 25,
 81
Privates on Parade, 138
Purple Rose of Cairo, The, 104, *105,* 107, 110
Pygmalion, 92

Quo Vadis, 13

Rabelais, François, 20
Radio Days, 104, *105*
Ramsden, John, 140, 141
Randle, Frank, 89
Rank Corporation, 90
Ranke, Leopold von, 25
Ray, Charles, 44
Richards, Jeffrey, 134
Richardson, Tony, 95
Robin Hood: Men in Tights, 16, 17
Rollins, Peter C., 14
Roman Holiday, 93
Roman Scandals, 12
romance comedy, 56–7, 72
Room at the Top, 90
Rosen, Philip, 197
Rosenstone, Robert A., 14, 74, 197
Roth, Philip, 108

satire, 10, 116–17, 141
Saturday Night and Sunday Morning, 95

Saura, Carlos, 11, 115, 117, 120
Saville, Philip, 96
Saving Private Ryan, 131
Saving Private Ryan from the ComedyChannel,
 131
Scarecrow, The, 43
Scoop, 108
Scott, Ridley, 9
Seabrook, John, 38
Sellers, Peter, *94,* 95
Sharansky, Natan, 159–60
Shaw, George Bernard, 92
Shivitti: A Vision, 170
Si Versailles, m'était conté, 10, *11*
Sight & Sound, 29
Simon, Neil, 107
Sims, Joan, 97
Sinful Davey, 95
situation comedy, 20–1, 134, 136–8, 145–6, 147
slapstick comedy, 88
Sleeper, 104
Small Time Crooks, 106, 107
Sobchack, Vivien, 197
Socrates, 22
Sophocles, 9
Space Balls, 21
Spanish Civil War films, 10, 115–17
 ! *Ay, Carmela!,* 120–2
 Belle époque, 117–19
 Libertarias, 122–3
 Vaquilla, La, 124–5
Spiegelman, Art, 27, 29, 156
Spielberg, Steven, 131
Stardust Memories, 104
Stav, Shira, 169
Stevenson, Robert Louis, 92, 94
Stonier, George, 133
subversive humour, 116–17
Sunshine Boys, The, 107
Svensk Filmindustri, 55
Sweet and Lowdown, 107
Sypher, Wylie, 37
Sysmäläinen, 12

Take the Money and Run, 104
Talmadge, Natalie, 40
Terry-Thomas, 93

That Mitchell and Webb Look, 142
theory of comedy, classic, 23
This Sporting Life, 90
Thomas, Gerald, 179
Thompson, J. Lee, 143
Thompson, Kristin, 41
Those Magnificent Men in Their Flying Machines, 93, 93, 94
Three Ages, The, 36, 36
Three Men in a Boat, 88
Till Death Us Do Part, 137–8, 145
Titfield Thunderbolt, 93
Tom Jones, 91, 92, 95, 96, 97
Top Secret!, 142, 143, 144
Toplin, Robert Brent, 14, 74
Trahair, Lisa, 46
Train de vie, 28, 29, 146
Trevelyan, John, 98
Trevor-Roper, H., 179
Trueba, Fernando, 115
Truth About Women, The, 86
Twain, Mark, 85

Uderzo, Albert, 16
Untergang, Der, 9, 132, 156
Ustinov, Peter, 96

Vaala, Valentin, 12
Valle-Inclán, Rámon del, 125
Vaquilla, La, 115, 124–5
Vicky Cristina Barcelona, 108
Vietnam War, 144, 147
Viking Film, 60
Virginian, The, 49
Virtanen, Jukka, 12
Visiteurs, Les, 11
vita è bella, La, 28, 29, 146, 156
Voltaire, 58

Waltz of the Toreadors, The, 92, 94, 95
Waterson, Sam, 106
Way Down East, 39, 40, 41, 42
Welch, Christopher Evan, 109
Welles, Orson, 16
Went the Day Well?, 143, 144
Whatever Works, 108–10
What's Up, Tiger Lily, 104, 106
When You Come Home, 89
Where Eagles Dare, 143
White, Hayden, 22, 25, 115
Widding, Lars, 59
Wilde, Oscar, 81, 85
Williams, Kenneth, 97
Williams, Linda, 35, 38, 46, 48
Wisdom, Norman, 90–1
Wister, Owen, 49
Wodehouse, P.G., 90
Wollen, Peter, 142
Wood, Even Rachel, 109
World War I, and film comedy, 145, 191
World War II, and film comedy, 10, 131, 132–48
Wrong Box, The, 92, 94
Wyler, William, 13

X-certified comedies, 91(table), 94–7

Yankee in King Arthur's Court, A, 87, 88
Yanne, Jean, 10
Young Frankenstein, 21
YouTube, 131

Zelig, 23–4, 24, 104, 106, 107, 107
Zimerman, Moshe, 11, 158, 164, 165, 167
Žižek Slavoj, 29
Zucker, David, 142
Zucker, Jerry, 142
Zugsmith, Albert, 95

Lightning Source UK Ltd.
Milton Keynes UK
UKHW051236170223
417189UK00010B/413